Manga for the Beginner

Manga for the Beginner

Everything You Need to Know
to Get Started Right Away!

CHRISTOPHER HART

Watson-Guptill Publications/New York

Executive Editor: Candace Raney
Senior Development Editors: Michelle Bredeson, Alisa Palazzo
Art Director: Timothy Hsu
Designers: T Hsu & Associates, Bob Fillie
Production Manager: Salvatore Destro

Contributing Artists

Denise Akemi Roberta Pares

Diana Fernandez Diogo Saito

Cristina Francisco Aurora Tejado

Elisa Kwon Nao Yazawa

Color by Richard and Tanya Horie (except for pages 58–59, 98–103, 105, 107)

First published in 2008 by Watson-Guptill Publications,
an imprint of the Crown Publishing Group,
a division of Random House, Inc., New York
www.crownpublishing.com
www.watsonguptill.com

Library of Congress Cataloging-in-Publication Data
Hart, Christopher.
 Manga for the Beginner : everything you need to start drawing right away! /
Christopher Hart.
 p. cm.
 Includes index.
 ISBN-13: 978-0-8230-3083-5 (alk. paper)
 ISBN-10: 0-8230-3083-0 (alk. paper)
 1. Comic books, strips, etc.—Japan—Technique. 2. Cartooning—Technique. I. Title.
 NC1764.5.J3H369286 2008
 741.5'1—dc22

 2007040490

Printed in Malaysia

9 / 16 15 14 13 12

This book is dedicated to all of my readers,
but especially to those who have practiced so much
that they have learned to live
with pencil smudge marks on their hands!

Contents

Introduction

WHEN I FIRST CAME UP WITH THE IDEA for this book, I saw nothing like it on the bookstore shelves. Although I did see piles of how-to-draw-manga books aimed at newbies, they showed mostly Americanized manga. I wanted to do something truly authentic, with tons of step-by-step instructions that can really get you where you want to go. And I wanted to cover the entire world of manga characters, from all genres and categories, not just the bland fare typically dished out to beginners.

The result is the first complete book on drawing manga for beginners. Sure, we'll start out covering all the basics: the manga head and body, the brilliant eyes, the body proportions, and more. But the instruction doesn't end there. It moves on to costume and character design, action poses, special effects, perspective, and staging stories in sequential panels—everything you need to draw manga and, should you care to take it this far, even create your own manga graphic novel.

The most popular styles of manga are featured throughout this book in easy-to-follow lessons that are fun to draw. There's shoujo, the famous "big-eyed" style that stars charming schoolgirls and schoolboys, and a huge section on shounen, or adventure-style, manga, which is packed with heroes, bad boys, martial arts fighters, and fearsome monsters. We've also got chibis (the cute and tiny people of manga), adorable manga animals, anthros (animals that are drawn to mimic people), and a vampire or two for you manga occult fans. So, whether you're a complete beginner or already have some drawing experience, I guarantee that *Manga for the Beginner* has something in it for you.

The Manga Head

ONE REASON WHY MANGA CHARACTERS are so appealing is because the shape of the head is kept simple and easy to take in at a glance. Also, there aren't any pronounced cheekbones, pouchy lines under the eyes, or heavy lines around the mouth to draw. How's that for good news? There *is*, however, a heavy focus on the eyes; but not to fear—that's the *fun* part, and you'll get lots of examples of how to approach drawing them.

TEEN GIRL

Many manga heroes and other characters are young, so we'll start with the ever-popular teen girl. The typical manga teenage girl has a rounded head that tapers to a pointed chin. Her eyes, like those of most manga characters, are huge and placed low on the face for a youthful appearance (see page 26 for more on drawing sparkling manga eyes).

Front View

Everyone starts with the front view, because it's the easiest pose to draw. But halfway into it, the beginner may become a bit frustrated. Well, let me let you in on a little secret: The front view is actually one of the hardest poses to draw! It's unexpectedly difficult. No wonder beginners find it challenging, and here's why: In the front view, you have to draw the entire outline of the head symmetrically, lining up the eyes and ears perfectly, foreshortening the nose, and designing a hairstyle that covers the entire head. Quite an assignment. It's tough to get all this on the first try. But if you break down the process into simple steps, it becomes much easier. And if you add intersecting horizontal and vertical guidelines, you'll be confident of where to place the features.

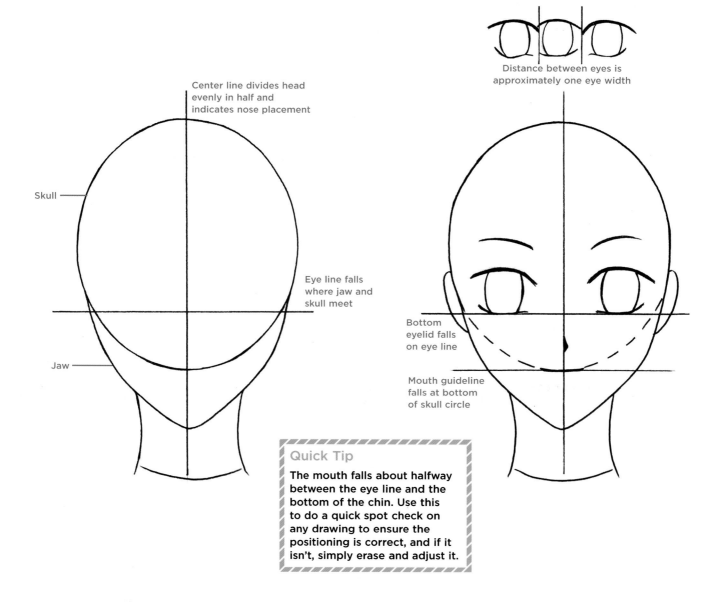

Distance between eyes is approximately one eye width

Center line divides head evenly in half and indicates nose placement

Skull

Eye line falls where jaw and skull meet

Jaw

Bottom eyelid falls on eye line

Mouth guideline falls at bottom of skull circle

Quick Tip

The mouth falls about halfway between the eye line and the bottom of the chin. Use this to do a quick spot check on any drawing to ensure the positioning is correct, and if it isn't, simply erase and adjust it.

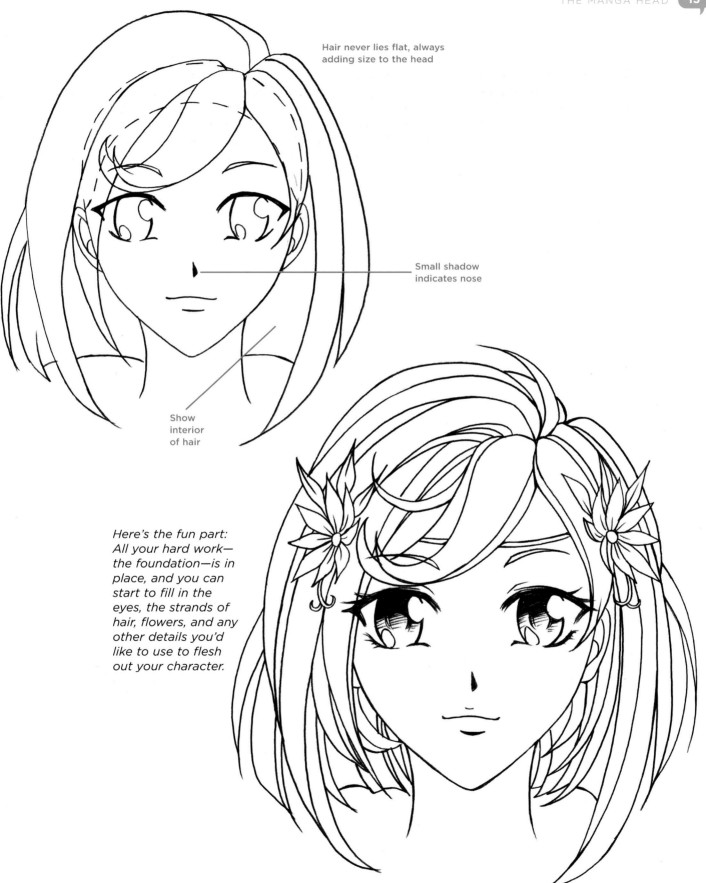

Hair never lies flat, always adding size to the head

Small shadow indicates nose

Show interior of hair

Here's the fun part: All your hard work— the foundation—is in place, and you can start to fill in the eyes, the strands of hair, flowers, and any other details you'd like to use to flesh out your character.

Profile

The profile, or side view, is easy to draw—except for one part (isn't there always a caveat?). The sticking point is the mouth/chin area underneath the nose. If an artist is going to get a bit off track, that's often where it happens. Remember that, on female characters, the lips always protrude past the chin.

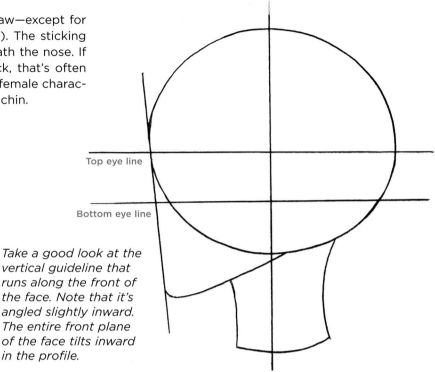

Top eye line

Bottom eye line

Take a good look at the vertical guideline that runs along the front of the face. Note that it's angled slightly inward. The entire front plane of the face tilts inward in the profile.

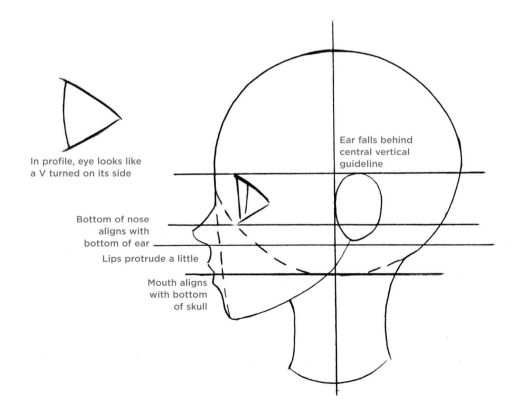

In profile, eye looks like a V turned on its side

Ear falls behind central vertical guideline

Bottom of nose aligns with bottom of ear

Lips protrude a little

Mouth aligns with bottom of skull

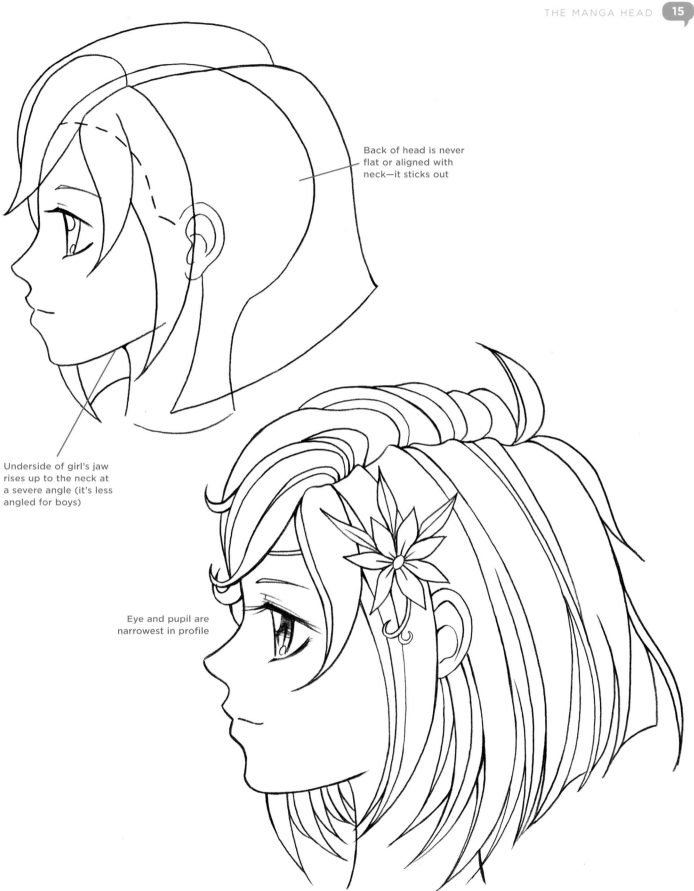

Back of head is never flat or aligned with neck—it sticks out

Underside of girl's jaw rises up to the neck at a severe angle (it's less angled for boys)

Eye and pupil are narrowest in profile

3/4 View

The 3/4 view is halfway between the front view and the profile. It is generally considered the most pleasing angle in which to draw a character. Beginners tend to shy away from it because it involves drawing some things in perspective (meaning that you must draw elements that are farther away from you smaller than those that are closer to you). So, the far side of the face is diminished in the 3/4 view. Additionally, the bridge of the nose cuts off part of the far eye. Despite these complications, this is actually *not* a difficult pose to draw. With just a few attempts, beginners can usually master this pose and, suddenly, have an entirely new angle in their repertoire—one that makes the character look its best. The key to making this pose work is the center line. With the exception of the front view, the center line *curves* around the face; it is *never* a straight line. The bridge of the nose follows the center line, cutting off part of the far eye as mentioned. Remember that and you'll be able to draw this angle easily.

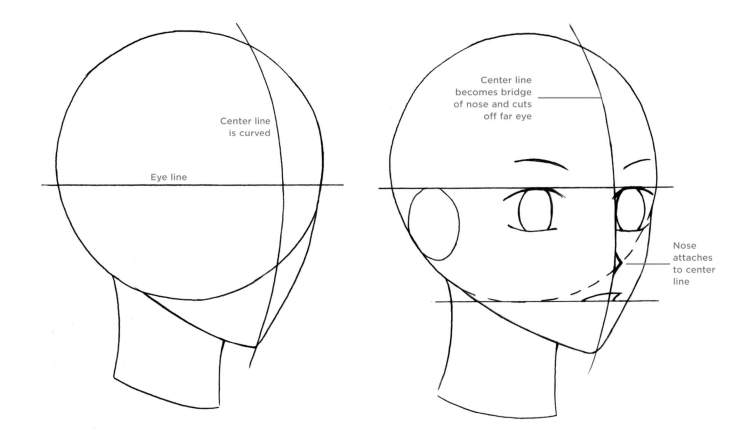

Center line is curved

Eye line

Center line becomes bridge of nose and cuts off far eye

Nose attaches to center line

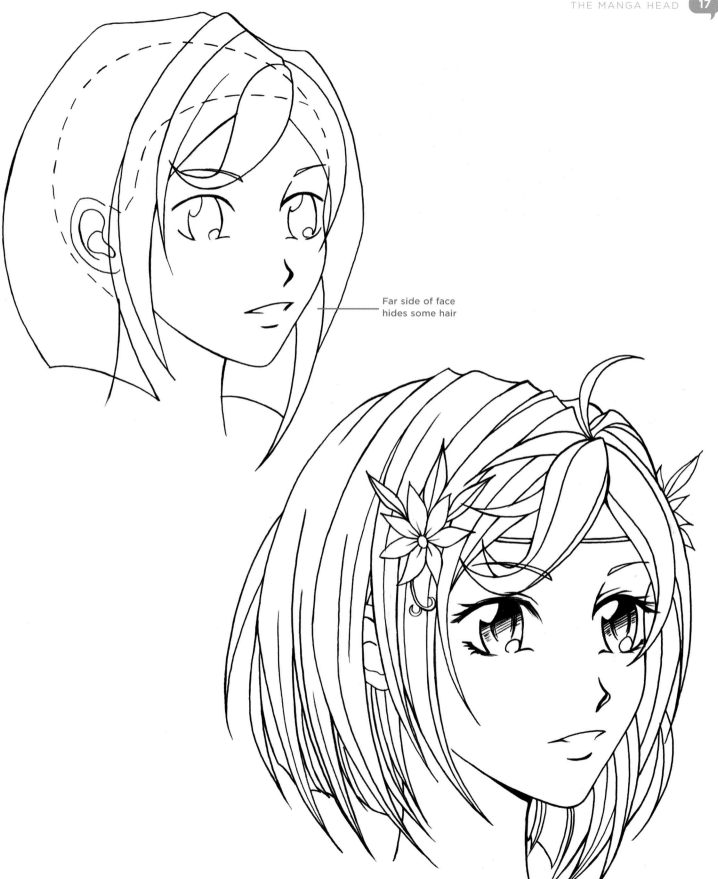

Far side of face
hides some hair

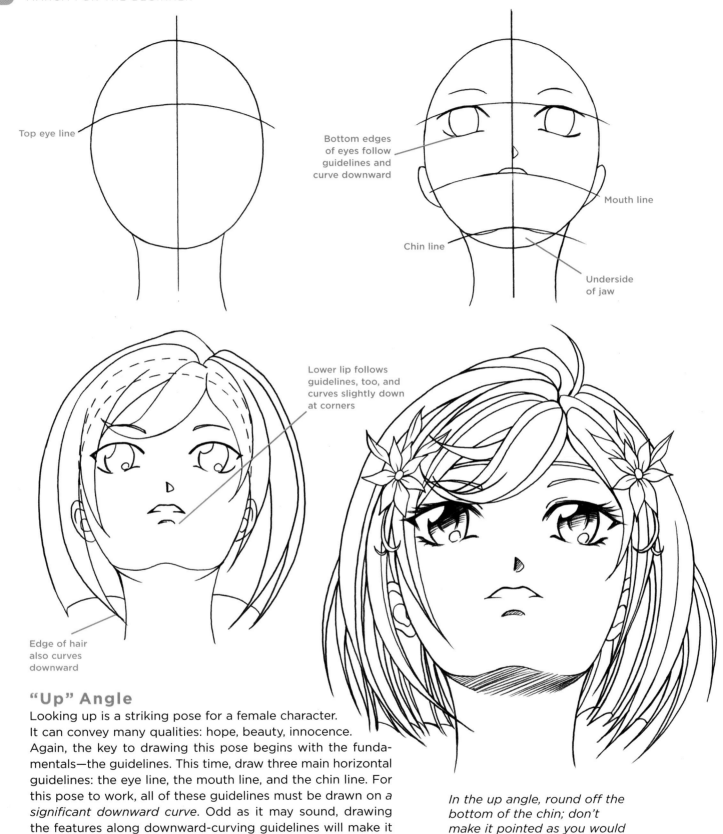

Top eye line

Bottom edges
of eyes follow
guidelines and
curve downward

Mouth line

Chin line

Underside
of jaw

Lower lip follows
guidelines, too, and
curves slightly down
at corners

Edge of hair
also curves
downward

"Up" Angle

Looking up is a striking pose for a female character.
It can convey many qualities: hope, beauty, innocence.
Again, the key to drawing this pose begins with the funda-
mentals—the guidelines. This time, draw three main horizontal
guidelines: the eye line, the mouth line, and the chin line. For
this pose to work, all of these guidelines must be drawn on *a
significant downward curve*. Odd as it may sound, drawing
the features along downward-curving guidelines will make it
seem as though we're looking up at the character.

*In the up angle, round off the
bottom of the chin; don't
make it pointed as you would
on the typical manga head.*

"Down" Angle

Drawing a character looking down calls for a greater use of perspective than does any other angle of the head. It might *feel* wrong to exaggerate the drawing to such a degree in the first few steps, but as you'll see, sometimes things that are correct don't always feel correct at first. In fact, that's one of the first lessons you learn in life-drawing classes. So, for example, it might not feel correct to see so much of the top of the character's head or to draw the nose of the character so close to the mouth, but remember that from this angle, perspective distorts things. Here, we reverse the angle of the guidelines so that they all curve *upward*.

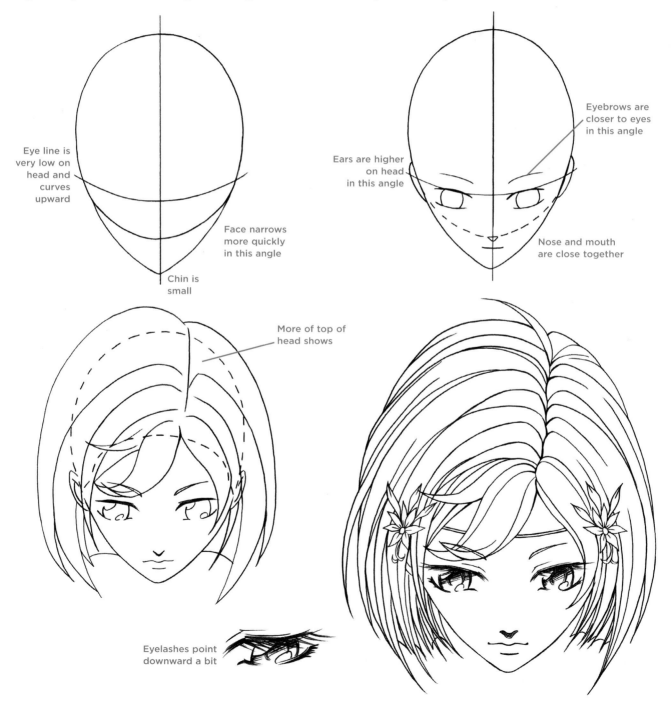

Eye line is very low on head and curves upward

Face narrows more quickly in this angle

Chin is small

Eyebrows are closer to eyes in this angle

Ears are higher on head in this angle

Nose and mouth are close together

More of top of head shows

Eyelashes point downward a bit

TEEN BOY

The outline of the boy's head is similar to that of the girl, but the jaw is more angular and the chin is more square (less pointed at the tip). In addition, the overall head shape is a little bit more oblong, less circular. Also, the eyebrows are thicker, but the eyes are smaller. The neck is wider and sometimes has an indication of an Adam's apple, which you don't see in girls and women.

Front View

Note that the eye line in this front view is the top eye line, whereas the eye line in the Teen Girl front view on page 12 is the bottom eye line. Using either guide-line works; it's just a matter of personal taste.

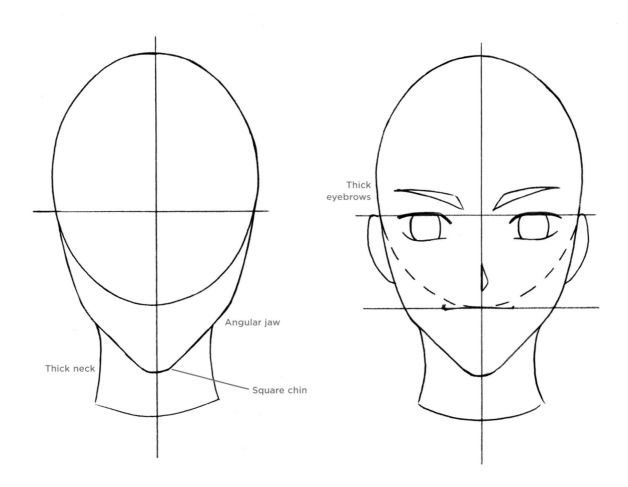

Thick eyebrows

Angular jaw

Thick neck

Square chin

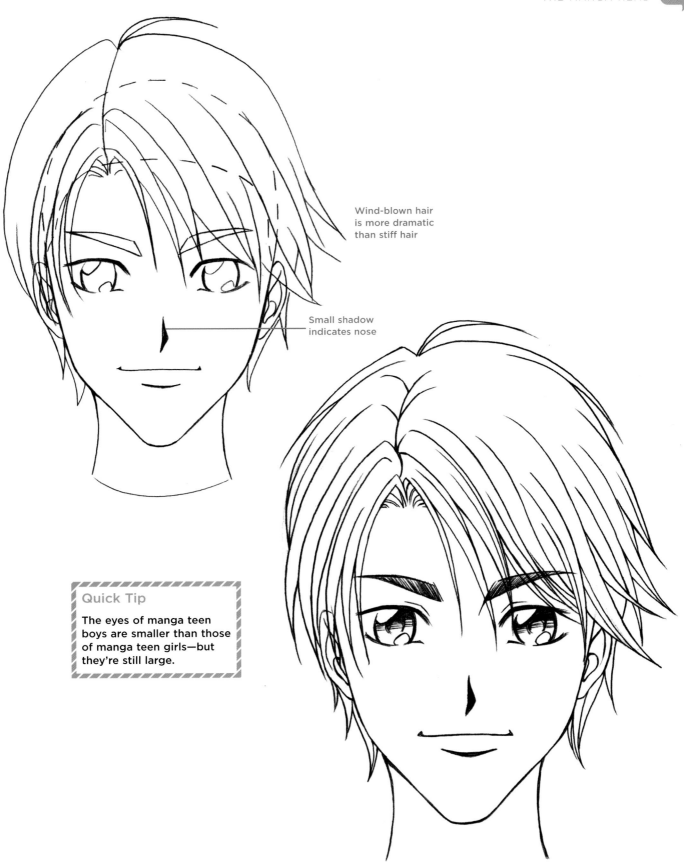

Wind-blown hair
is more dramatic
than stiff hair

Small shadow
indicates nose

Quick Tip

The eyes of manga teen
boys are smaller than those
of manga teen girls—but
they're still large.

Profile

As with the female profile, the angle of the front plane of the face tilts slightly inward from the forehead to the chin in the male profile. And note the hard jawline; it's not soft like on the teen girl.

Top eye line

Bottom eye line

Eyebrow extends beyond front of eye

Eye set back from edge of head

Bottom of ear aligns with bottom of nose

Lips protrude and fall even with base of skull

Hair flops in front of eyes

Square jaw

Slightly recessed chin

3/4 View

As a young boy matures, his face becomes sleeker. You can see this in the far side of his face.

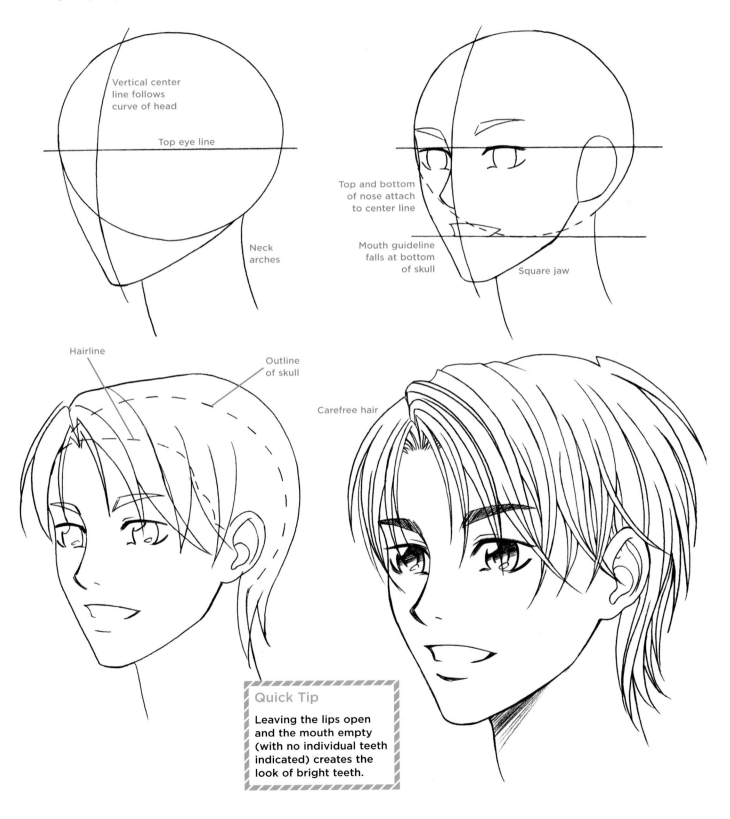

Vertical center line follows curve of head

Top eye line

Neck arches

Top and bottom of nose attach to center line

Mouth guideline falls at bottom of skull

Square jaw

Hairline

Outline of skull

Carefree hair

Quick Tip

Leaving the lips open and the mouth empty (with no individual teeth indicated) creates the look of bright teeth.

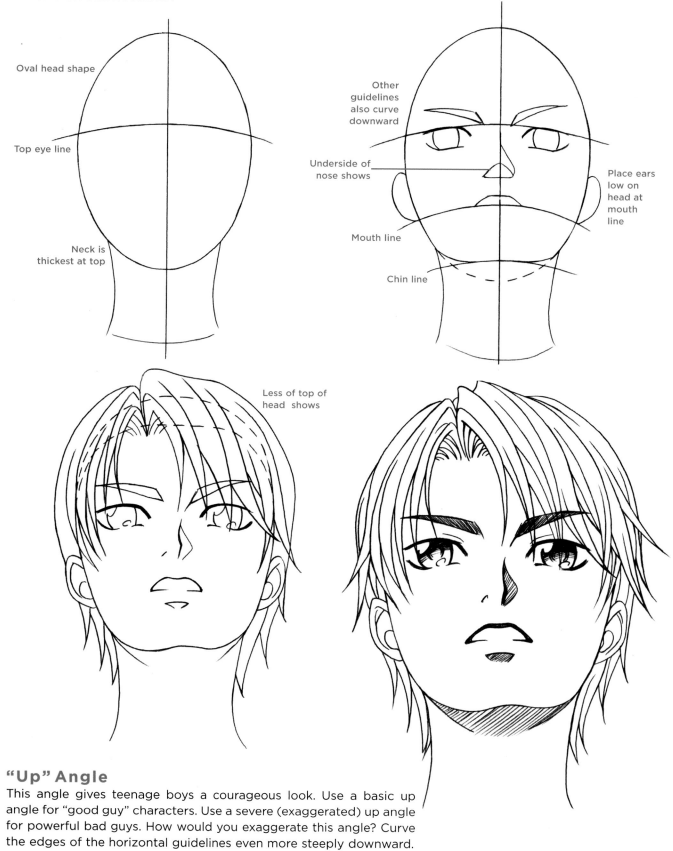

Oval head shape

Top eye line

Neck is thickest at top

Other guidelines also curve downward

Underside of nose shows

Mouth line

Chin line

Place ears low on head at mouth line

Less of top of head shows

"Up" Angle

This angle gives teenage boys a courageous look. Use a basic up angle for "good guy" characters. Use a severe (exaggerated) up angle for powerful bad guys. How would you exaggerate this angle? Curve the edges of the horizontal guidelines even more steeply downward.

"Down" Angle

With boy characters, this angle creates a moody, reflective attitude. Here, the guidelines curve upward at the edges, and you see more of the top of the head and less of the mouth-and-chin area, which is foreshortened.

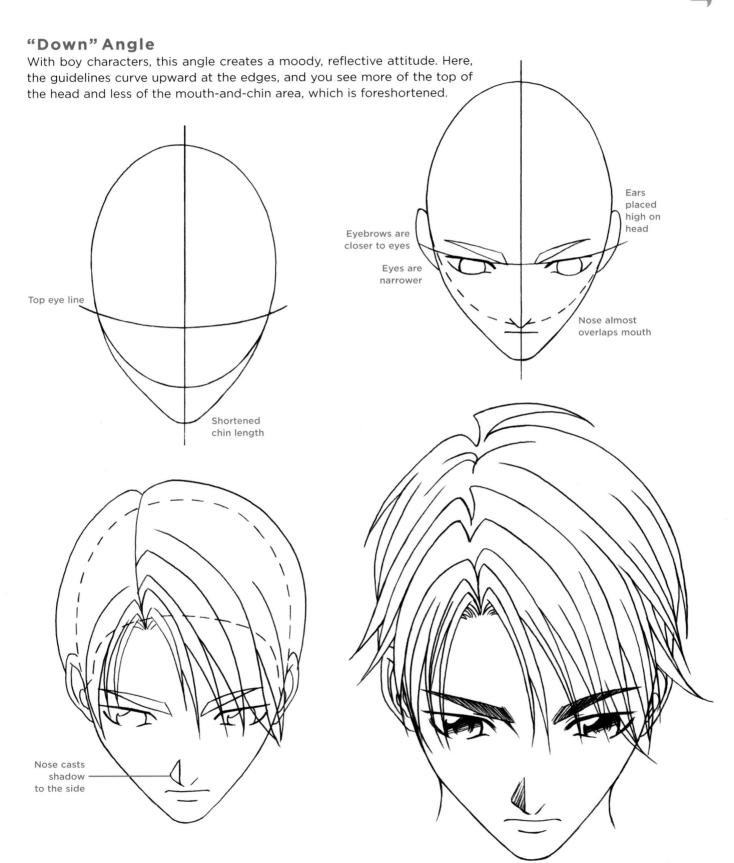

Top eye line

Shortened chin length

Ears placed high on head

Eyebrows are closer to eyes

Eyes are narrower

Nose almost overlaps mouth

Nose casts shadow to the side

SPARKLING MANGA EYES

I know, this is the part you've been waiting for! Nothing says *manga* so much as the eyes. They spotlight the charisma and sheer brilliance of these popular, expressive characters. There are many ways to draw manga eyes; however, the shoujo style famous for its big-eyed, youthful personalities is perhaps the most popular manga style of all, so we'll focus on shoujo-style eyes, which all share common traits that give them a consistently charming appearance.

It's easy to be dazzled by the beauty of manga eyes, but you still have to start with simple shapes to end up with eyes as pretty as those shown here. So, first, the basics that apply to both male and female eyes: Start with ovals for the irises (the colored part of the eyeball), not circles. Frame the eyeball with a heavy top eyelid and a thin lower eyelid. Note that the upper eyelids arch toward the bridge of the nose, as if they're bending toward each other.

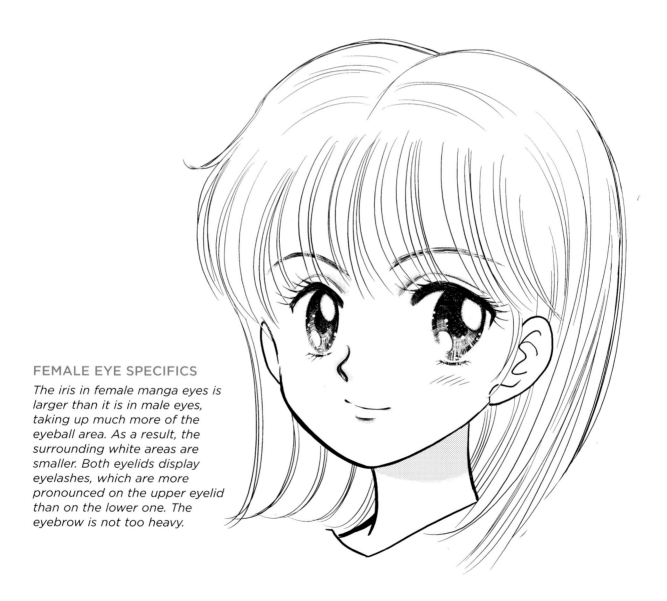

FEMALE EYE SPECIFICS

The iris in female manga eyes is larger than it is in male eyes, taking up much more of the eyeball area. As a result, the surrounding white areas are smaller. Both eyelids display eyelashes, which are more pronounced on the upper eyelid than on the lower one. The eyebrow is not too heavy.

MALE EYE SPECIFICS

The iris in male manga eyes is smaller than it is in female eyes, taking up less of the eyeball area. So, use a smaller oval to indicate it. There are no—or only the barest minimum of—eyelashes. The eyebrow, while still not too bushy, is thicker than the female eyebrow.

EYE SHINES AND OTHER DETAILS

Sometimes, it's the little things that make the biggest impact in your drawings. For example, note that in both female and male eyes there are two main eye shines, placed diagonally across from each other within the iris. The top shine is always larger. There is also a dark outline around the iris (which is an optional element) and the central dark pupil. A line above the top eyelid indicates the crease where the eyelid folds back into the eye socket when the eye is open. There's also a miniline on the outer corner of the eye that indicates the change from upper to lower eyelid.

Additionally, it's rarely that you'll see manga eyes without some texturing inside of the iris. To texture the eye, vary the light and dark strokes of your pencil shading by applying more or less pressure. These are subtle details, but they make a big difference.

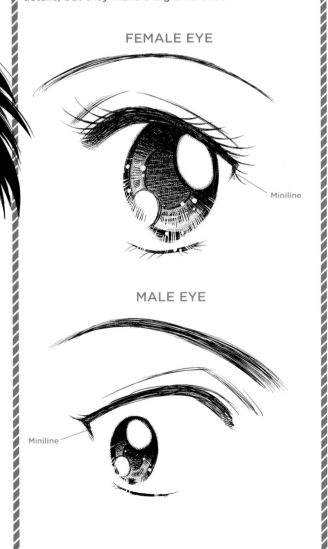

FEMALE EYE

Miniline

MALE EYE

Miniline

SHOUJO EYE STYLES

Here are some variations of eye types, all within the shoujo style. With the nose and mouth being much more subtle on manga-style characters than they are on American-style characters, the eyes become the central focus of the face.

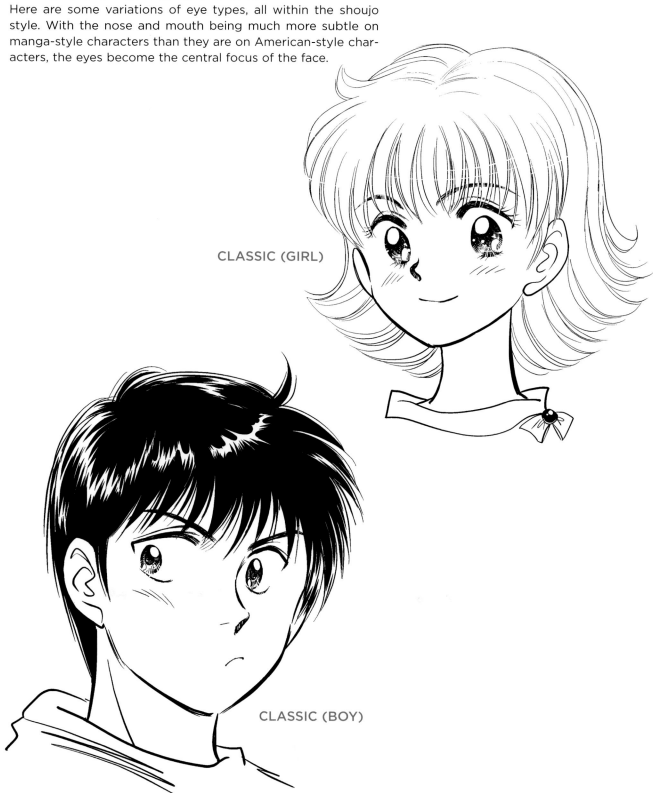

CLASSIC (GIRL)

CLASSIC (BOY)

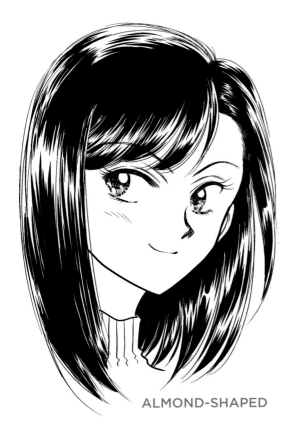

ALMOND-SHAPED

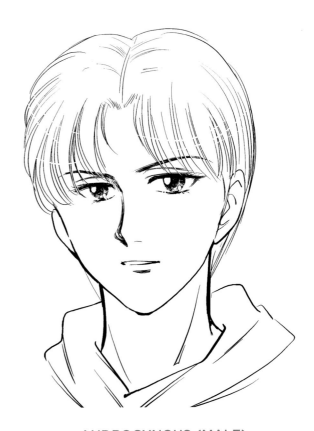

ANDROGYNOUS (MALE)

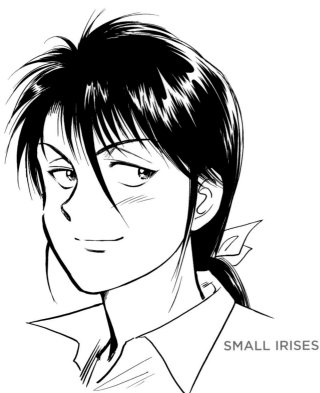

SMALL IRISES

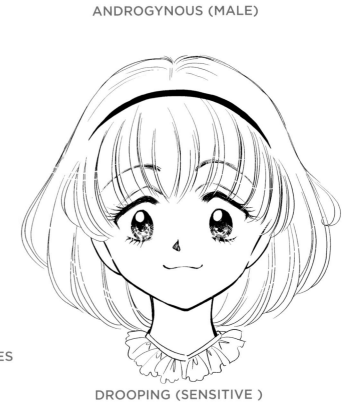

DROOPING (SENSITIVE)

EYE EXPRESSIONS

Okay, be honest. Are you guilty of trying to create an expression using only the mouth? How do you plead? I'll let you off with a warning this time. As you can see from these examples, the mouth is important, but it's often only a *supporting* element, while the eyes are where the emotions really catch fire. You probably already know that the eyebrows help create an expression, but don't leave out the heavy eyelids, which are just as important in conveying attitudes. Lots of expressions depend upon how high the eyelids rise above the eyes or on whether the eyelid touches, or actually crushes down on, the eyeball. In the Suspicious, Sleepy, Tearful, and Determined expressions, the upper eyelids make contact with the pupils. And note that the *eyeball itself* changes shape and size according to the expression.

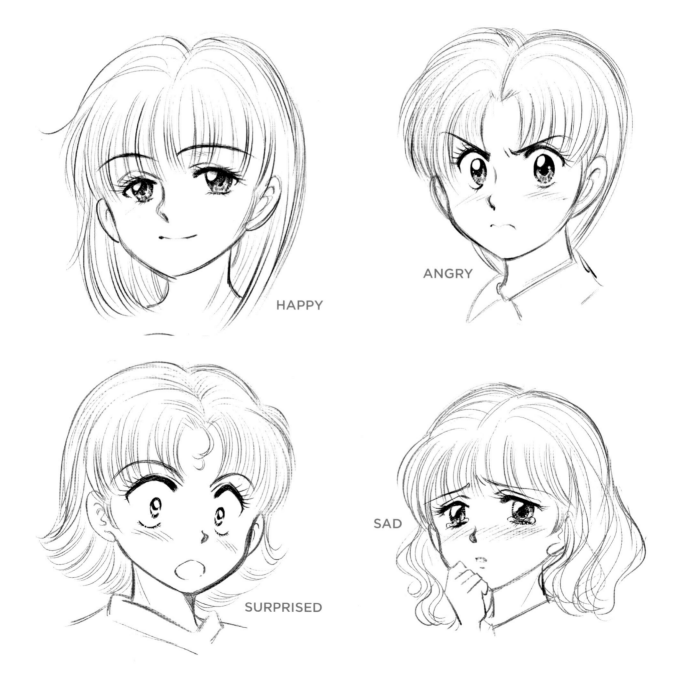

HAPPY

ANGRY

SURPRISED

SAD

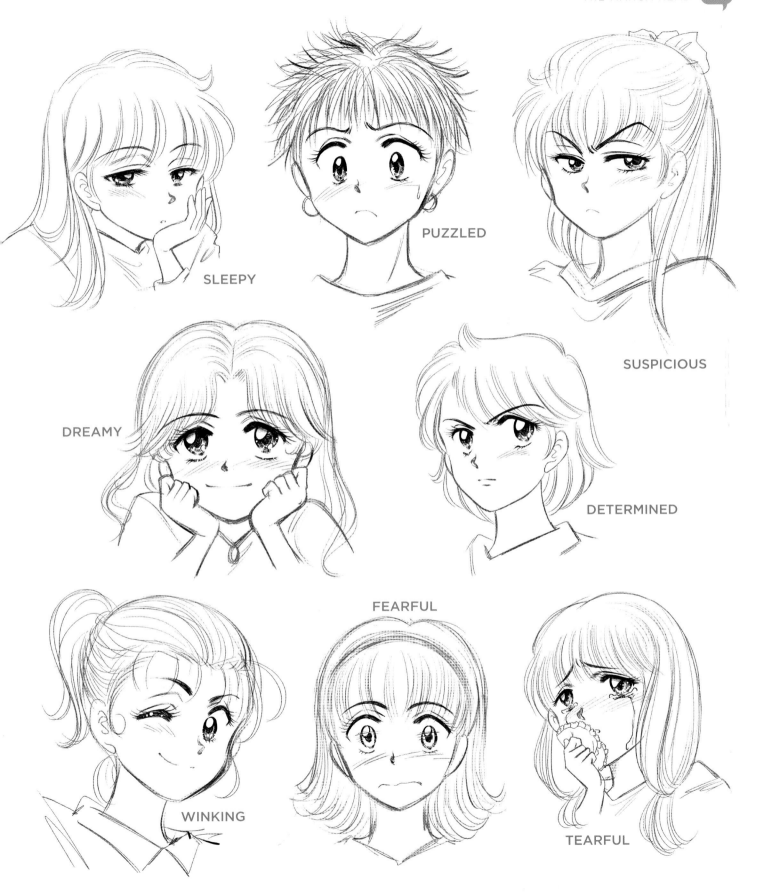

SLEEPY

PUZZLED

SUSPICIOUS

DREAMY

DETERMINED

FEARFUL

WINKING

TEARFUL

MANGA HAIR

Hair is a very important feature in manga. It's used to add glamour, to add size to the head (and thereby increase the visual presence of the character), and to carve out a unique identity for a character whose face might otherwise look similar to others. In fact, when magical girls are members of teams, they often look so similar that their hairstyles are one of the primary ways to tell them apart.

Hairstyles for Girls

Ponytails are common on female characters throughout manga. They can be centered on the head or positioned slightly off center for a more casual look. Buns are also very popular, especially in the magical girl genre. Long, wavy hair is popular for manga schoolgirls. Ringlets are mostly used on characters in historical manga genres or stories.

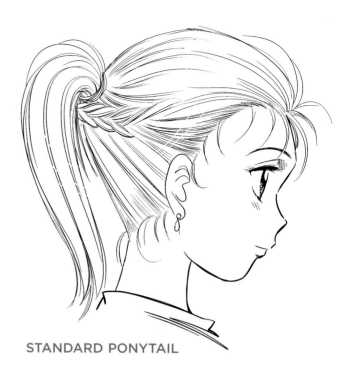

STANDARD PONYTAIL

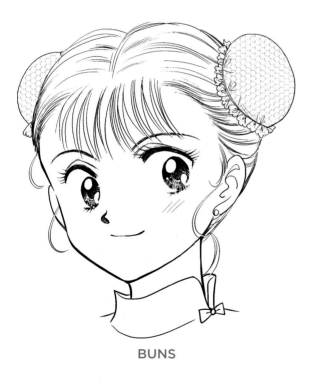

BUNS

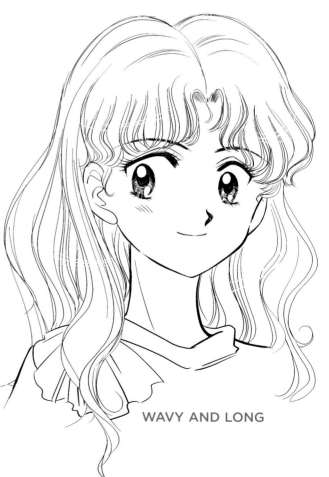

WAVY AND LONG

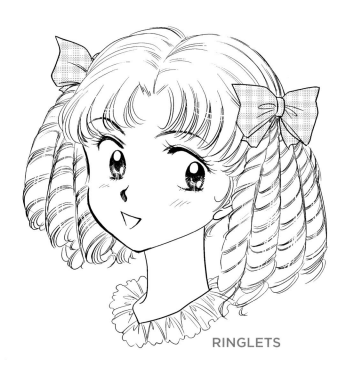

RINGLETS

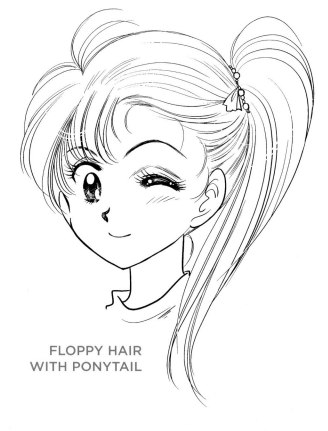

FLOPPY HAIR
WITH PONYTAIL

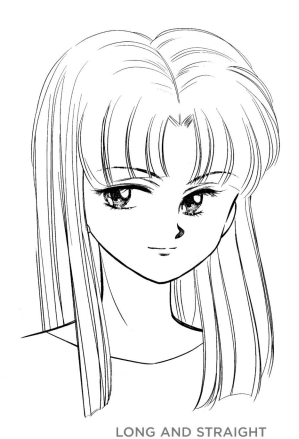

LONG AND STRAIGHT

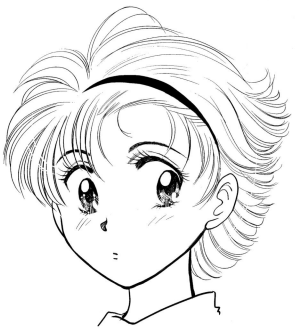

SMALL HEADBAND WITH
HAIR BRUSHED FORWARD

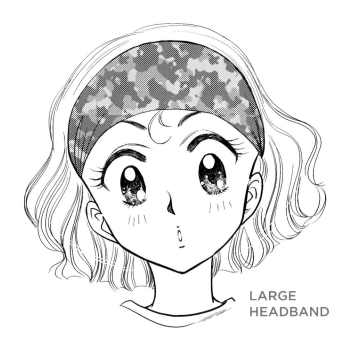

LARGE
HEADBAND

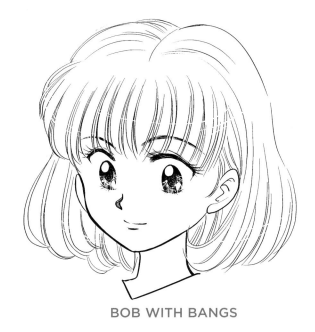

BOB WITH BANGS

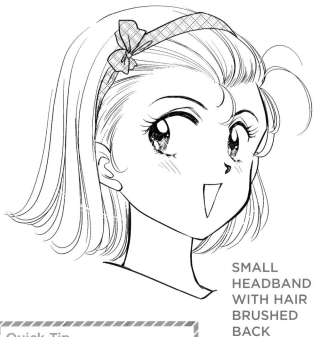

SMALL
HEADBAND
WITH HAIR
BRUSHED
BACK

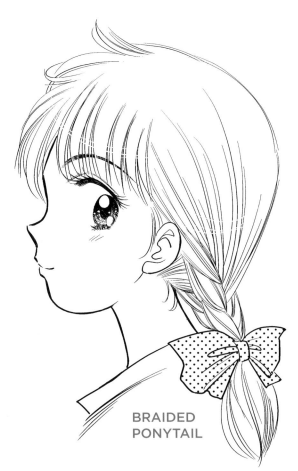

BRAIDED
PONYTAIL

Quick Tip

When drawing fine hair in which
individual strands are seen, draw
less detail on top. Leave that area
minimally rendered so that it will
read as a bright spot where an
overhead light—either the sun or
interior lighting—is hitting the
hair and leaving a pleasant shine.

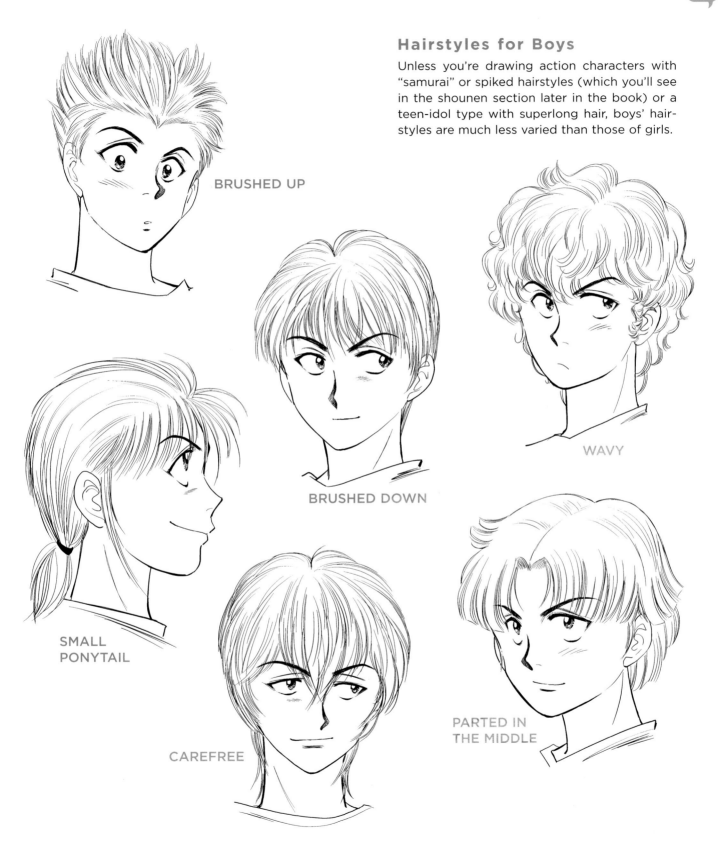

Hairstyles for Boys

Unless you're drawing action characters with "samurai" or spiked hairstyles (which you'll see in the shounen section later in the book) or a teen-idol type with superlong hair, boys' hairstyles are much less varied than those of girls.

BRUSHED UP

BRUSHED DOWN

WAVY

SMALL PONYTAIL

CAREFREE

PARTED IN THE MIDDLE

The Basic Manga Body

SOME PEOPLE LOVE TO DRAW HEADS but are somewhat intimidated about tackling the body. The truth is that many aspiring manga artists greatly underestimate their own abilities—and their experience. Think about it. You don't see huge eyeballs or mouths in your normal daily routine, but throughout the day, you do continually see people—bodies—walking past you. You notice their torsos, arms, and legs. You only need to tap into that part of your brain where images of the body are already stored. That's a lot of what artists do. They make a mental comparison in order to correct their own drawings.

FRONT VIEW

Although the front view isn't the most natural-looking pose, having a character stand squarely in a front pose is the clearest way to show the entire figure. (Pages 47 and 48 show how to pose characters more naturally in the front view, which requires tilting the shoulders and hips.)

Keep the following three benchmarks in mind to help in getting the proportions right:

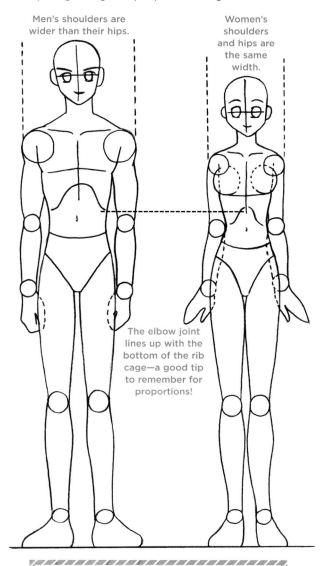

Men's shoulders are wider than their hips.

Women's shoulders and hips are the same width.

The elbow joint lines up with the bottom of the rib cage—a good tip to remember for proportions!

Quick Tip

Major joints—like the shoulders, elbows, and knees—are best represented by circles, as it reminds the artist that they have thickness.

Shoulders

A man's shoulder should look like a flexed muscle, but a woman's should not.

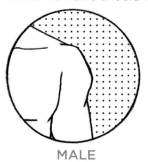

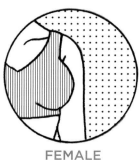

MALE

FEMALE

Waist

A woman's waist falls higher up on her body than a man's falls on his body.

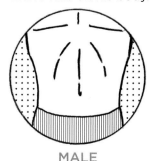

MALE

FEMALE

Pelvic Bone (Hip Area)

Here's an area that gives artists problems, mainly because it's a little mysterious. We don't think of the pelvis as the large, bony object that it is. The pelvic bone gives the hips their shape. The thing to remember is that male hips are taller but narrower in width, while female hips are shorter but wider.

MALE

FEMALE

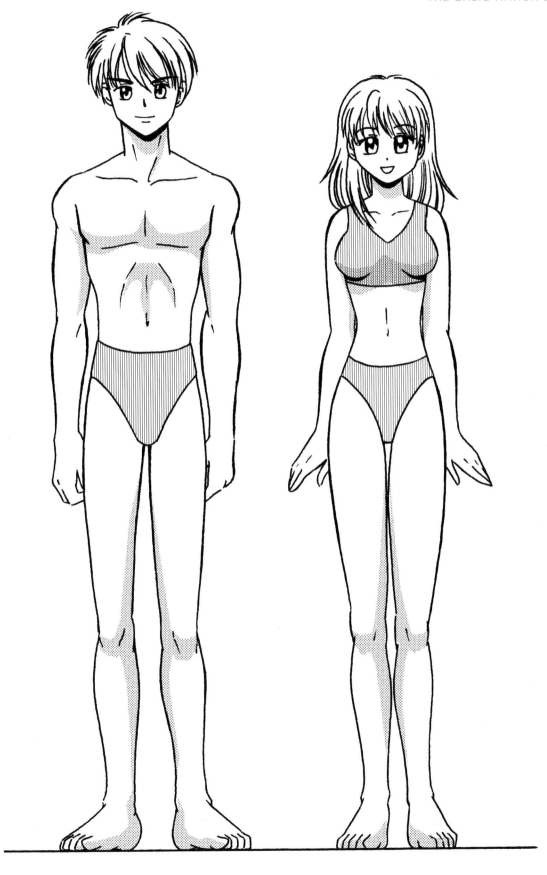

SIDE VIEW

A side view is a dispassionate view. When a character is shown in a side view, the reader is not directly drawn into the action in the scene, because the angle isn't moving the figure toward or away from us. So, as readers, we just sit back and watch the action or watch the scene unfold. It's a good transition angle. It can work well between two more-intense shots to change the pace visually.

Things to note about this pose:

There's mass to the back. The line of the back doesn't continue straight down from the neck. It curves outward. Don't draw it as a straight line.

The collarbone provides a small "ledge" for the chest muscles.

The calves have some thickness. They aren't skinny pipes.

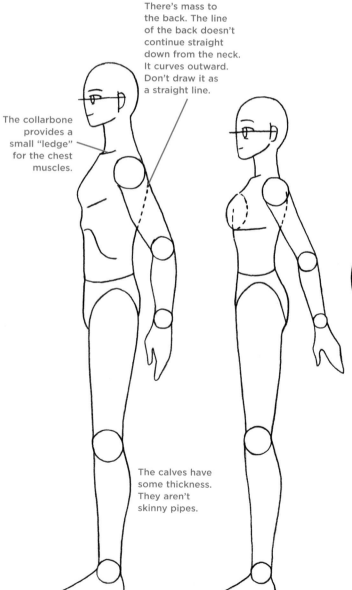

Midsection

In a side view, women have a graceful sweeping curve to the lower back. In men, this area bumps out more abruptly where it hits the latissimus dorsi muscles, or "lats." In both cases, the front of the torso is flatter than the back.

MALE FEMALE

Arms

Female arms are sleeker and straighter, while male arms are more muscular; draw them rounded outward slightly.

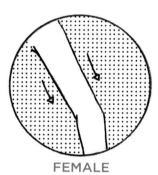

MALE FEMALE

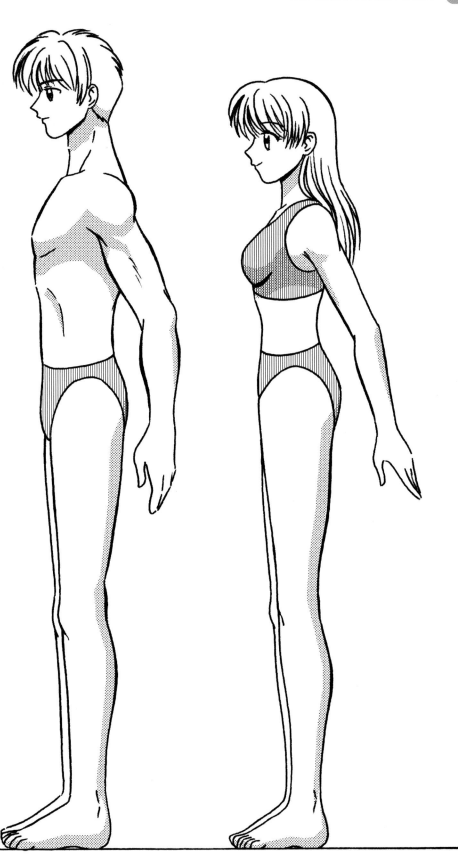

DEVELOP A CRITICAL EYE

An artist looks at his or her drawing and thinks, Does this look like what I'm trying to draw? You should develop what I call a critical eye— the ability to judge your own work. But keep in mind that it's just as important to be able to praise your own work as it is to see where it's flawed. Encourage your strengths, practicing what you're already good at, but also don't be afraid to try something new that might seem more challenging at first, like drawing the entire body. Your talent will develop. Trust it.

3/4 VIEW

The 3/4 view is a very natural-looking pose. Unlike the front view, the characters appear relaxed, even though their shoulders and hips are square.

Here are a few things to note about this pose:

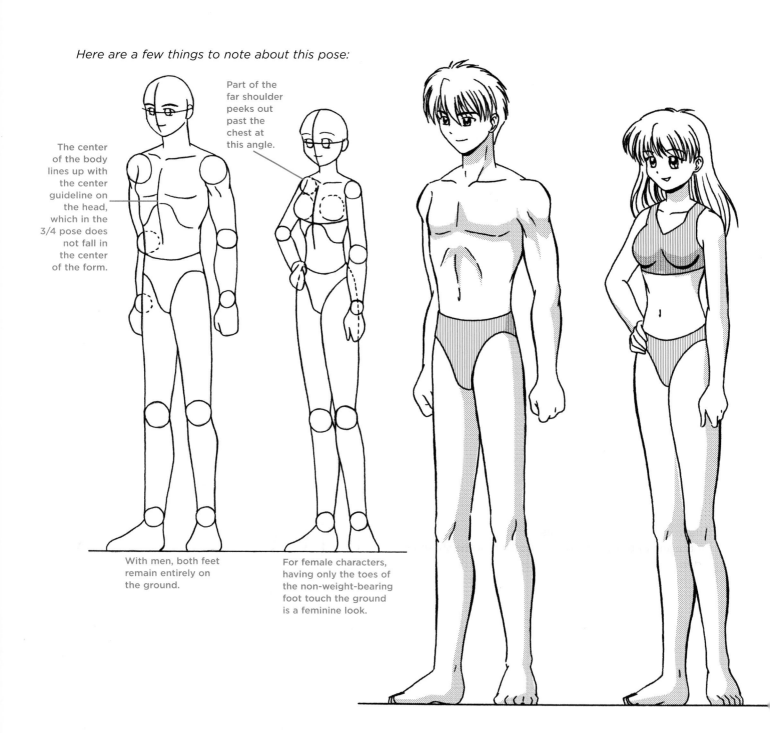

The center of the body lines up with the center guideline on the head, which in the 3/4 pose does not fall in the center of the form.

Part of the far shoulder peeks out past the chest at this angle.

With men, both feet remain entirely on the ground.

For female characters, having only the toes of the non-weight-bearing foot touch the ground is a feminine look.

Things to note about this pose:

At this angle, the line of the neck continues past the jawline.

The line of the back overlaps the far shoulder. There should be more length from the shoulder to the neck on the near side than on the far side.

The near leg overlaps the far one.

The spine doubles as the center line, which, remember, does not fall in the center of the form in a 3/4 view.

3/4 REAR VIEW

When would you need an angle like this? When you have two people talking to each other. One of them would most likely be posed in a 3/4 front view, facing the reader, while the other would be—you guessed it—in a 3/4 rear view, facing the first character. So, it's very helpful to have this pose in your arsenal; otherwise, you'll always have to pose two characters talking to each other in profile, which, believe me, looks static after one shot.

Lower Back

On women, the small waistline widens out at the hips, while men have a small waist *and* small hips. Note that the line of the spine and the bottom of the shoulder blades are visible on both men and women.

MALE FEMALE

REAR VIEW

Manga is filled with dramatic moments. Characters say pithy things, then turn and walk away hauntingly. Sometimes they cry out for vengeance and run after the bad guys. Sometimes they run after their boyfriends or girlfriends. Sometimes they snub someone and simply keep walking past without saying a word. So, it's a good idea to become familiar with the rear view. It's not used as frequently as the others, but when you need it, you'll have it.

Things to note about this pose:

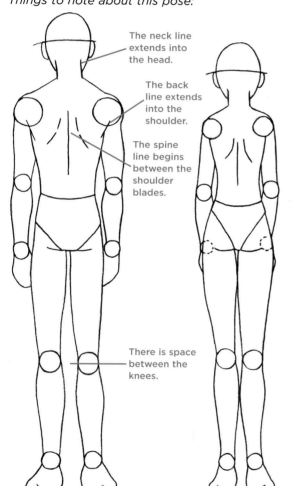

The neck line extends into the head.

The back line extends into the shoulder.

The spine line begins between the shoulder blades.

There is space between the knees.

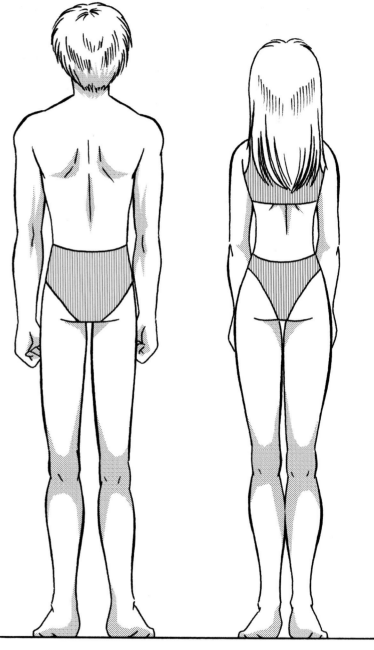

Upper Back

The tops of the shoulder blades (those little knobs toward the shoulders) attach to the ends of the collarbones, which are visible in the front view. The neck is not a separate bone but simply an extension of the spine.

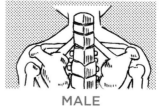

MALE

FEMALE

NATURAL STANDING POSES

Many aspiring artists show me their work. Oftentimes, the proportions are correct, the character is appealing, but you know what? It looks lifeless. What went wrong? The problem is more common than you might think, and it's also easy to correct: The artists don't understand the principles involved in a basic standing pose. So, the poses are stiff and unnatural, and the characters look frozen and self-conscious. Believe me when I tell you that this is the surest way to undo all the hard work you've put into making an otherwise fine drawing.

Standing poses are based on a few mechanics. By that, I mean that the body reacts as if it's built out of a stack of dominoes. When a leg or hip shifts to make the stance more comfortable, the rest of the body must adjust; otherwise, the entire stack of dominoes would go out of whack and tumble to the ground.

Stiff

This is what most beginners draw when they attempt a standing pose. But this is not how people stand. Notice the shoulders and hips: They're perfectly square. People don't stand this way, unless they're soldiers. Take a good look at the other noted elements that are wrong about this pose.

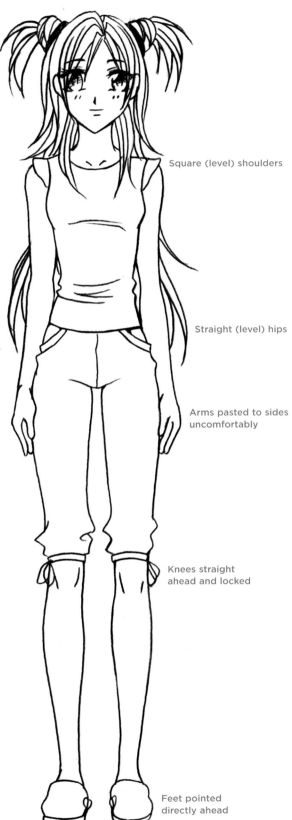

Square (level) shoulders

Straight (level) hips

Arms pasted to sides uncomfortably

Knees straight ahead and locked

Feet pointed directly ahead

More Relaxed

This is a slight improvement, as the knees and feet are pointed outward at a slight angle. The shoulders are also a bit relaxed, and the arms are positioned more loosely around the body and slightly forward of the hips and thighs.

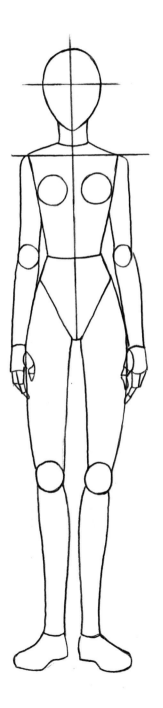

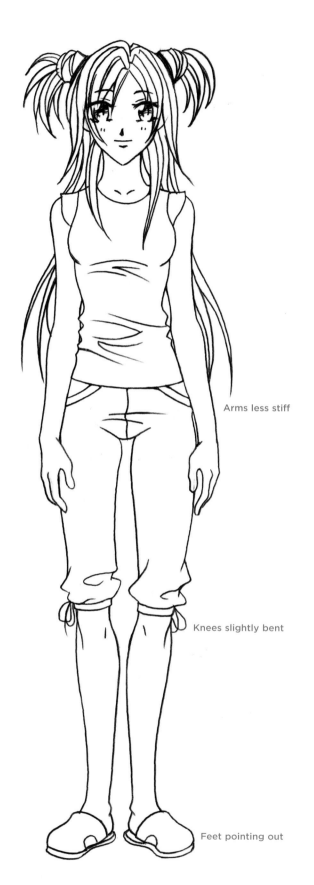

Arms less stiff

Knees slightly bent

Feet pointing out

Most Natural

This is the way a real person stands. Doesn't it just *feel* more comfortable, even to look at? You'd get a muscle cramp in the previous two poses, but you could stand like this comfortably. Here's how the different parts of the body react to one another, like dominoes: The weight-bearing leg (the one to the reader's right) locks under the weight of the body. This pushes the hip up on that side of the body. To compensate, the shoulder on that side of the body dips down, forcing the opposite shoulder to rise to counterbalance. This, in turn, pushes down the hip on the opposite side of the body, which reduces the amount of space between that hip and the floor and forces that leg to move away from the body to accommodate its own length.

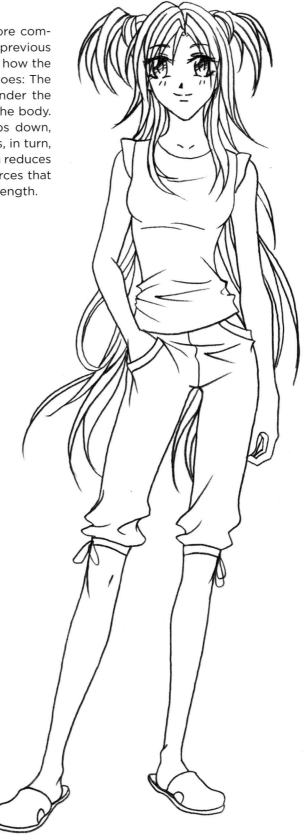

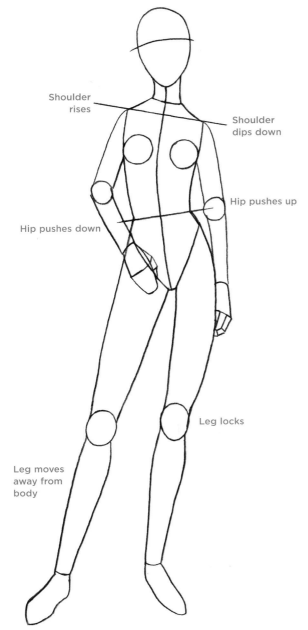

Shoulder rises

Shoulder dips down

Hip pushes up

Hip pushes down

Leg locks

Leg moves away from body

Variations on the Standing Pose

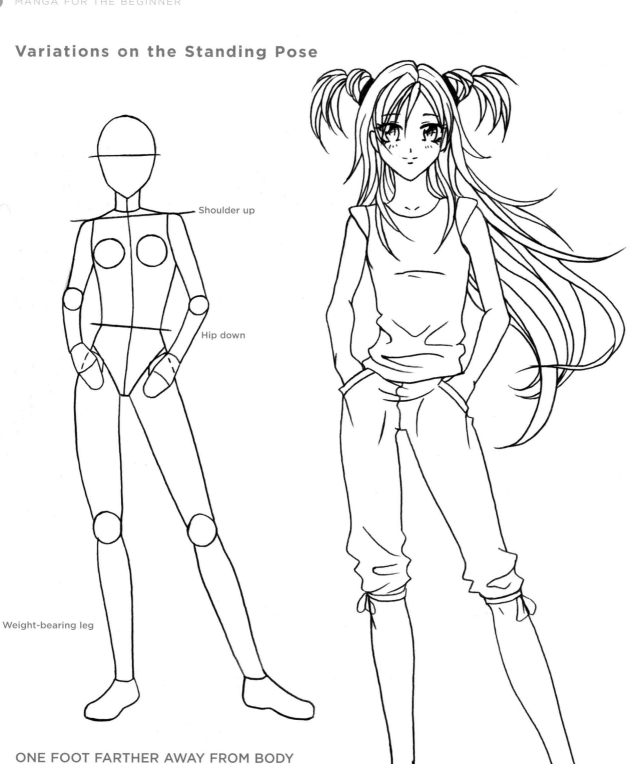

Shoulder up

Hip down

Weight-bearing leg

ONE FOOT FARTHER AWAY FROM BODY
Similar to the pose on the previous page, this variation moves the non-weight-bearing leg farther away from the weight-bearing one. This gives the pose a more stylish attitude. Note that the heel of the weight-bearing foot aligns with the pit of the neck.

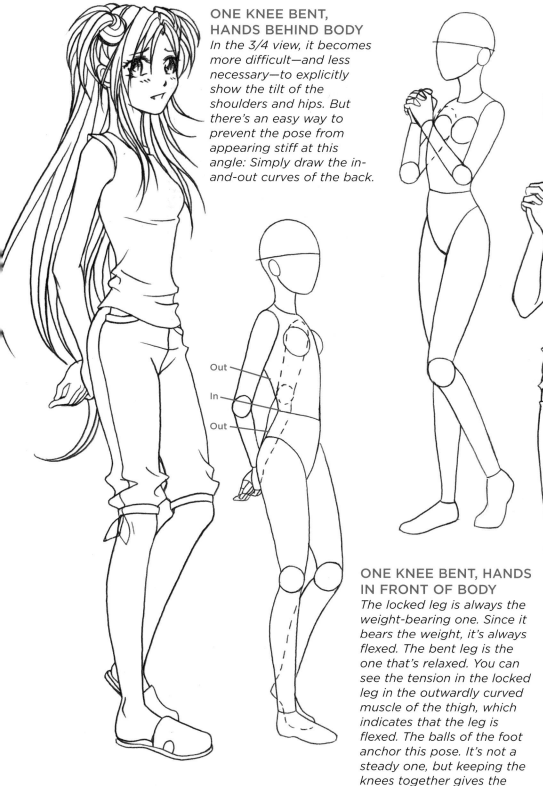

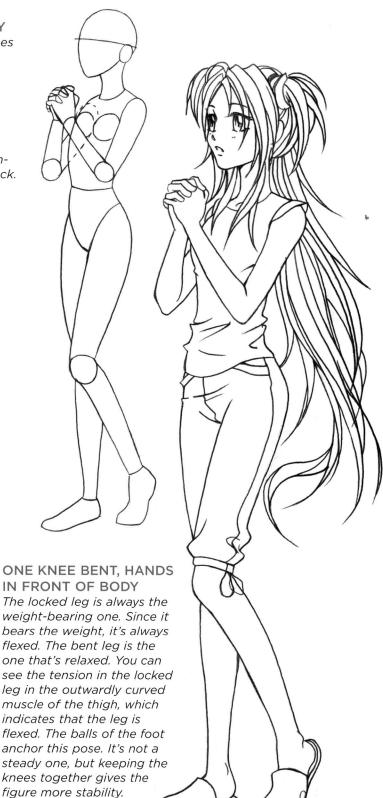

ONE KNEE BENT, HANDS BEHIND BODY

In the 3/4 view, it becomes more difficult—and less necessary—to explicitly show the tilt of the shoulders and hips. But there's an easy way to prevent the pose from appearing stiff at this angle: Simply draw the in-and-out curves of the back.

Out

In

Out

ONE KNEE BENT, HANDS IN FRONT OF BODY

The locked leg is always the weight-bearing one. Since it bears the weight, it's always flexed. The bent leg is the one that's relaxed. You can see the tension in the locked leg in the outwardly curved muscle of the thigh, which indicates that the leg is flexed. The balls of the foot anchor this pose. It's not a steady one, but keeping the knees together gives the figure more stability.

AGE/HEIGHT COMPARISON

Manga has more variations and subdivisions among its young characters than any other genre of comics, with tweens (about ten to thirteen years old), young teens, middle teens, and older teens all featured. It's important to match the height, angularity, and muscle development of a character with his or her age.

Boys

A manga boy character starts out life with a soft, round build. In the teen years, he becomes skinny and lanky. As an adult, he begins to fill out and gain muscles. Note, too, that the younger the character, the larger the eyes.

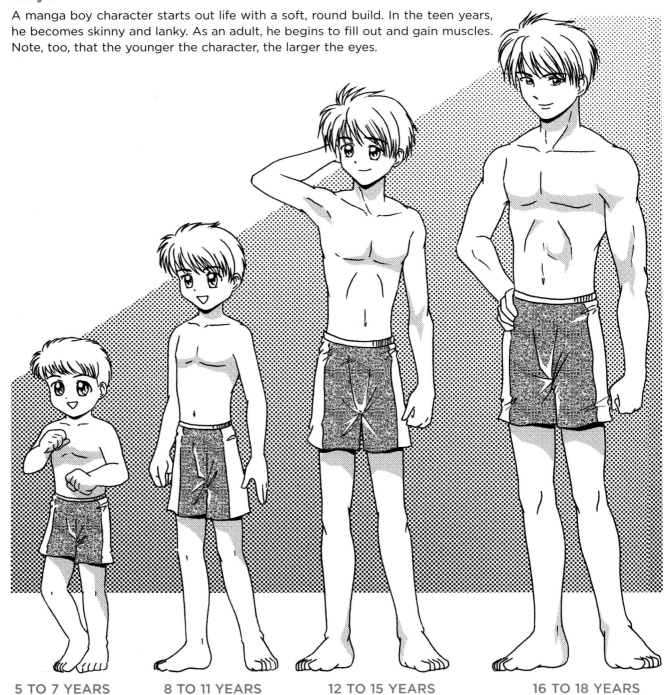

| 5 TO 7 YEARS | 8 TO 11 YEARS | 12 TO 15 YEARS | 16 TO 18 YEARS |

Girls

As little children, manga girls have cute, pudgy, pear-shaped bodies with little tummies. Then they sort of "string-bean-out" between the ages of eight and eleven. From twelve to fourteen, they begin to assume a feminine shape, but just sort of. In the manga genre, they maintain that look throughout the high-school years.

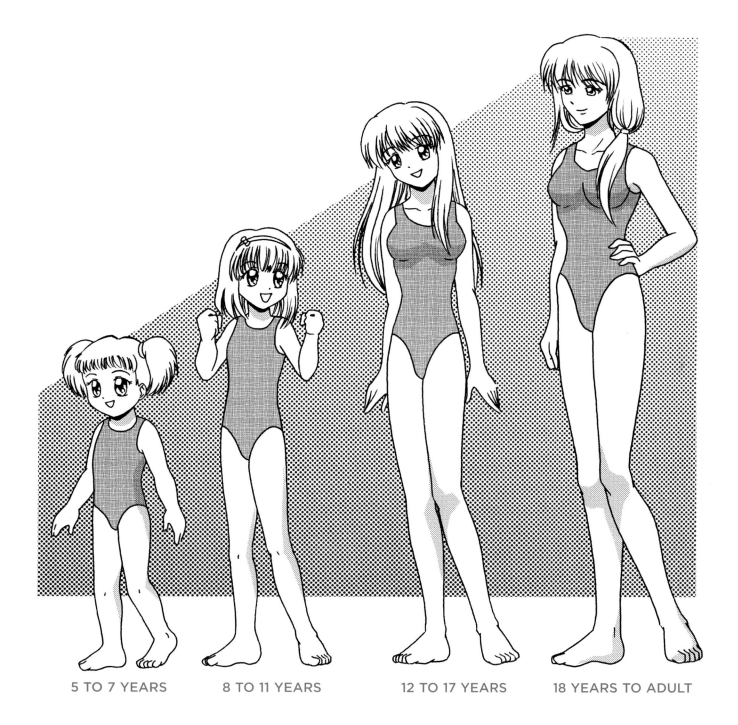

| 5 TO 7 YEARS | 8 TO 11 YEARS | 12 TO 17 YEARS | 18 YEARS TO ADULT |

HANDS

There are four basic angles from which to show the hands: from the front (palm facing up), the back (palm facing down), the inside (thumb toward the reader), and the outside (pinky toward reader). That said, however, there are an infinite number of hand positions. Hands can be utilitarian and simply serve a function, such as holding a pencil, or they can be expressive and convey emotion, such as tapping impatiently on a countertop. If you're intimidated by the idea of drawing the hand, you can refer to the master diagram: your own hand! Hey, I'm not kidding—every professional artist uses his or her own hand as a model for quick reference.

The Skeleton

All artists, at one time or another, have wondered about where the joints are on the fingers or thumbs. Let's go to the source: the skeleton. As you can see, each bone of the thumb and fingers gets shorter as you move toward the tips. Most of the palm is made up of a continuation of finger bones with a cluster of smaller bones at the base. The skeleton gives a clear overall concept of the hand, but for drawing purposes, you can start with a simplified model of the hand, sectioned into individual joints.

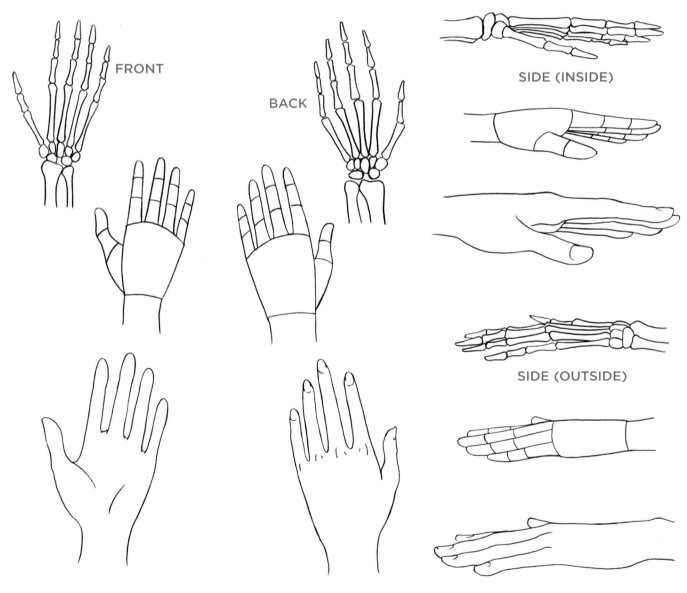

FRONT

BACK

SIDE (INSIDE)

SIDE (OUTSIDE)

Female

Pretty face, pretty hands. They go together. It takes a subtle touch to draw pretty hands: no hard and straight lines, no sharp points for nails (I've seen some beginners do that, and the nails look like claws!). When the fingers are bent, you have to indicate the knuckles just slightly; if you don't, they will look like noodles. But, in general, feminine hands show little in the way of knuckle definition.

Male

Male hands are slightly more challenging to draw than female hands, because they aren't as soft looking. To make them more rugged, you need to draw each bent joint with a harder angle. And remember this important hint: The top sides of the fingers are always flat; it's the undersides that are slightly rounded with padding.

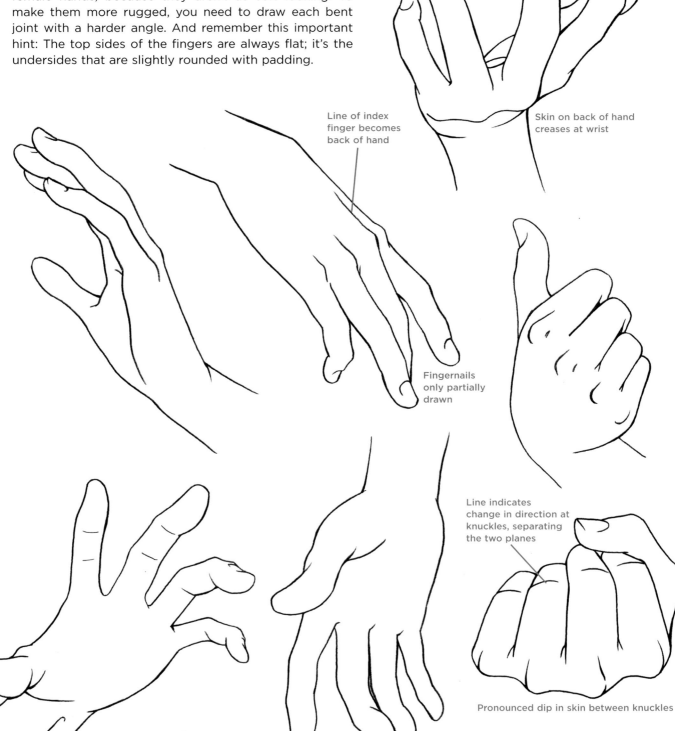

Line of index finger becomes back of hand

Skin on back of hand creases at wrist

Fingernails only partially drawn

Line indicates change in direction at knuckles, separating the two planes

Pronounced dip in skin between knuckles

Hand Accessories

Props and costumes often extend to the hands. Whether wearing something or holding something, hands are part of the character's personality.

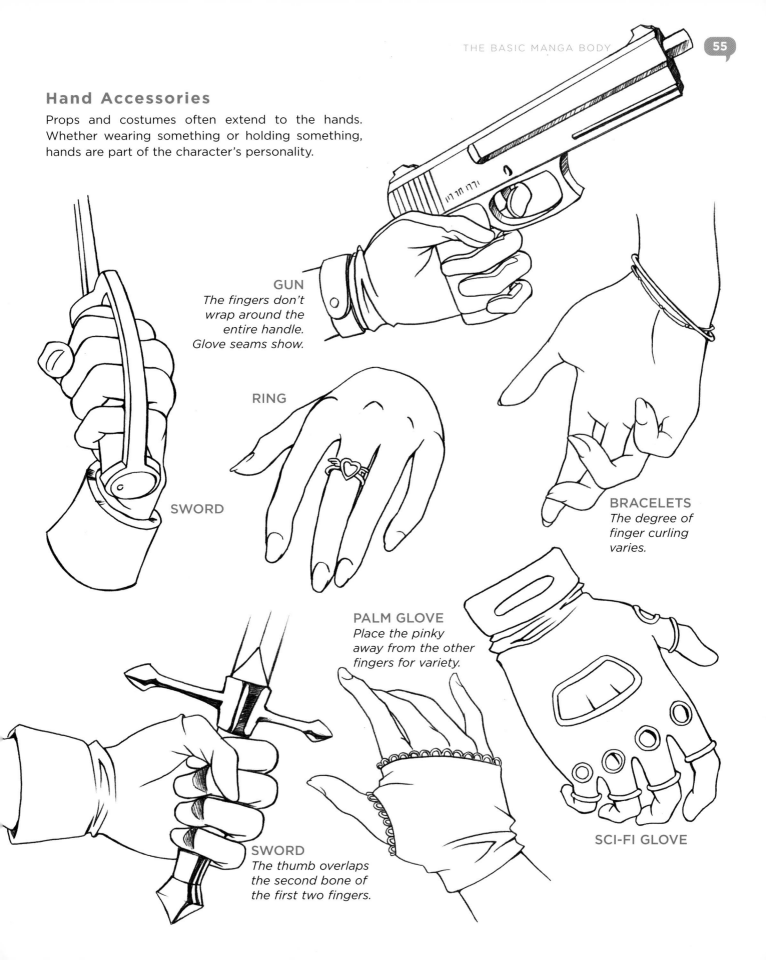

GUN
The fingers don't wrap around the entire handle. Glove seams show.

RING

SWORD

BRACELETS
The degree of finger curling varies.

PALM GLOVE
Place the pinky away from the other fingers for variety.

SCI-FI GLOVE

SWORD
The thumb overlaps the second bone of the first two fingers.

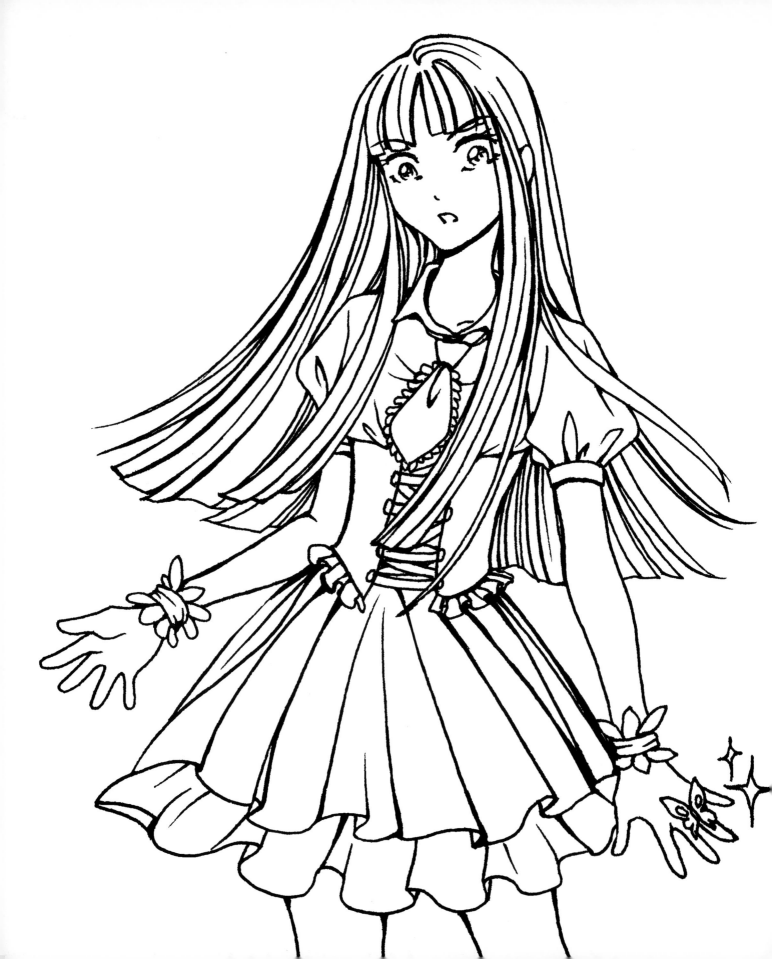

Clothing & Costumes

LET'S FACE IT, every teenage girl is looking to add a little glamour to her life. And all the popular guys—whether they want to admit it or not—are conscious of the way they look. They may put a lot of effort into looking as if they don't care about their appearance, but they do. The popular boys and girls of manga have expensive taste, and the good thing is this: It doesn't cost any more to draw an obscenely expensive Italian outfit than a pair of polyester pants. So, go for the bells and whistles.

CLOTHING STYLES FOR DIFFERENT STAGES OF LIFE

Just as proportions and height differ from one age to another, clothing styles also change as characters grow and interests and activities develop.

Boys

An older teen wears cooler clothes than he did when he was a kid. And any teen wears cooler clothes than me! Note how clothing style changes to suit the various stages of life of the same character.

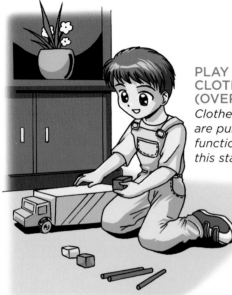

PLAY CLOTHES (OVERALLS)
Clothes are purely functional at this stage.

PRETEEN CASUAL
These are rough-and-tumble clothes.

COOL TEEN CASUAL
Clothes help him carve out his own identity.

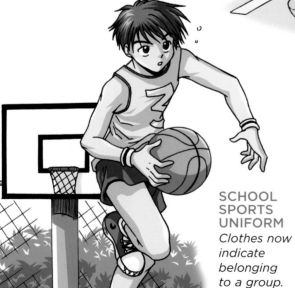

SCHOOL SPORTS UNIFORM
Clothes now indicate belonging to a group.

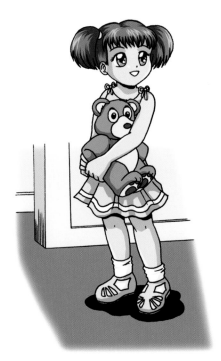

Girls

Unlike boys' clothes, girls' clothes are a fashion statement at every stage of life. They start off as one-piece items and become separate, mix-and-match garments as girls get older.

PRETEEN SPORTY
Sidewalk sports are popular activities for youngsters—and good opportunities to draw action.

PRETTY TODDLER DRESS
Note the comfort toy.

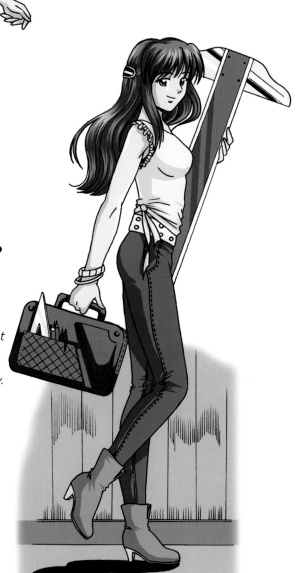

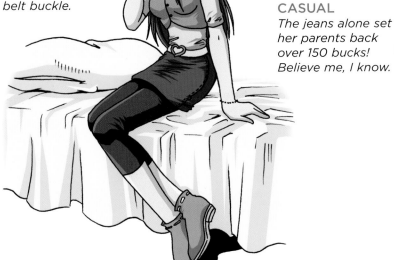

TEEN CASUAL
Note the heart belt buckle.

COOL TEEN CASUAL
The jeans alone set her parents back over 150 bucks! Believe me, I know.

SCHOOLGIRL UNIFORMS

An enormous number of manga stories are set in Japanese high schools, where specific styles of Japanese school uniforms are the norm for girls. So, let's familiarize ourselves with the look of the popular school uniforms, starting with the girls.

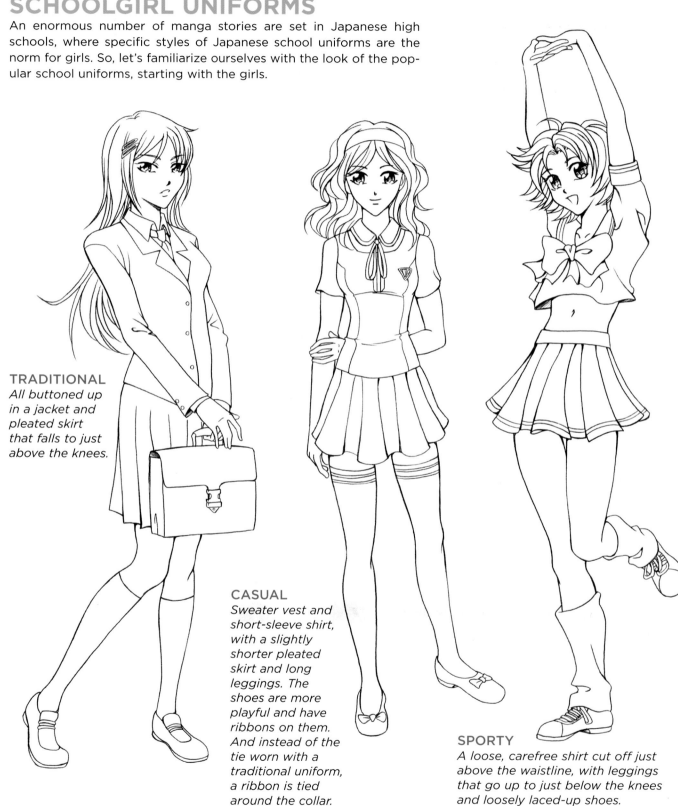

TRADITIONAL
All buttoned up in a jacket and pleated skirt that falls to just above the knees.

CASUAL
Sweater vest and short-sleeve shirt, with a slightly shorter pleated skirt and long leggings. The shoes are more playful and have ribbons on them. And instead of the tie worn with a traditional uniform, a ribbon is tied around the collar.

SPORTY
A loose, carefree shirt cut off just above the waistline, with leggings that go up to just below the knees and loosely laced-up shoes.

SCHOOLBOY OUTFITS

Most teenage boys are sort of . . . um . . . slobs. Come on, admit it. But there are exceptions. Every school has a few guys all the girls have crushes on. And all the other characters are jealous of these guys. These lady-killers are always tall and thin. Their outfits are sharp and formfitting. These guys look like they just fell out of a men's fashion magazine.

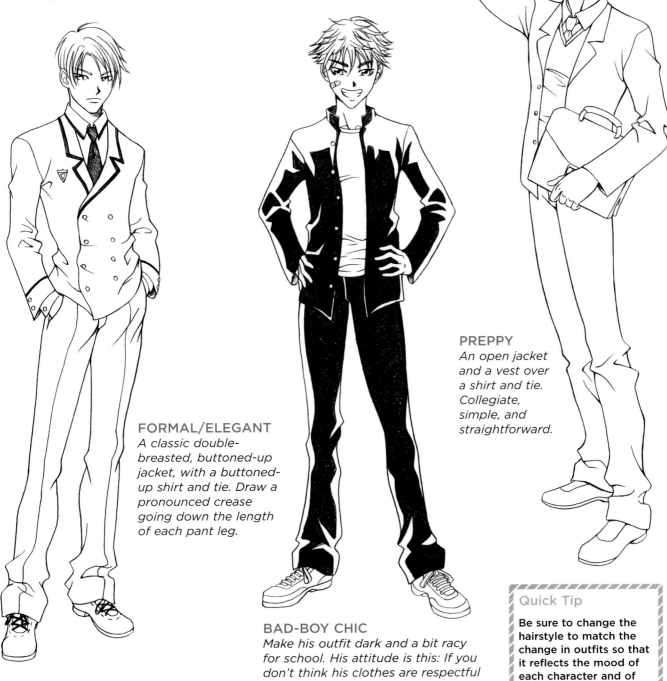

FORMAL/ELEGANT
A classic double-breasted, buttoned-up jacket, with a buttoned-up shirt and tie. Draw a pronounced crease going down the length of each pant leg.

BAD-BOY CHIC
Make his outfit dark and a bit racy for school. His attitude is this: If you don't think his clothes are respectful enough, too bad! He wears a crewneck shirt and sneakers.

PREPPY
An open jacket and a vest over a shirt and tie. Collegiate, simple, and straightforward.

Quick Tip

Be sure to change the hairstyle to match the change in outfits so that it reflects the mood of each character and of the clothes.

SUPERCHIC OUTFITS

Outside of school, the uniforms come off and the trendy clothes go on. Remember, Tokyo is one of the major fashion cities of the world, along with New York, London, Paris, and Rome. People there gobble up the latest trends from all around the globe, and this is reflected in what they wear.

When the outfits are stylish enough to look like they came straight off the runways, the characters wearing them should be either older teens or, more likely, twentysomethings. Characters in their midteens still need to retain some of their childhood innocence. That's what makes them interesting. Also, midteens haven't yet developed the body language to pull off the slightly disinterested poses that more sophisticated women in these haute couture clothes are so good at.

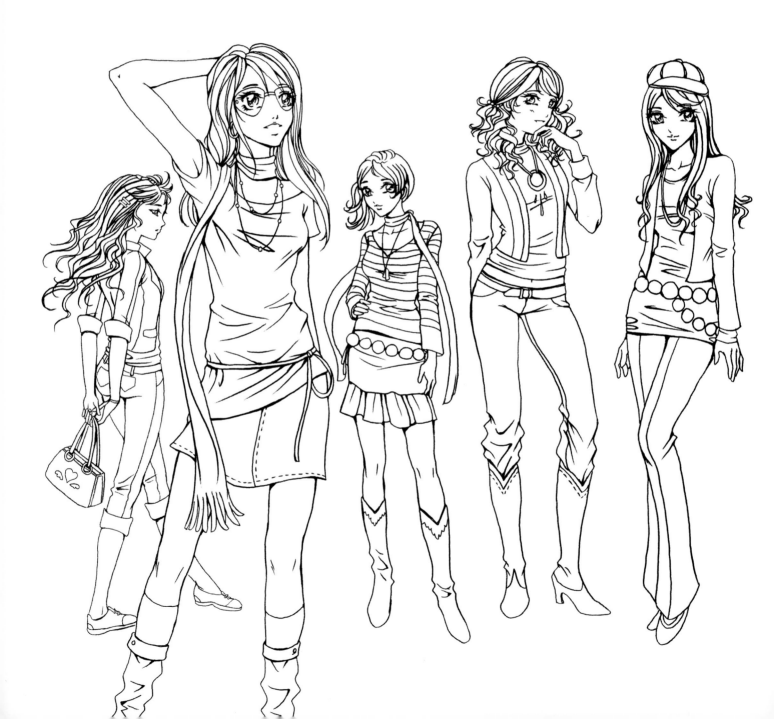

MAGICAL GIRL COSTUMES

One of the more popular genres in manga is a subgenre of shoujo (girls' manga) called *magical girls*. Magical girls are ordinary schoolgirls who, usually by accident, discover that they can transform into superempowered, idealized versions of themselves. In this transformed state, they appear in hyperglamorized school uniforms. You can get very creative in designing these. Keep in mind that the long, flowing, fanciful hair is also an integral part of the magical girl look.

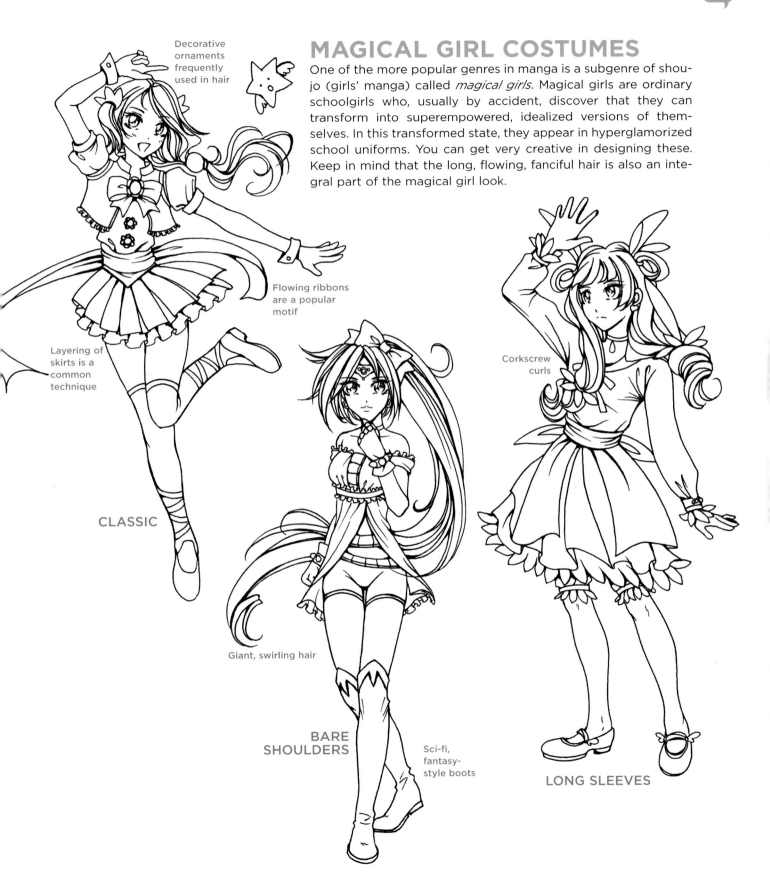

Decorative ornaments frequently used in hair

Flowing ribbons are a popular motif

Layering of skirts is a common technique

CLASSIC

Corkscrew curls

Giant, swirling hair

BARE SHOULDERS

Sci-fi, fantasy-style boots

LONG SLEEVES

Dynamic Action Poses

EVER WONDER WHAT MAKES a professional artist's action poses look so cool? Well, you're about to find out. You're going to see that certain principles are used over and over again to make poses more dramatic. They are: (1) having the figures lean *into* the pose, (2) using speed lines and forced perspective, (3) creating emphatic facial expressions, (4) indicating secondary actions, and (5) adding background motion.

SIMPLE JAB

This playful punch is a jab, which is a short, straight punch thrown with the near arm (on the same side as the near foot).

Beginner's Drawing

The beginner gets all of the basic elements correct, and yet, the pose sort of lacks impact, doesn't it? Why? First of all, the character is facing us squarely. What if we were to twist her so that she is facing us at a 3/4 angle instead? Wouldn't that look more dramatic?

Intermediate's Drawing

That's better. By turning her at a 3/4 angle, it looks as if her fist is traveling toward us—not sideways, as in the first drawing. And the background "speed lines" can now be drawn in perspective, as well, meaning that they widen out as they come toward us, instead of remaining parallel to one another as they do in the previous drawing. Still, although this drawing is very much improved, it could still use a little more punch, if you'll pardon the pun.

Pro's Drawing

Now I can really feel the action! So what's changed? For one, the facial expression gives it an extra kick. The girl's hair is ruffled (a *secondary action*, explained at right), which shows us that she's moving. The fist has been high-lighted by the addition of speed lines to the punching arm. That "blur" really shows movement!

SECONDARY ACTION

Let me take a moment to explain the important concept of *secondary action*, which is vital for conveying any sort of motion. Take the example of a person running. What happens? The leg takes a long stride, and the pants flap in response. The flapping is a reaction to the first action of the leg moving. The flapping is a secondary action. You see secondary actions in many things, such as in the way the hair moves in response to the head turning. For another example, think of a ribbon attached to a baton that's being waved around. The baton moving is the primary action, and the ribbon trailing behind is the secondary action.

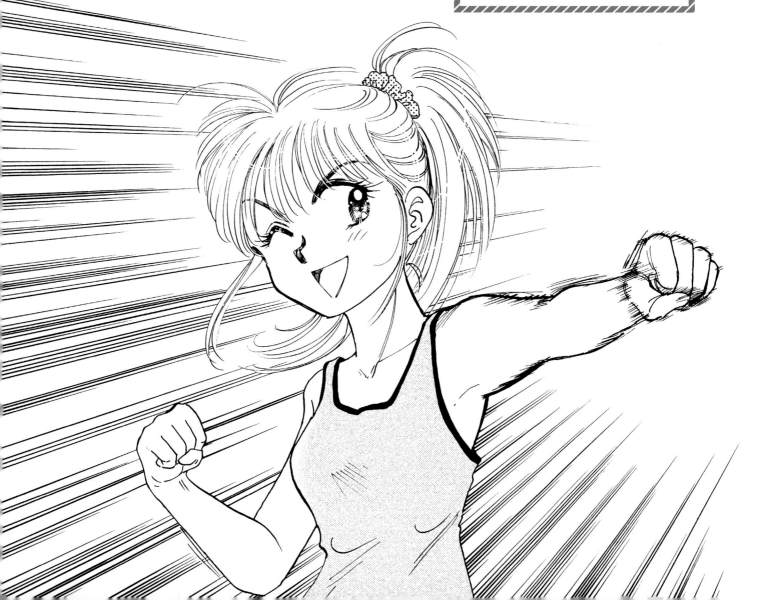

SWORD STRIKE

If your character is going to be a fighter, then she has to put some effort into it. This is sometimes hard to do, especially when the character otherwise looks meek. But that's part of the fun—transforming a petite girl into a dynamic defender. Go for the big emotions, the big effects, and then, after the fight, bring it back down again.

Beginner's Drawing

The upper body and lower body are facing the same direction; there's no motion. The knees are locked and stiff, and the hair is totally relaxed (i.e., still).

Intermediate's Drawing

The hair begins to react to the striking motion. The upper body begins to pivot. One knee turns inward, and there are a few speed lines—although they are kind of unconvincing.

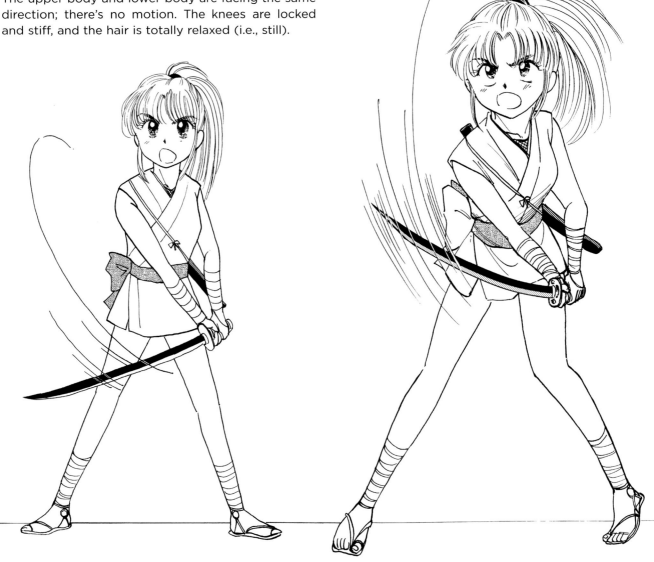

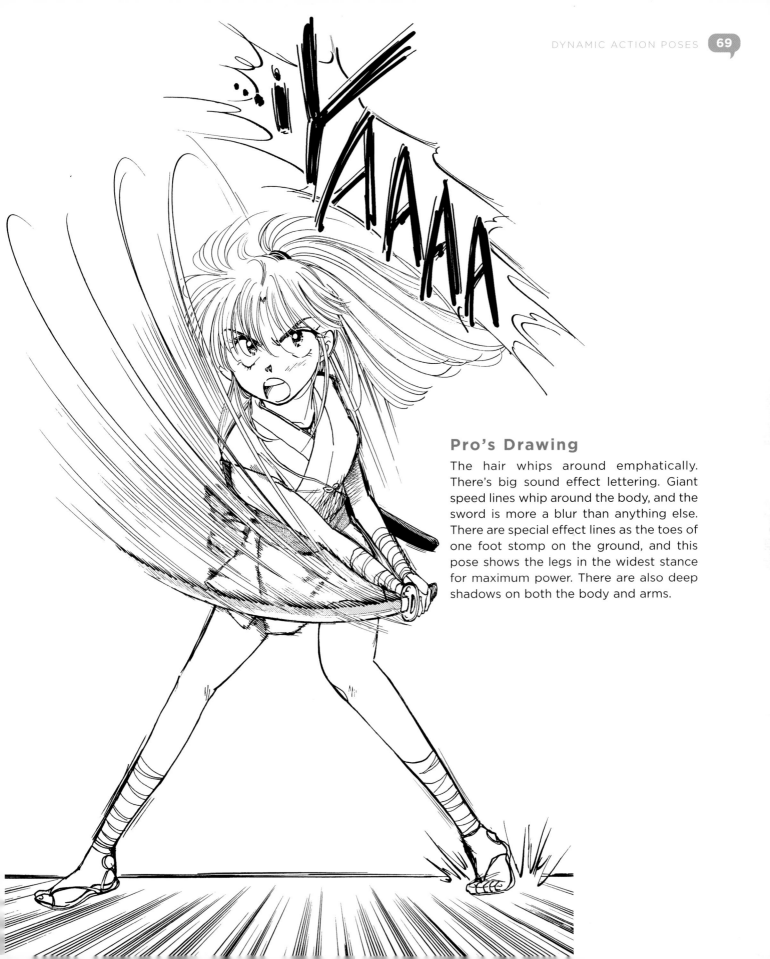

Pro's Drawing

The hair whips around emphatically. There's big sound effect lettering. Giant speed lines whip around the body, and the sword is more a blur than anything else. There are special effect lines as the toes of one foot stomp on the ground, and this pose shows the legs in the widest stance for maximum power. There are also deep shadows on both the body and arms.

PLAYFUL RUN

Drawing a figure running straight toward the reader often gives new and intermediate artists some difficulty. It's usually because they don't know exactly where to position the bent leg and its foot, and they also don't realize that the lower leg should be in total shadow. Also, the tilt of the shoulders is the extra little secret that adds that finishing touch.

Beginner's Drawing

The shoulders and hips are totally level. There's an unnatural space between the bent leg and the straight one. The hair is relaxed, making it look completely still.

Intermediate's Drawing

Here, the torso pivots to the side. The extended arm is pulled in closer to the body, and the forearm of the bent arm angles inward toward the body, with the fist overlapping the shoulder. The shirt, skirt, and hair display slight secondary action as they react to the motion of the run. The bent leg makes contact with straight one.

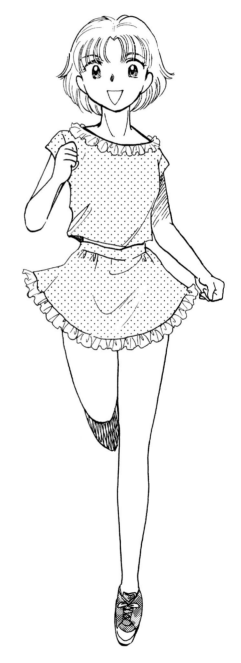

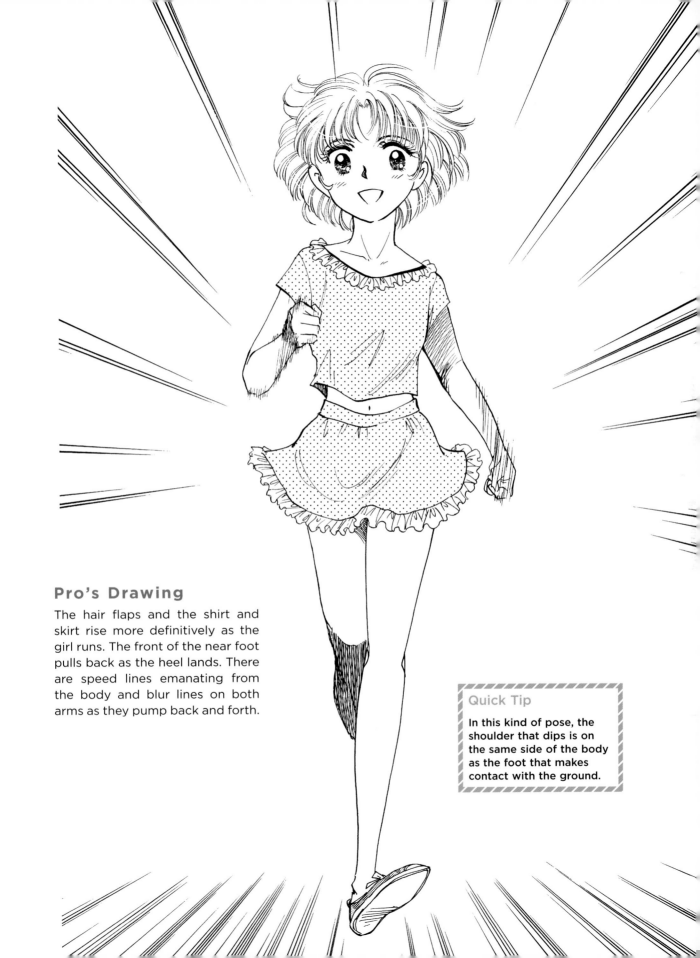

Pro's Drawing

The hair flaps and the shirt and skirt rise more definitively as the girl runs. The front of the near foot pulls back as the heel lands. There are speed lines emanating from the body and blur lines on both arms as they pump back and forth.

Quick Tip

In this kind of pose, the shoulder that dips is on the same side of the body as the foot that makes contact with the ground.

FORWARD CHARGE

I love it! This is what really makes manga exciting—the intensity and the way the characters take themselves so seriously. They're totally immersed in the moment. Their emotional fever sucks all the oxygen out of the room. How can you not get swept along in her fury? Well . . . if you were to draw it in one of the first two ways, you wouldn't get quite as swept along.

Beginner's Drawing

The extended leg is too straight; it looks like she's just standing on it. The angle of the bent elbow is sharp and unnatural. The perspective isn't forced enough, so the head and shoulders appear straight up; the head should overlap the shoulders more so that she appears to be leaning forward.

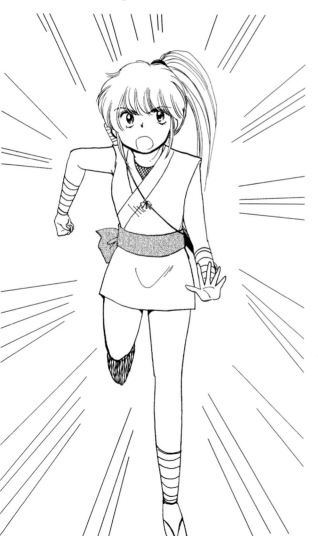

Intermediate's Drawing

The angle of the bent arm opens up more. The legs tilt to one side. The straight arm exhibits more foreshortening, so it appears to come toward the reader more. The hand has not been enlarged enough, however, to take into account the effects of perspective.

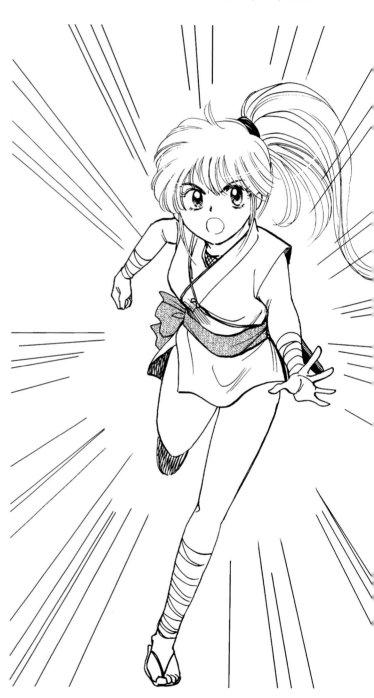

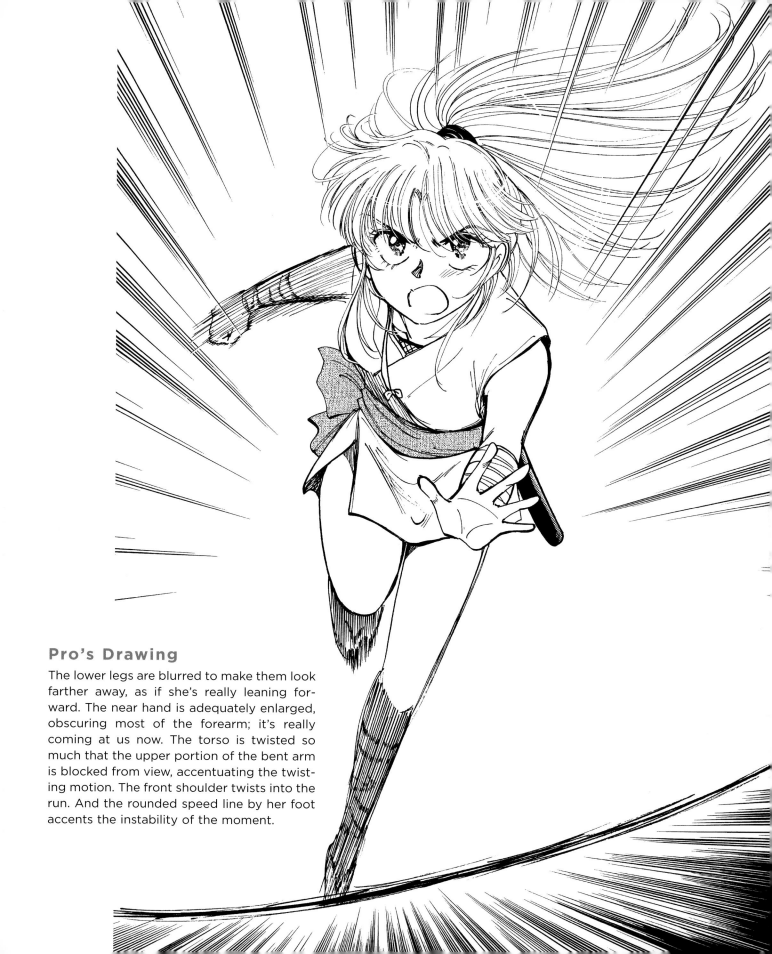

Pro's Drawing

The lower legs are blurred to make them look farther away, as if she's really leaning forward. The near hand is adequately enlarged, obscuring most of the forearm; it's really coming at us now. The torso is twisted so much that the upper portion of the bent arm is blocked from view, accentuating the twisting motion. The front shoulder twists into the run. And the rounded speed line by her foot accents the instability of the moment.

FLYING

Hey, this magical girl's not levitating, and she's not floating. She's *flying*! This has to be clear in the drawing. She has to look not only like she's going somewhere but like she's directing the movement. In the first two poses, she looks airborne all right—but almost as if she has been lifted by a rope in a theatrical stage production. But in the third pose—with knee lifted high, back arched, and wing tips all the way back—she looks like she's piloting this plane.

Beginner's Drawing

The arms and legs are stiff and symmetrically posed (called "twinning"). The dress is also stiff, instead of flowing.

Intermediate's Drawing

The position of the legs is varied. The far arm stretches back so far that it practically disappears behind the body, streamlining the pose, and the fabric starts to look less stiff.

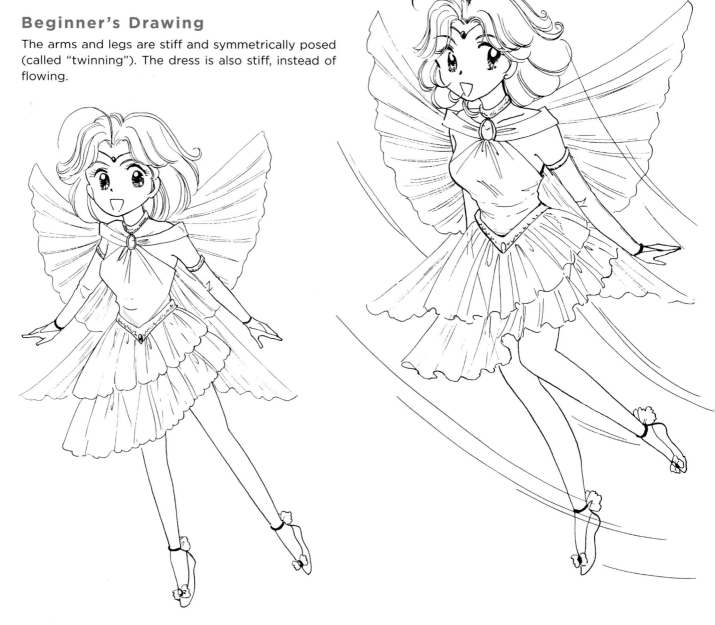

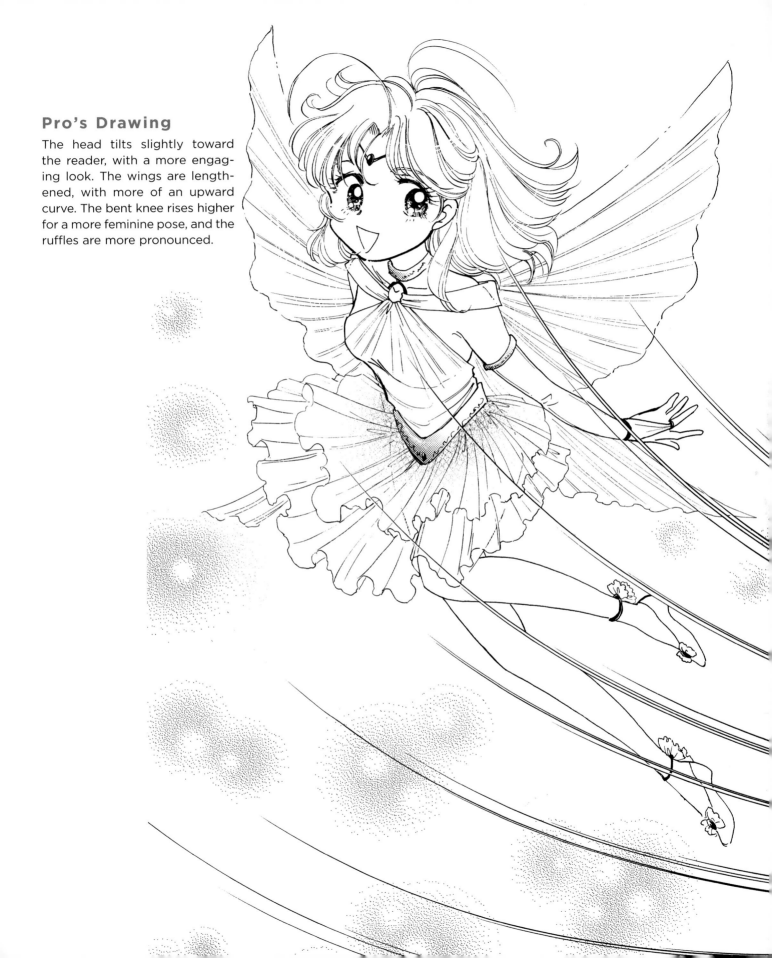

Pro's Drawing

The head tilts slightly toward the reader, with a more engaging look. The wings are lengthened, with more of an upward curve. The bent knee rises higher for a more feminine pose, and the ruffles are more pronounced.

Popular Manga Characters

MANGA IS FILLED WITH A HUGE VARIETY of charismatic characters. There are adorable chibis, female cyborgs, gothic vampires, and more. This section introduces you to some of the most colorful, exciting, and loved figures in the world of manga. I think you'll like this part. It's when we take a little respite from the art lessons and just have fun following the steps to draw cool characters.

CHIBI GIRL

A *chibi* (pronounced CHEE-bee) is a tiny person with superexaggerated proportions. Chibis have huge heads and small bodies, sort of like toddlers. They boast, perhaps, the biggest eyes in all of mangadom. Since the eyes take up so much room on the chibi face, the head needs to be stretched and, therefore, usually ends up being oval-shaped to accommodate the oval-shaped eyes. Chibi characters have a simplified look. Their faces don't show any expression lines—and hardly even a nose! And their fingers are only partially defined. But don't skimp on the outfit. I know one artist who did that. His chibi got very ticked off at him. Erased his entire portfolio one night while he was sleeping. Mischievous critters.

Chibis can also be turned into chibi/anthro combos. This little cutie is a chibi/rabbit. No tail or buckteeth necessary, just a couple of fluffy ears on top of her head do the trick.

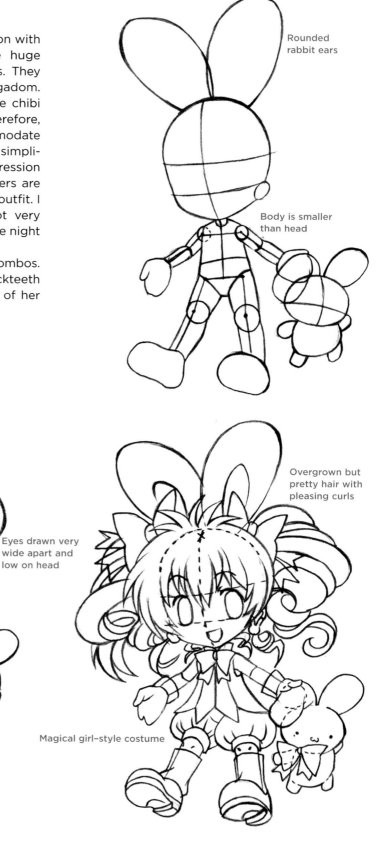

Rounded rabbit ears

Body is smaller than head

Eyes drawn very wide apart and low on head

Overgrown but pretty hair with pleasing curls

Magical girl–style costume

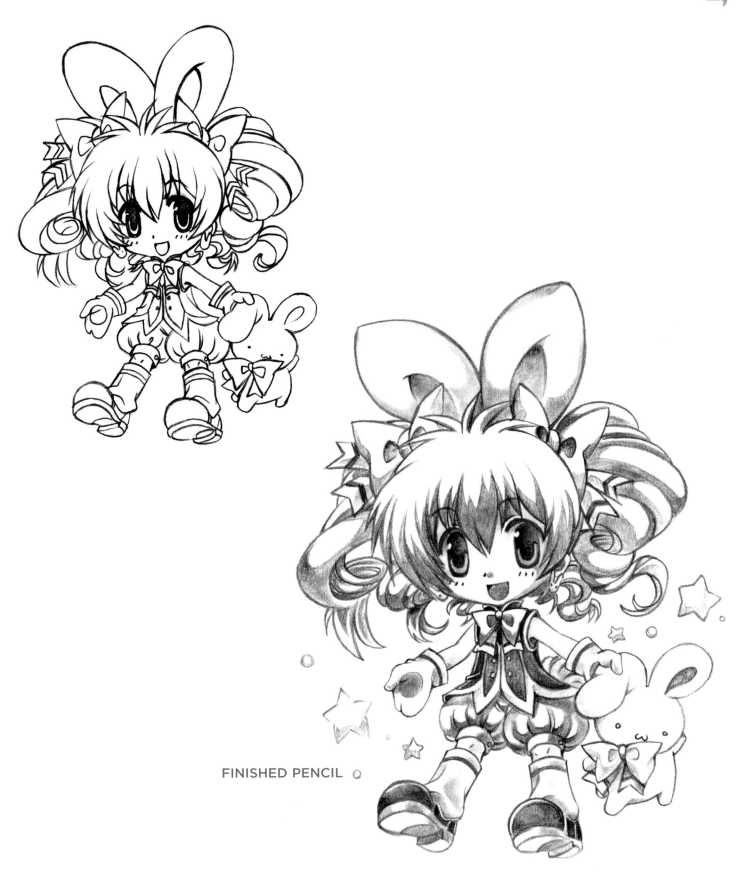

FINISHED PENCIL

CREATING A FINAL INKED DRAWING

When you ink a drawing, it's always a "final" ink. There's no such thing as a "rough" ink. So, make sure you've got the pencil version tight and exactly how you want it before you begin. But you're the artist. You get to decide how you like the image. As you ink your drawing, you may decide to leave out a line or alter a line. Go for it. This is art, not architecture. Use your inspiration. But don't stray too far. Inking is different from freehand drawing.

Many artists ink right over their original pencil drawing, which eliminates that drawing. That's a standard practice. But it also assumes that you're a pretty good inker, because if you make a mistake, your original pencil drawing is history. You could still trace your inked drawing—the one that has a mistake on it—to have something from which to make another inked drawing, but then you're once removed from your original pencil drawing, and that may sap some life from the image, like making a copy from a copy.

A better method, in my opinion, is to ink over a tracing you have made of your pencil drawing, which you can generate using either tracing paper made for inking or a light box. That way, you create an inked drawing without destroying the original pencil drawing in the process.

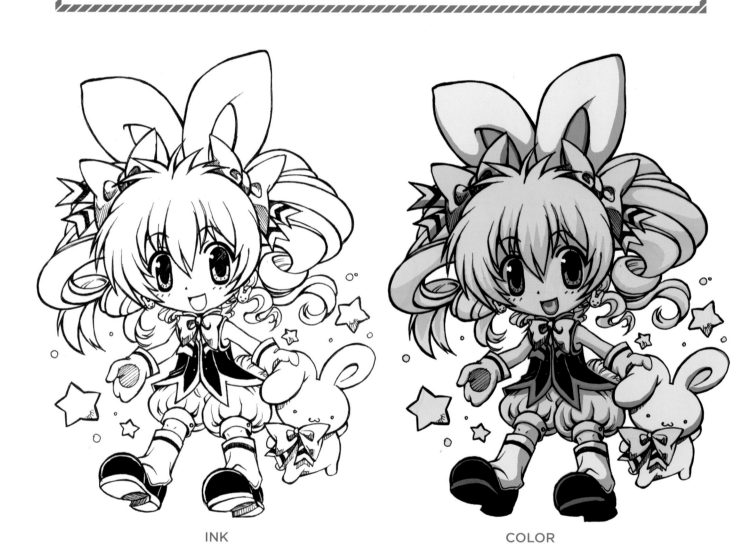

INK

COLOR

PRETTY TEEN GIRL

Most kids and young teens have trouble standing or sitting still. They have too much energy. Try to capture this quality when drawing them, to give them a youthful appearance. Take this playful teen as an example. She's twisting her knees and feet together, pulling her arm behind her back, and pushing out her tummy, all in an effort just to stand in one place.

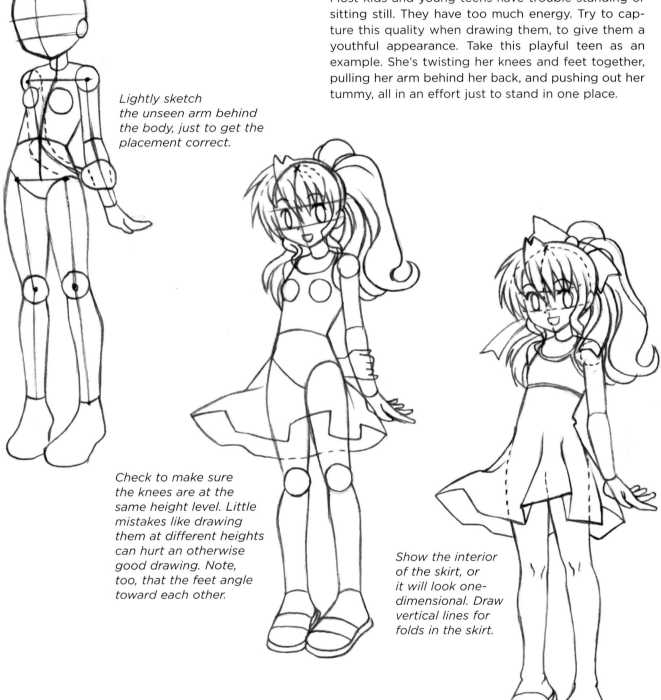

Lightly sketch the unseen arm behind the body, just to get the placement correct.

Check to make sure the knees are at the same height level. Little mistakes like drawing them at different heights can hurt an otherwise good drawing. Note, too, that the feet angle toward each other.

Show the interior of the skirt, or it will look one-dimensional. Draw vertical lines for folds in the skirt.

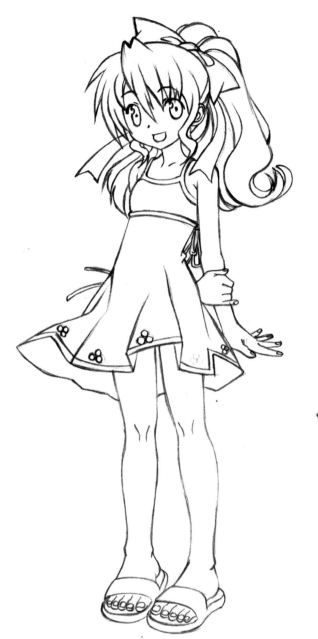

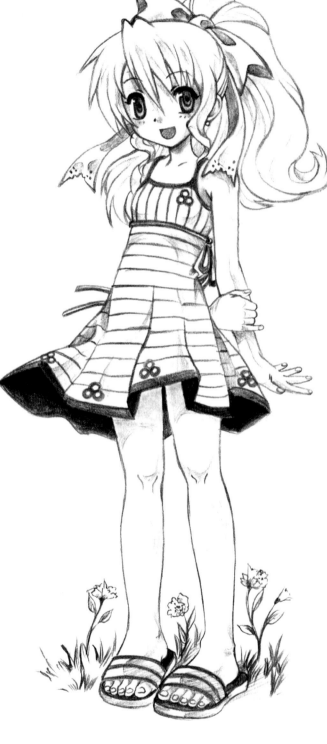

FEMALE FACES

On charming female characters, the mouth should always be drawn small and dainty, unless the character's in the middle of an outrageous fit of anger or laughter, in which case you can go wacky for a moment. But for a sweet or innocent look, a small smile works best. Draw the eyes big, and let them communicate most of the feeling. Give them dark, arching eyelids (for glamour), long eyelashes, and noticeable eye shines.

FINISHED PENCIL

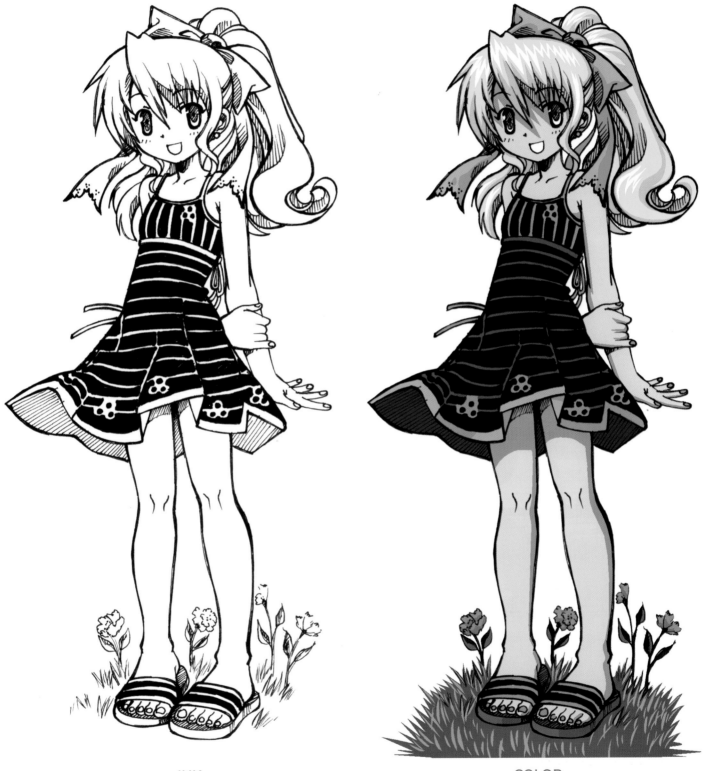

INK

COLOR

HANDSOME TEEN BOY

This casual, good-looking character is very popular with readers of high school manga adventures. He's a "teen crush" who wears oversized, baggy clothes, which is a different look from the supertall, lanky teenager wearing European fashions (see page 61). This guy's more of an American charmer. He has been known to cause longstanding friendships to dissolve into catfights. His slightly disinterested look makes him seem unattainable, and to high school girls, that makes him utterly irresistible. Go figure.

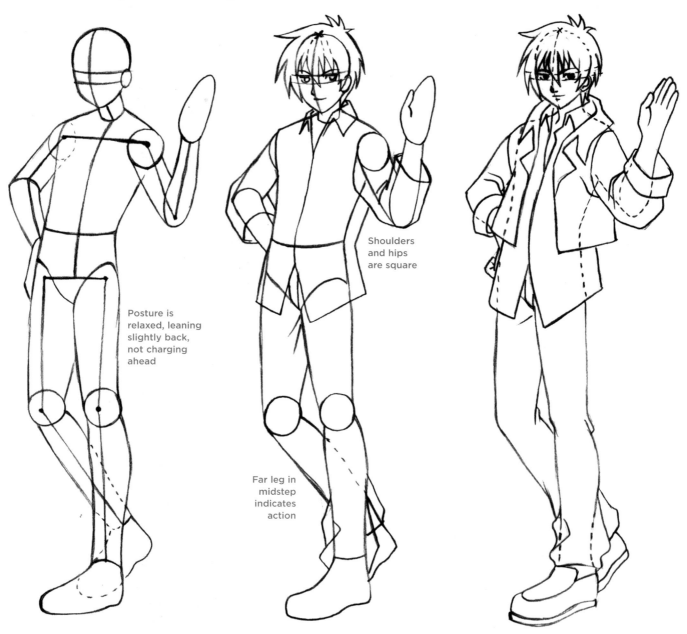

Posture is relaxed, leaning slightly back, not charging ahead

Shoulders and hips are square

Far leg in midstep indicates action

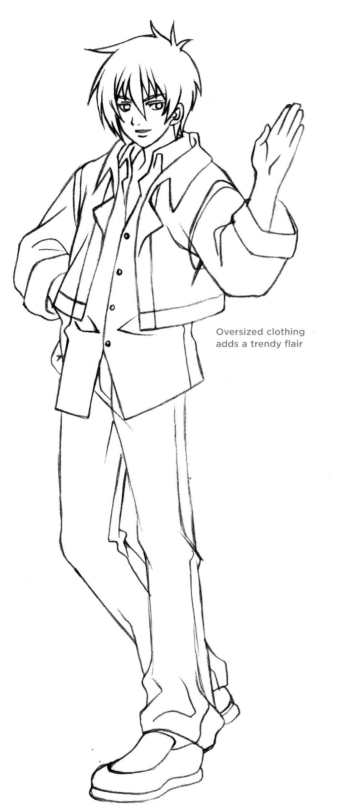

Oversized clothing
adds a trendy flair

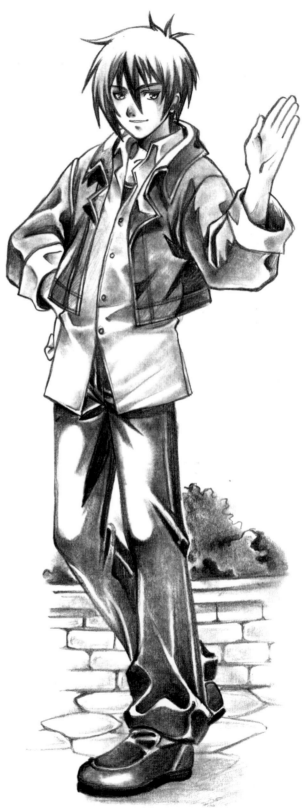

FINISHED PENCIL

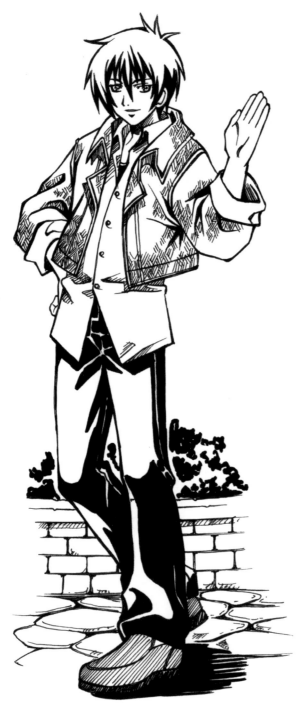

INK

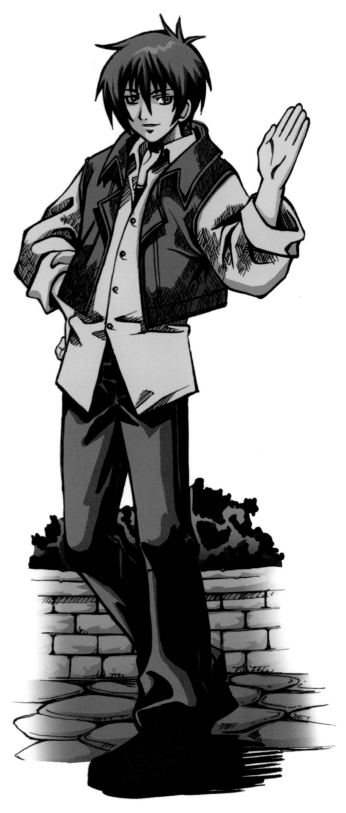

COLOR

A NOTE ABOUT HIGHLIGHTS

When either pencil-shading or inking, you can indicate bright areas on the clothing (highlights) to make it appear that light is hitting the character. Simply leave those areas unshaded or uninked, and shade, ink, or crosshatch around them. Those white areas will then look illuminated by comparison.

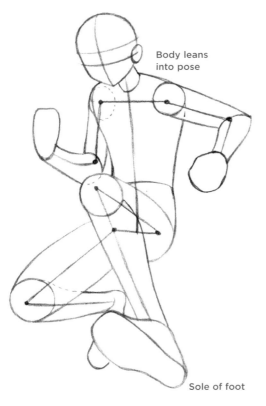

Body leans
into pose

Sole of foot

MARTIAL ARTS FIGHTER

As this fighter comes flying toward you, his legs are coiled up, ready to let loose a powerful kick. It's important that you show the sole of the shoe on the near foot: That tips off the reader that a kick is coming. If his front foot were pointing downward instead, then heck, he would look as if he could be dancing! Well, not a very good dance, granted, especially with those clenched fists, but still, it's the underside of the foot coming right at your face that makes it crystal clear that this is a fighting pose. Note, too, that his mouth is open; he's belting out a karate yell as he delivers the strike.

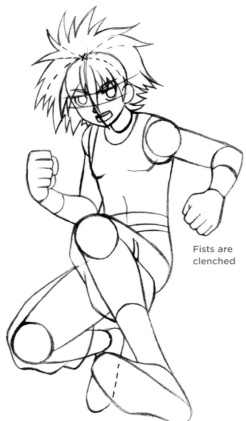

Fists are
clenched

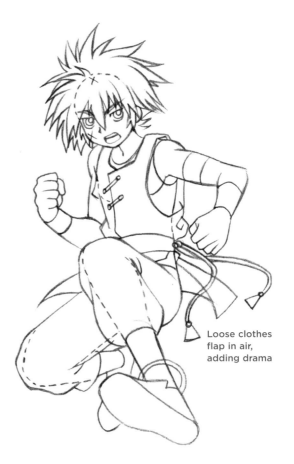

Loose clothes
flap in air,
adding drama

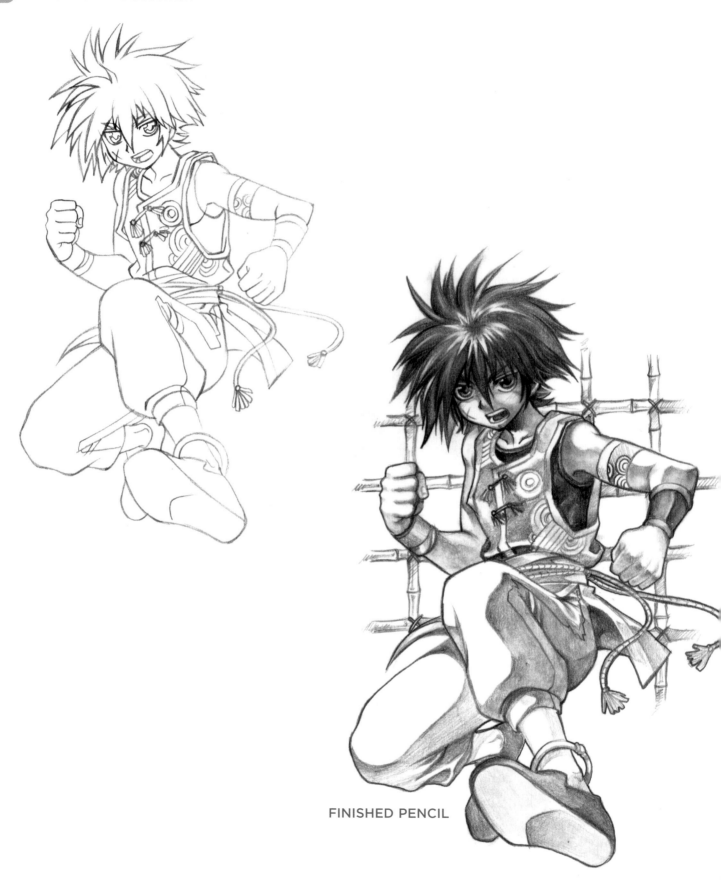

FINISHED PENCIL

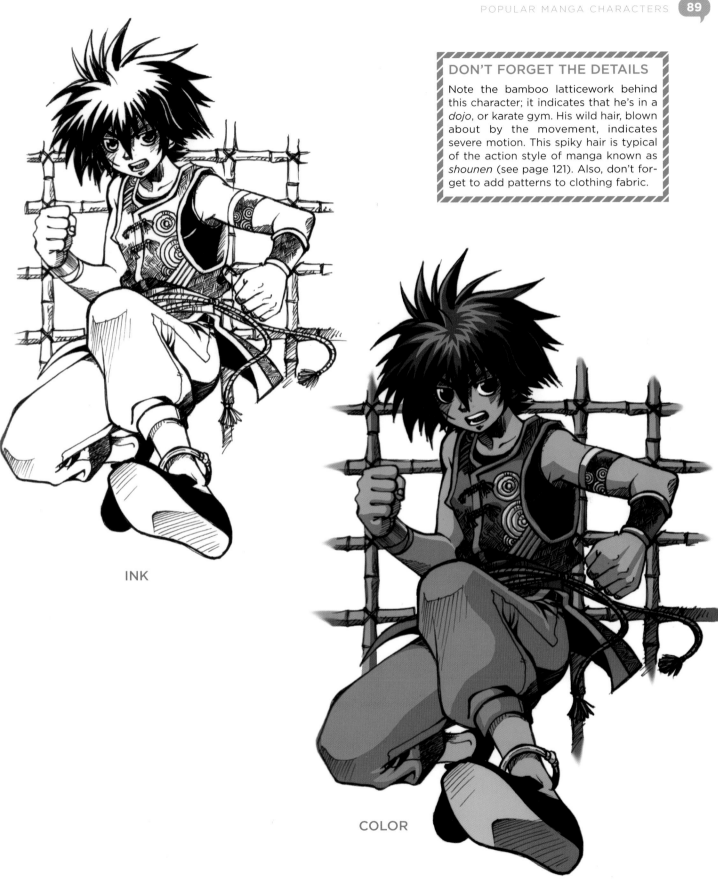

DON'T FORGET THE DETAILS
Note the bamboo latticework behind this character; it indicates that he's in a *dojo*, or karate gym. His wild hair, blown about by the movement, indicates severe motion. This spiky hair is typical of the action style of manga known as *shounen* (see page 121). Also, don't forget to add patterns to clothing fabric.

INK

COLOR

FEMALE MECHA FIGHTER

This heavily fortified outfit is more than a protective suit; it's also a weaponized machine. There are concealed lasers and guns that can be called upon to fire at a moment's notice, as well as rocket launchers under her boots to help her escape any dangerous situation. If she needs more firepower, cannons can appear through hidden flaps.

The way to make this character appealing is to pay special attention to the figure and to be sure that it's not obscured by the bulky gear she is wearing. To do this, you have to sketch the figure first and build the mecha suit second, as you can see from the steps. The trick to drawing convincing mecha armor is to use areas of the body—the rib cage, the hips, the shoulders, the kneecaps, and so on—to create and place the sections of the mecha suit. This will help you avoid making the suit overcomplicated. It should look *functional,* not ungainly and impractical.

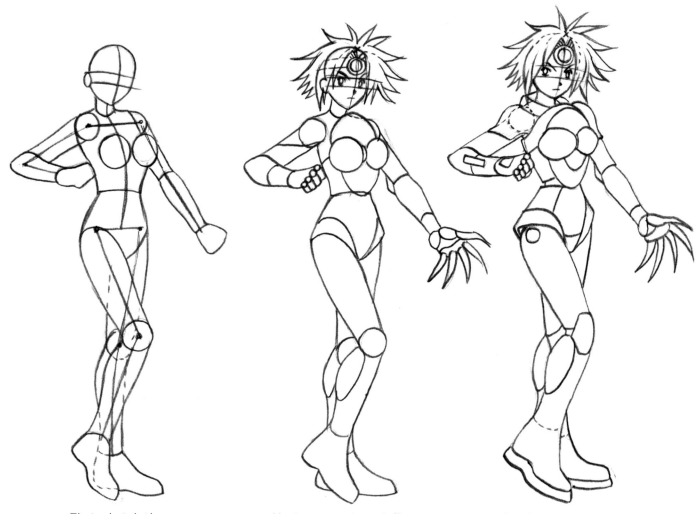

First, sketch the natural female figure.

Next, compartmentalize various sections of the figure.

Continue compartmentalizing the body, adding more details.

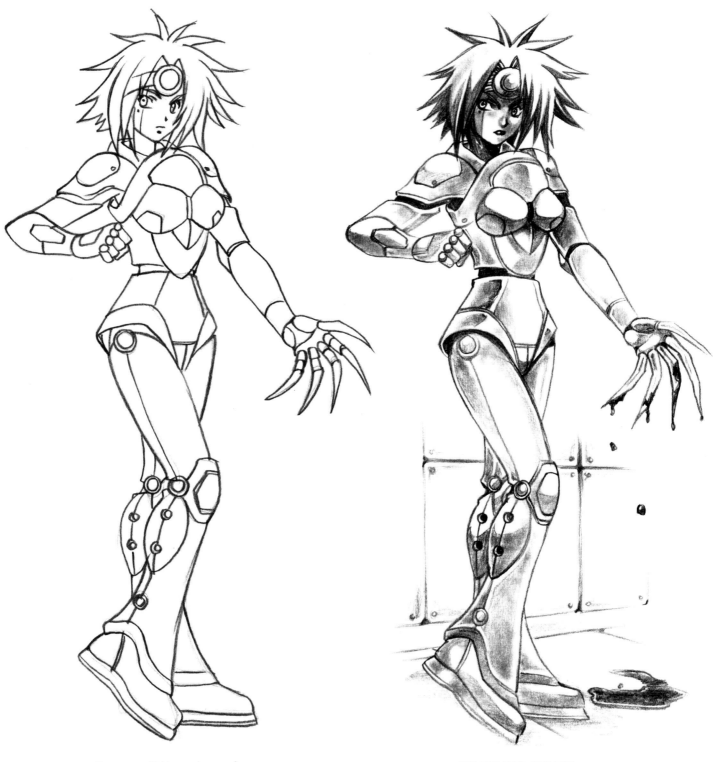

Square off the edges of things for a more robotic look, while at the same time flaring out the metal plates and adding rivets.

FINISHED PENCIL

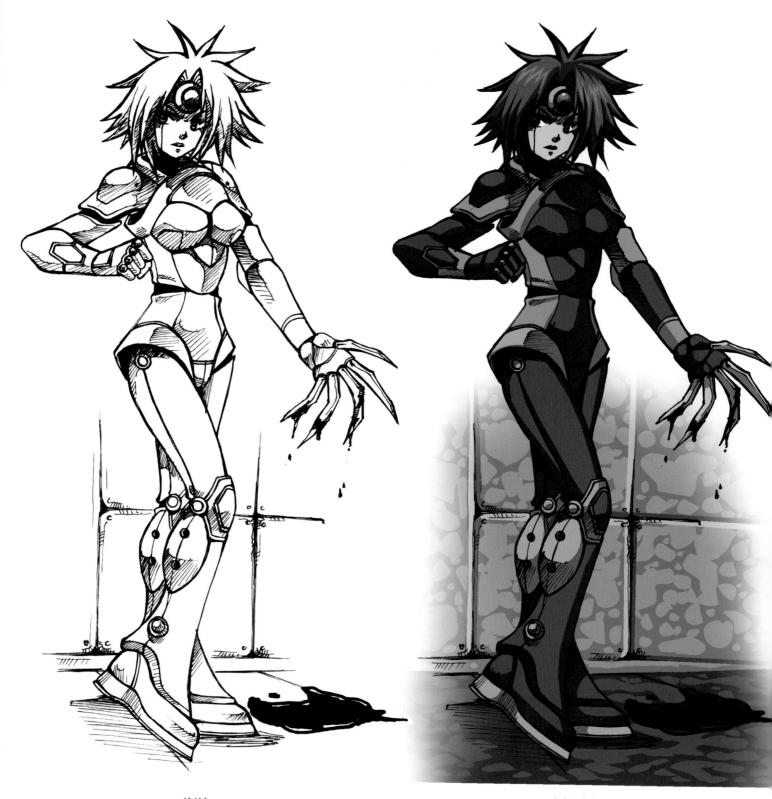

INK

COLOR

VAMPIRE

Another popular icon in the world of manga is the star of horror and the supernatural: the vampire. The manga vampire is typically a romantic figure, with long hair and dashing good looks. He often belongs to a category of characters known as *bishies*, which are androgynous male characters. They generally don't walk around with giant, spooky vampire wings or huge fangs. Instead, their power comes from their personal magnetism. They are the glamour boys of the occult world. They are moody, mysterious, contemplative, mercurial, sardonic, and a bunch of other vocabulary words.

From the start, the near hand is drawn large in the foreground, exaggerating perspective and enhancing impact.

The near upper arm is foreshortened to show the effects of perspective on the figure. The far hand, presses against the far hip, hidden from view. The hair falls to midway down the back.

Notice how the figure leans back at the waist.

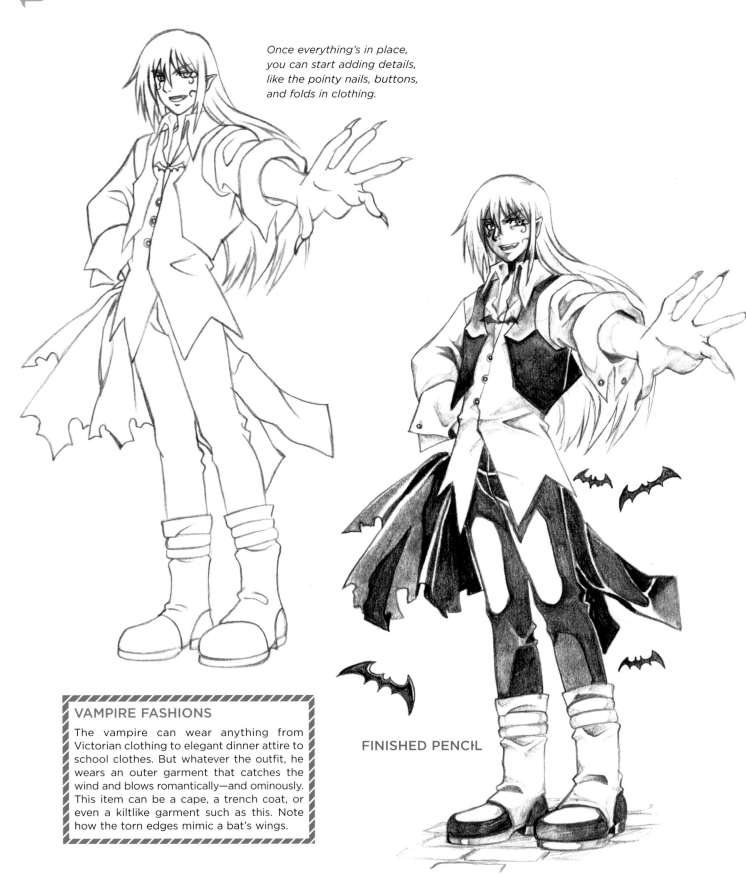

Once everything's in place, you can start adding details, like the pointy nails, buttons, and folds in clothing.

FINISHED PENCIL

VAMPIRE FASHIONS

The vampire can wear anything from Victorian clothing to elegant dinner attire to school clothes. But whatever the outfit, he wears an outer garment that catches the wind and blows romantically—and ominously. This item can be a cape, a trench coat, or even a kiltlike garment such as this. Note how the torn edges mimic a bat's wings.

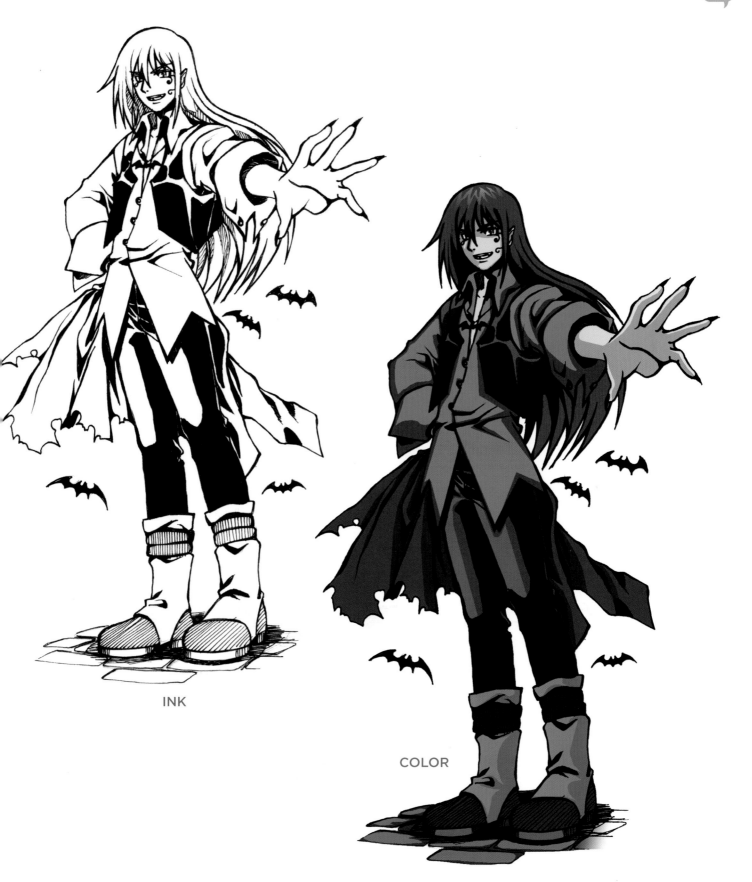

INK

COLOR

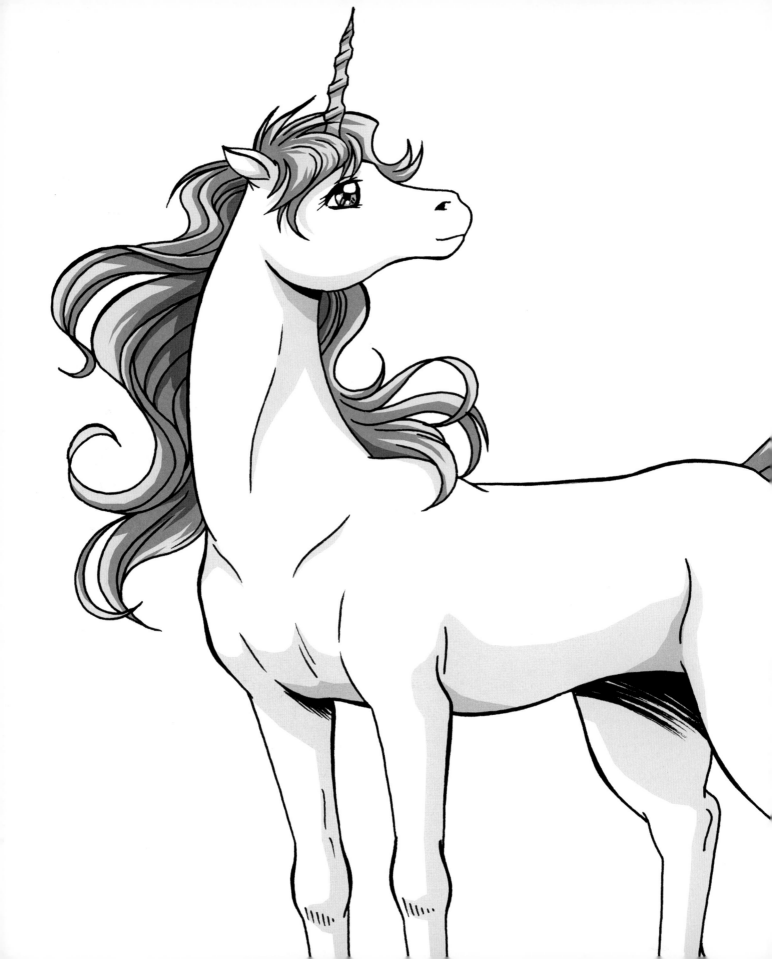

Cute Manga Animals

MANGA BOYS AND GIRLS HAVE PETS, just like you and me. They also have exciting adventures that take them to lands with animals who befriend them. Sometimes, magic transports characters to enchanted worlds where they meet mystical guides accompanied by magical creatures such as unicorns. All these types of animals have a special charm, because they're drawn in the manga style, which we'll take a look at now.

FLUFFY CAT

There are so many personalities you can give a cat: mischievous, curious, playful, evil. Sometimes it's fun to draw cats slithering around the legs of the chairs in your house. This one is a fluffy sweetheart.

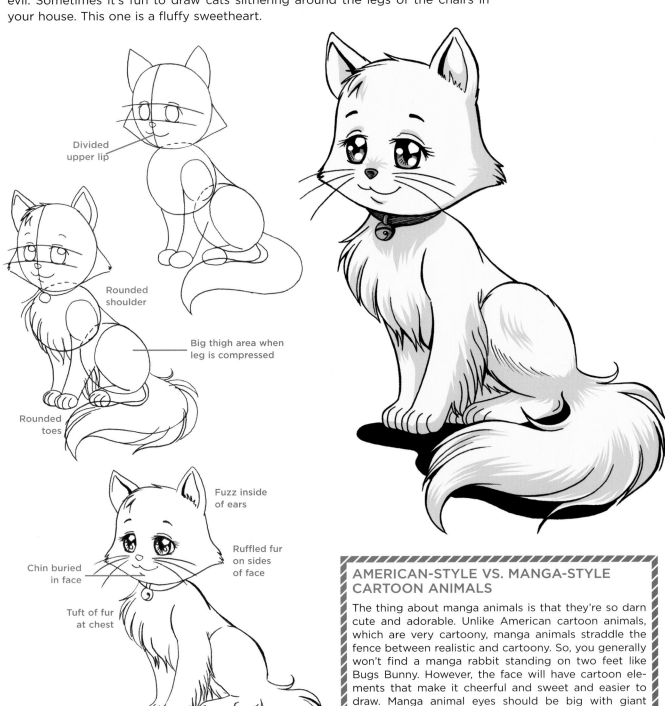

Divided upper lip

Rounded shoulder

Big thigh area when leg is compressed

Rounded toes

Fuzz inside of ears

Ruffled fur on sides of face

Chin buried in face

Tuft of fur at chest

AMERICAN-STYLE VS. MANGA-STYLE CARTOON ANIMALS

The thing about manga animals is that they're so darn cute and adorable. Unlike American cartoon animals, which are very cartoony, manga animals straddle the fence between realistic and cartoony. So, you generally won't find a manga rabbit standing on two feet like Bugs Bunny. However, the face will have cartoon elements that make it cheerful and sweet and easier to draw. Manga animal eyes should be big with giant shines in them—much like the classic big eyes on manga humans. And by giving manga animals long eyelashes, you imbue them with a look of kindness.

PLAYFUL PUPPY

Dogs and pups make great supporting characters, especially in scenes in which kids are despondent and need a friend to talk to—even if the friend can't talk back. Puppies bring an audience into a story and make the human character sympathetic. Note that tongue out and one ear up is a happy expression, unless you're a person, in which case, it's just weird.

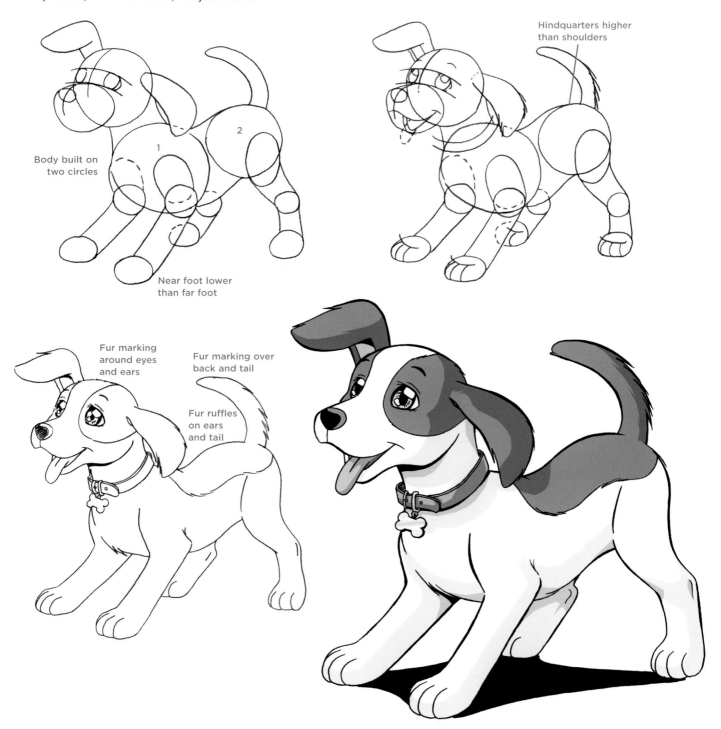

Body built on two circles

Near foot lower than far foot

Hindquarters higher than shoulders

Fur marking around eyes and ears

Fur marking over back and tail

Fur ruffles on ears and tail

CUTE MOUSE

Don't draw a long snout on a mouse, or you'll turn it into a rat!
A cartoon mouse is cute because it has a short nose.

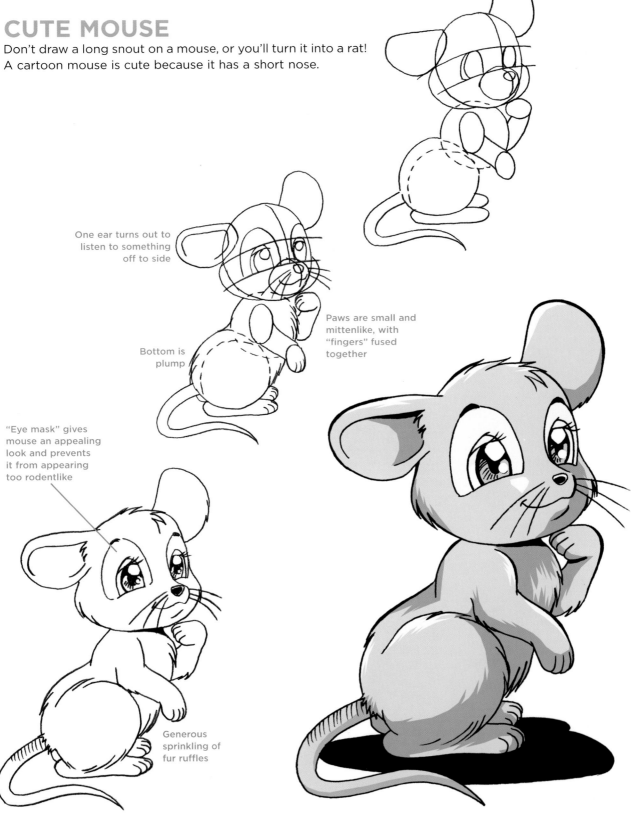

One ear turns out to listen to something off to side

Paws are small and mittenlike, with "fingers" fused together

Bottom is plump

"Eye mask" gives mouse an appealing look and prevents it from appearing too rodentlike

Generous sprinkling of fur ruffles

TINY CHIPMUNK

Chipmunks are real cuties! I've got one in my backyard. You can't believe how tiny they are until you see them—about a third of the size of a squirrel. And they're very, very fast. You can recognize one instantly by the brown and white striping.

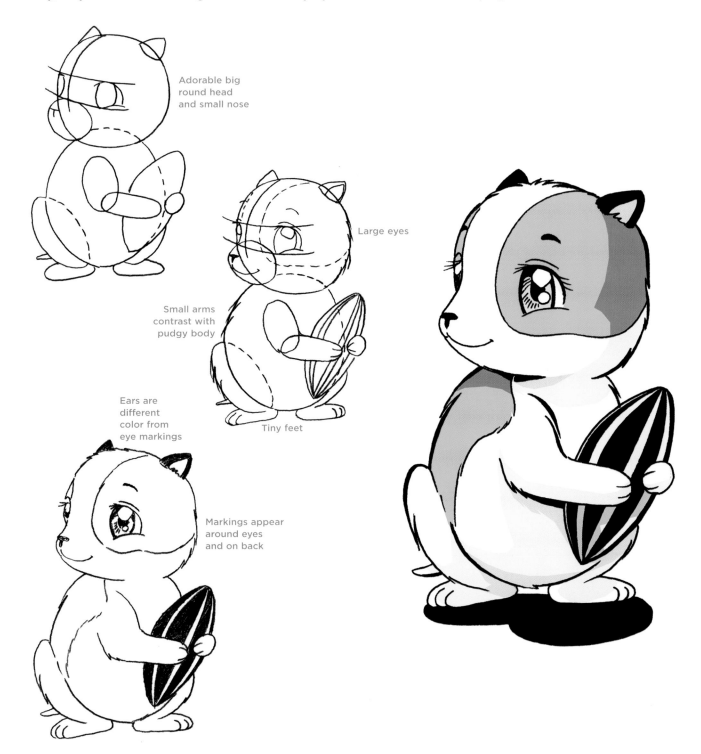

Adorable big round head and small nose

Large eyes

Small arms contrast with pudgy body

Tiny feet

Ears are different color from eye markings

Markings appear around eyes and on back

BUNNY RABBIT

Usually thought of as a backyard animal, in manga, the bunny rabbit is also cast as a curious fantasy character. As such, it can be colored pink, blue, light green, and so on. It doesn't have to be a natural color. Note that on real rabbits, the ears point back or down, not up.

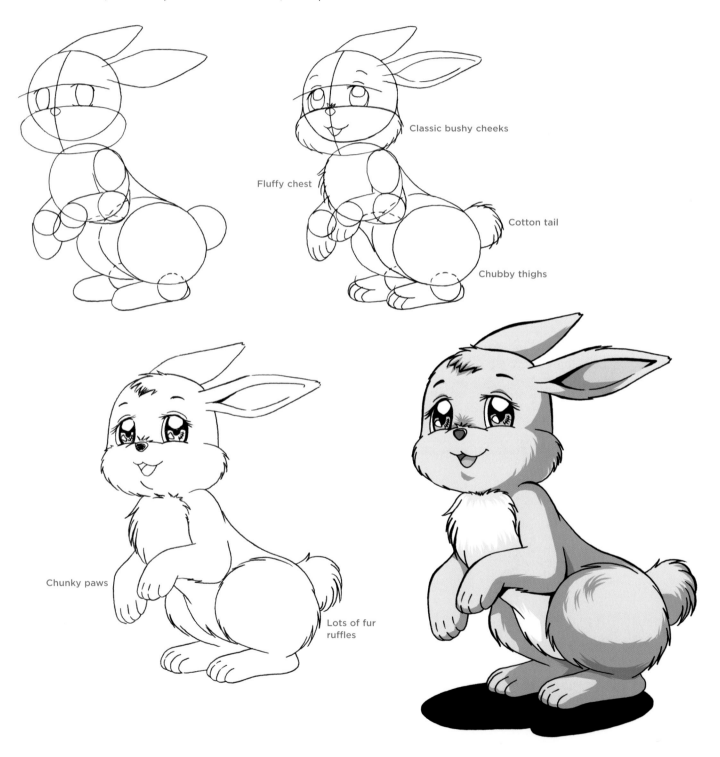

Classic bushy cheeks

Fluffy chest

Cotton tail

Chubby thighs

Chunky paws

Lots of fur ruffles

CHARMING TORTOISE

Do you know the difference between a turtle and a tortoise? It's important to know for drawing, because in comics, tortoises are often used as characters but turtles seldom are. A turtle can swim and has webbed or fin-type feet, but a tortoise is a terrestrial turtle and doesn't swim. A tortoise has feet like an elephant. Tortoises have squarer faces, which are cuter than the more reptilian heads of some turtles, such as deep-sea turtles. Tortoises have high shells, whereas turtles have low shells. Most cartoon "turtles" are actually tortoises.

A real tortoise, in fact, has a sweet, charming disposition, very much like its cartoon counterpart. I used to own a couple of tortoises. One of them would actually come to the sound of her name and eat right out of my hand. Her name was Samantha. When I moved to New York from Los Angeles, I gave her to the L.A. zoo. She loved to be scratched under the chin. This is what she looked like.

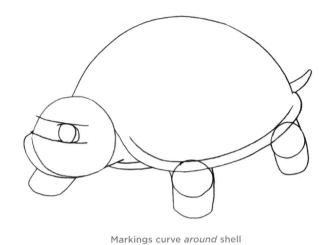

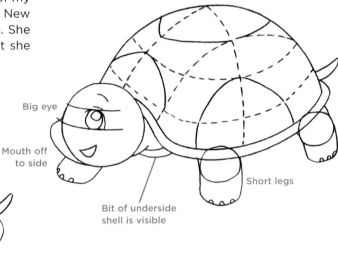

Markings curve *around* shell

Big eye

Mouth off to side

Bit of underside shell is visible

Short legs

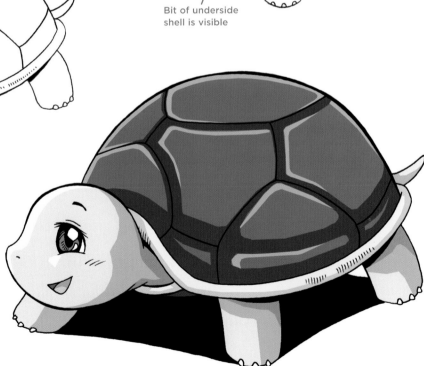

GRACEFUL DEER

A beautiful and captivating sight in the woods or forest! The gaze of a deer casts an almost hypnotic spell. Speckles on its back signify that it's a youngster. Keep antlers modest, or the deer will look aggressive.

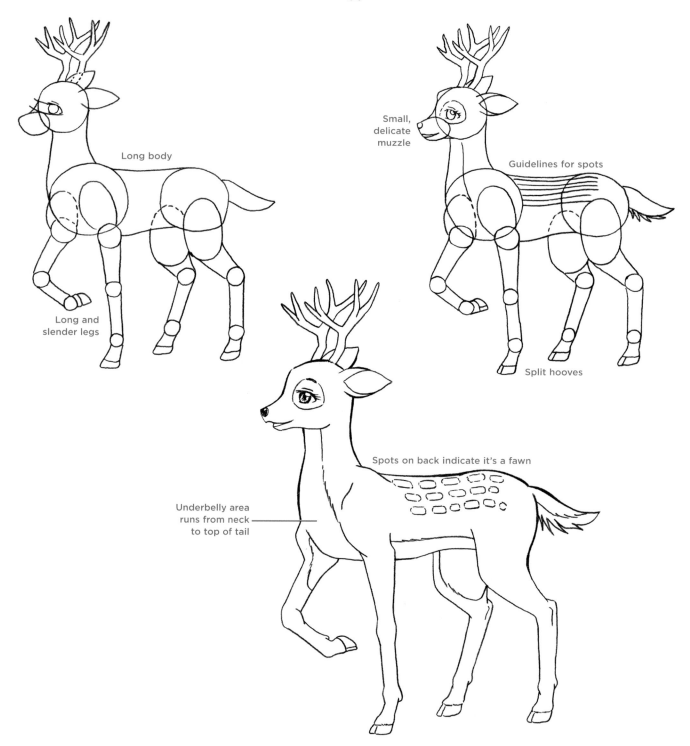

Long body

Long and slender legs

Small, delicate muzzle

Guidelines for spots

Split hooves

Spots on back indicate it's a fawn

Underbelly area runs from neck to top of tail

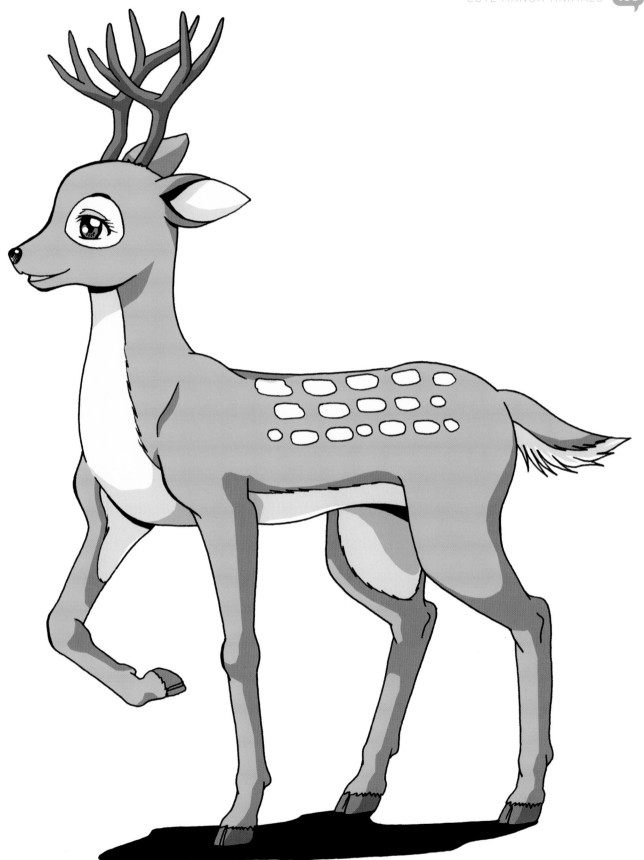

MAGICAL UNICORN

The unicorn is the most popular fantasy animal in shoujo (pronounced SHOW-joe), the manga category read primarily by girls. The original unicorn depicted in art was an aggressive, bearded beast, but over the years, it has evolved into a sweet, serene animal—one that brings joy and light with it.

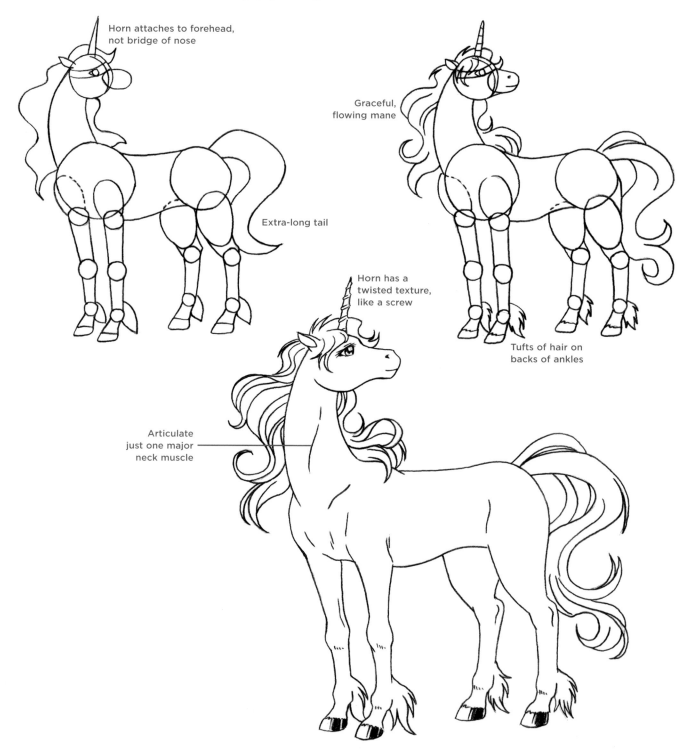

Horn attaches to forehead, not bridge of nose

Extra-long tail

Graceful, flowing mane

Horn has a twisted texture, like a screw

Tufts of hair on backs of ankles

Articulate just one major neck muscle

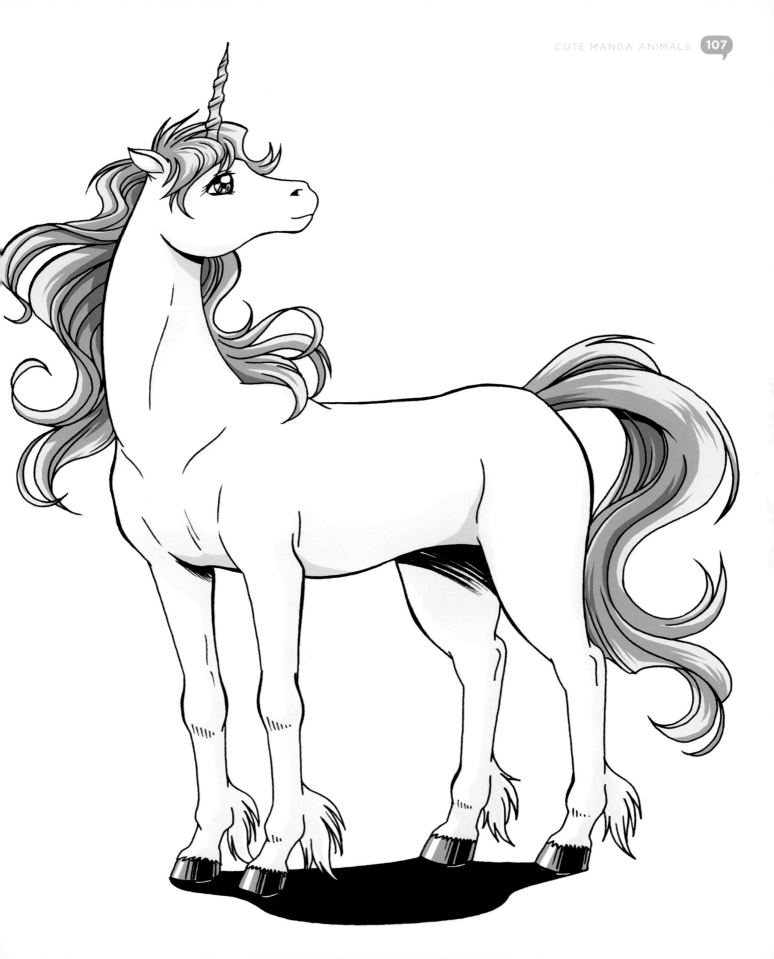

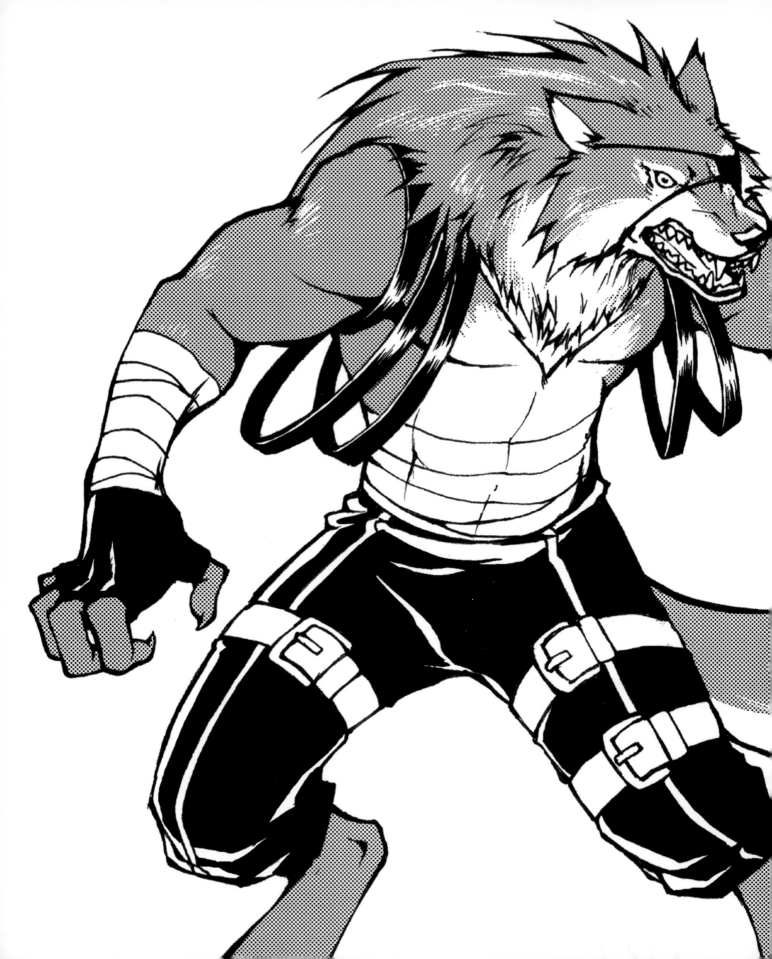

Anthros

ANTHROS ARE POPULAR CHARACTER TYPES in some subgenres of manga. *Anthro* is short for *anthropomorphic*, which means *having human traits or forms*. When you assign human characteristics to nonhuman things, such as animals, that is anthropomorphism. There are two basic types of anthros: feminine animal-girl characters, the most popular of which are cat-girls, and ferocious animal-human fighter types featured in the manga action genre, shounen. The true anthro, however, takes on more of the animal's anatomy.

CAT

The cat-girl is the most popular type of anthro, because she's pretty, cute, and feminine. Most cat-girls have a very human face and mostly human anatomy, with add-ons such as cat ears, a tail, and paws that make her look feline. This character appears in many genres, including shoujo, bishoujo, fantasy, and samurai manga.

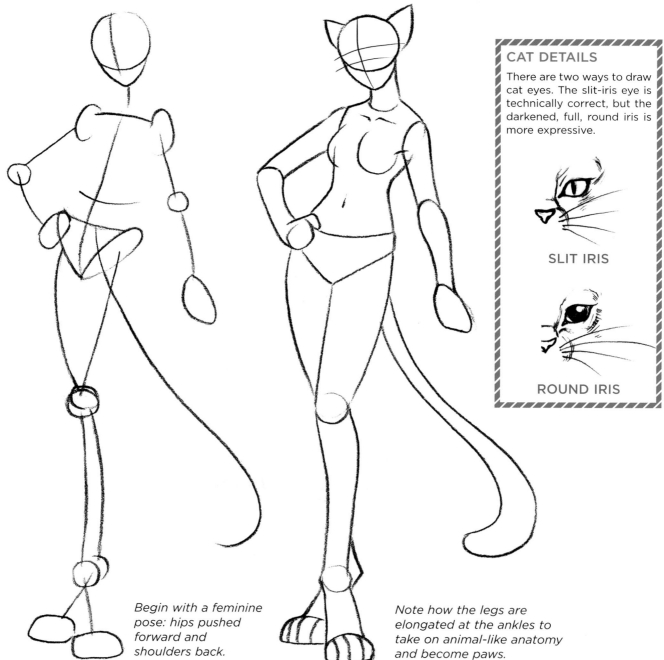

Begin with a feminine pose: hips pushed forward and shoulders back.

Note how the legs are elongated at the ankles to take on animal-like anatomy and become paws.

CAT DETAILS

There are two ways to draw cat eyes. The slit-iris eye is technically correct, but the darkened, full, round iris is more expressive.

SLIT IRIS

ROUND IRIS

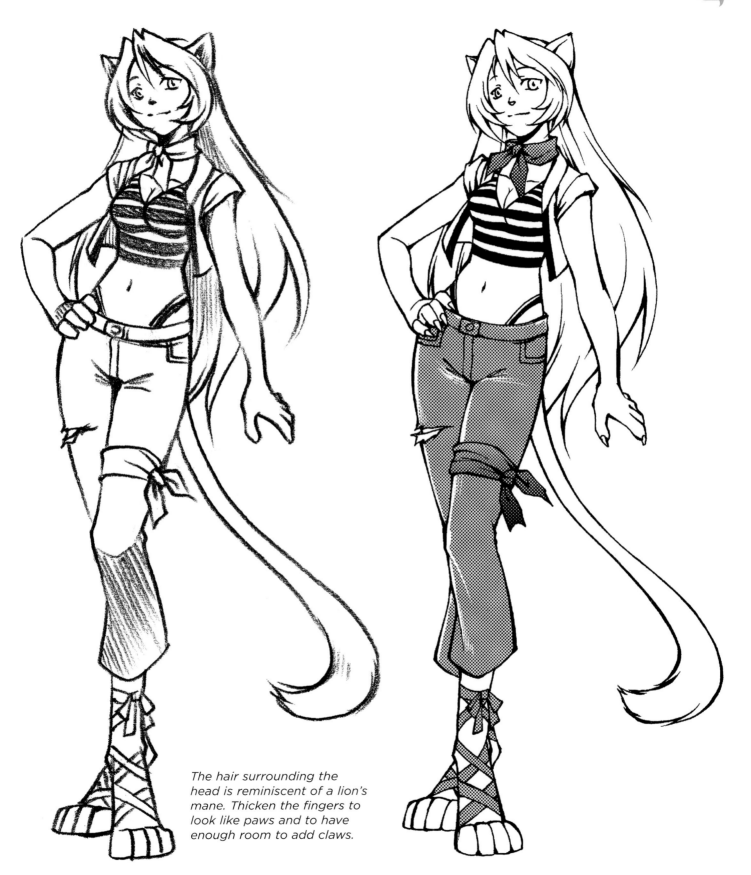

The hair surrounding the head is reminiscent of a lion's mane. Thicken the fingers to look like paws and to have enough room to add claws.

LIONESS

Continuing with the feline theme, this lioness anthro is queen of the jungle—a primitive ruler with the necklace and bracelets of a warrior people. Even though she cannot have a classic lion mane because she's female, she still has to have hair—it's the most effective way to feminize her face. Just giving her eyelashes won't even come close to doing the trick.

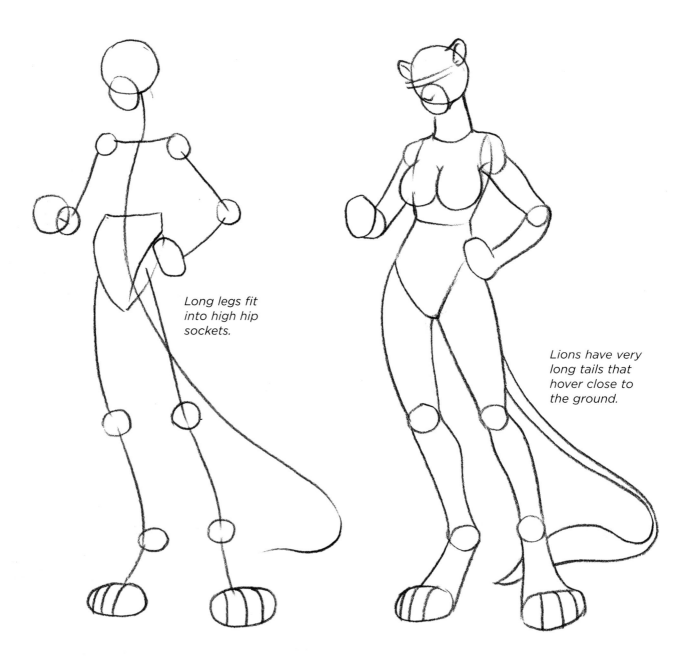

Long legs fit into high hip sockets.

Lions have very long tails that hover close to the ground.

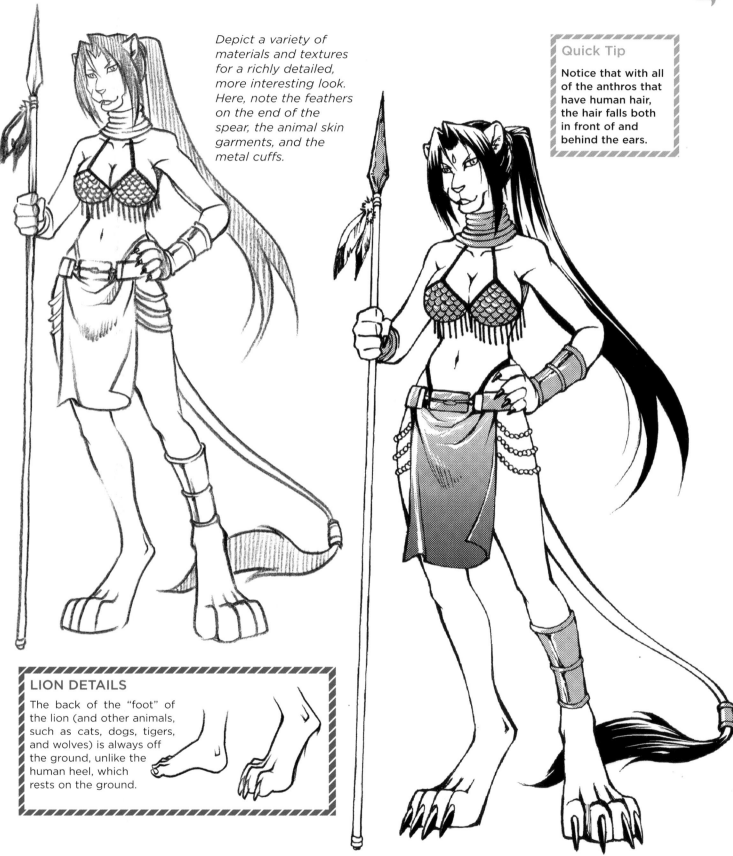

Depict a variety of materials and textures for a richly detailed, more interesting look. Here, note the feathers on the end of the spear, the animal skin garments, and the metal cuffs.

Quick Tip

Notice that with all of the anthros that have human hair, the hair falls both in front of and behind the ears.

LION DETAILS

The back of the "foot" of the lion (and other animals, such as cats, dogs, tigers, and wolves) is always off the ground, unlike the human heel, which rests on the ground.

TIGER

This feline character is a fighter anthro and is very muscular and imposing. He's a proud warrior, a weapons expert, and a veteran of fantasy battles. Keep the entire body thick. Think of it as drawing an athlete, not a tiger. Once you place the stripes, the character really comes alive, but don't rush it—get the foundation in place first.

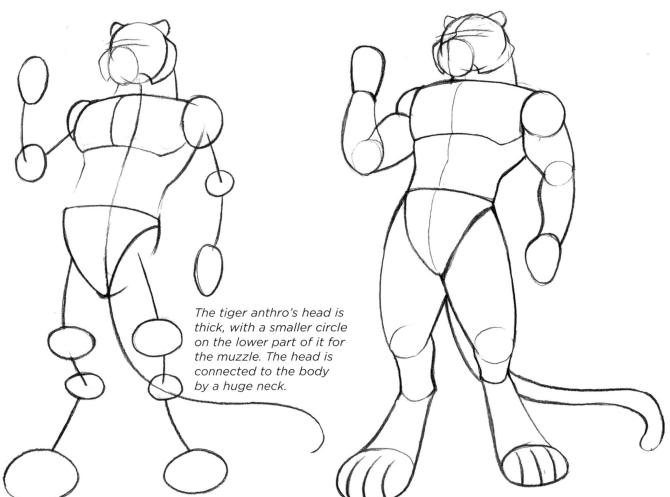

The tiger anthro's head is thick, with a smaller circle on the lower part of it for the muzzle. The head is connected to the body by a huge neck.

Note the proximity of the knee joints to the ankle joints, the giant paws, the melon-sized shoulders, and the tiny, rounded ears.

TIGER DETAILS

The tiger's pupil is a small dot in the middle of the eye. The stripes typically vary in thickness, breaking apart and coming back together in places.

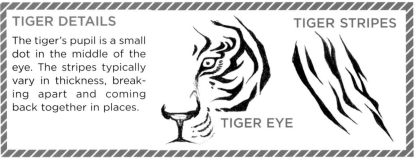

TIGER STRIPES

TIGER EYE

The tiger muzzle, like the lion's, is a bit flattened in the front.

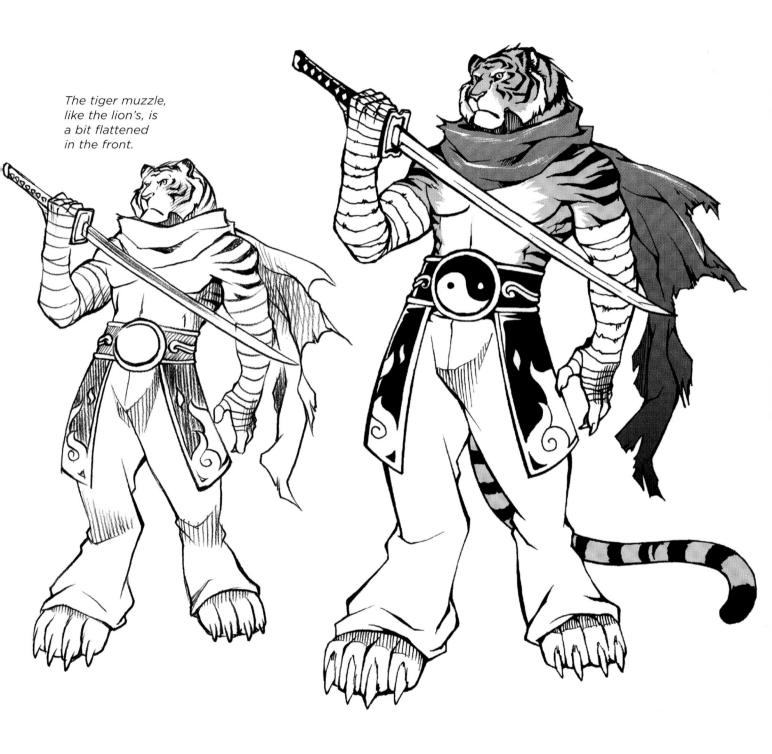

FOX

The long, slender nose of a fox lends itself to a feminine look. The wavy hair is a nice variation. The animalistic configuration of the limbs is saved for the legs only, and even then, it doesn't begin to take hold until we get to the feet, around the ankles. This makes this anthro easier to draw, because you're basically dealing with a human figure for 90 percent of the image.

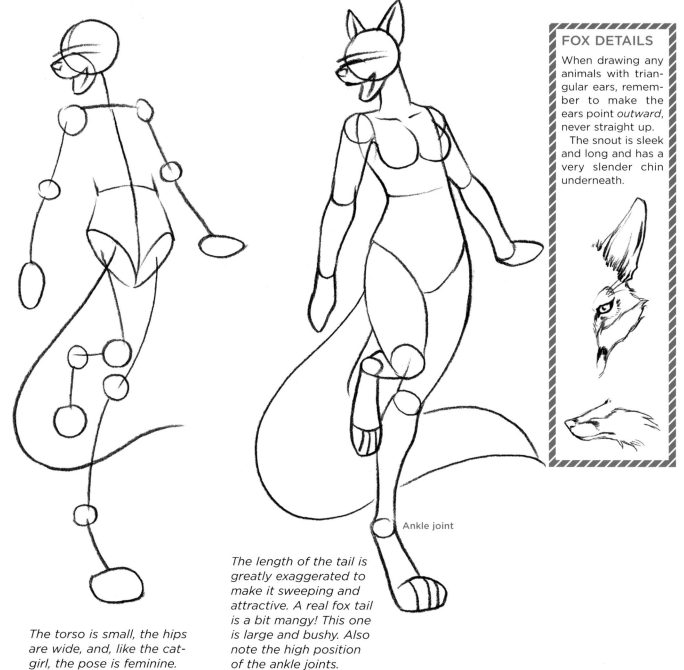

Ankle joint

The torso is small, the hips are wide, and, like the cat-girl, the pose is feminine.

The length of the tail is greatly exaggerated to make it sweeping and attractive. A real fox tail is a bit mangy! This one is large and bushy. Also note the high position of the ankle joints.

FOX DETAILS

When drawing any animals with triangular ears, remember to make the ears point *outward*, never straight up.

The snout is sleek and long and has a very slender chin underneath.

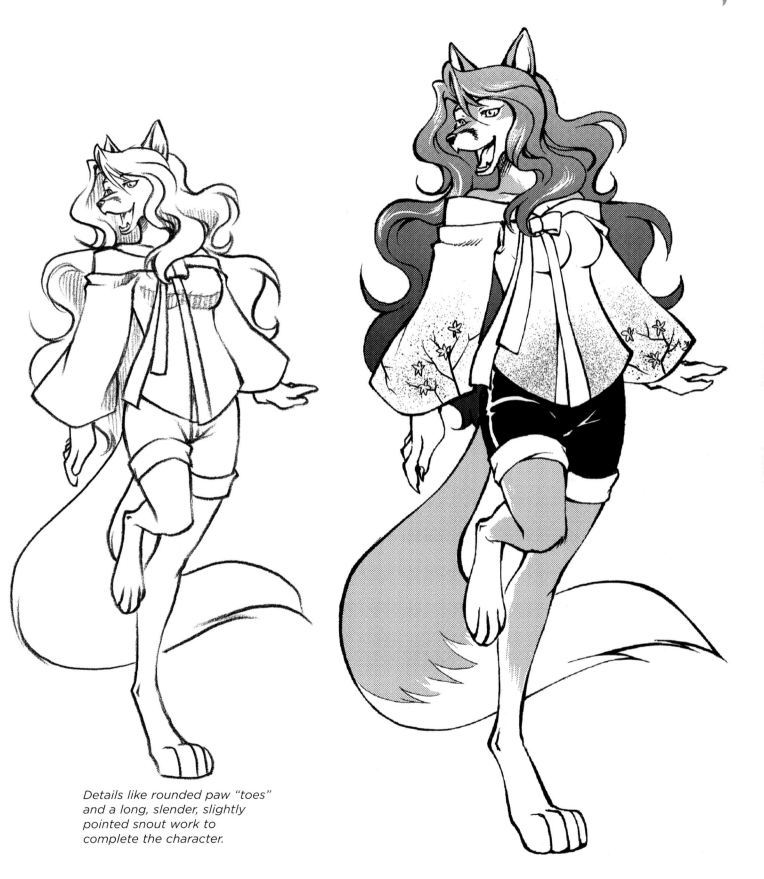

Details like rounded paw "toes" and a long, slender, slightly pointed snout work to complete the character.

WOLF

Whoa! This guy's been hitting the weight room pretty regularly. He's pumped. This is an example of how you can totally max out an anthro's frame. The character's build doesn't have to relate to the wolf's slinky physique at all. You're creating a completely new hybrid. You're also adding more costume, which further defines the character as a bad guy; note the eye patch, fingerless gloves, and forearm wraps.

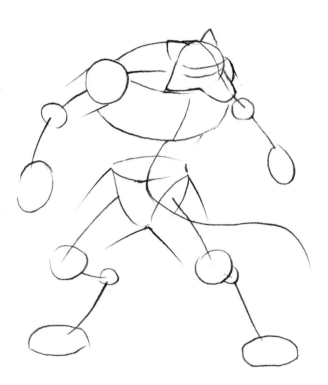

The anthro wolf has a supermassive chest and small hips. The hunched back and the head below the shoulder level create a powerful look.

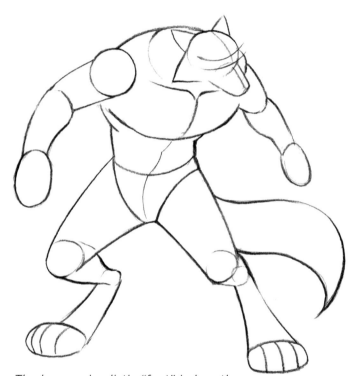

The long, animalistic "feet" imbue the character with a particularly feral look . . .

WOLF DETAILS

The wolf's piercing stare is created by the dark pockets of shadow on either side of the eyeball and the tiny pupil.

Note the exaggerated thickness of the neck—almost like a lion's mane.

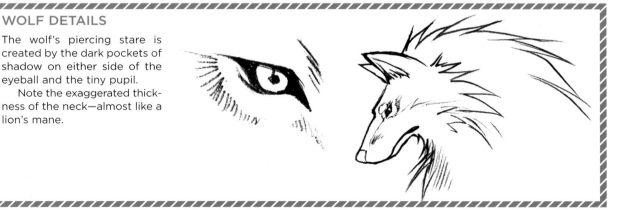

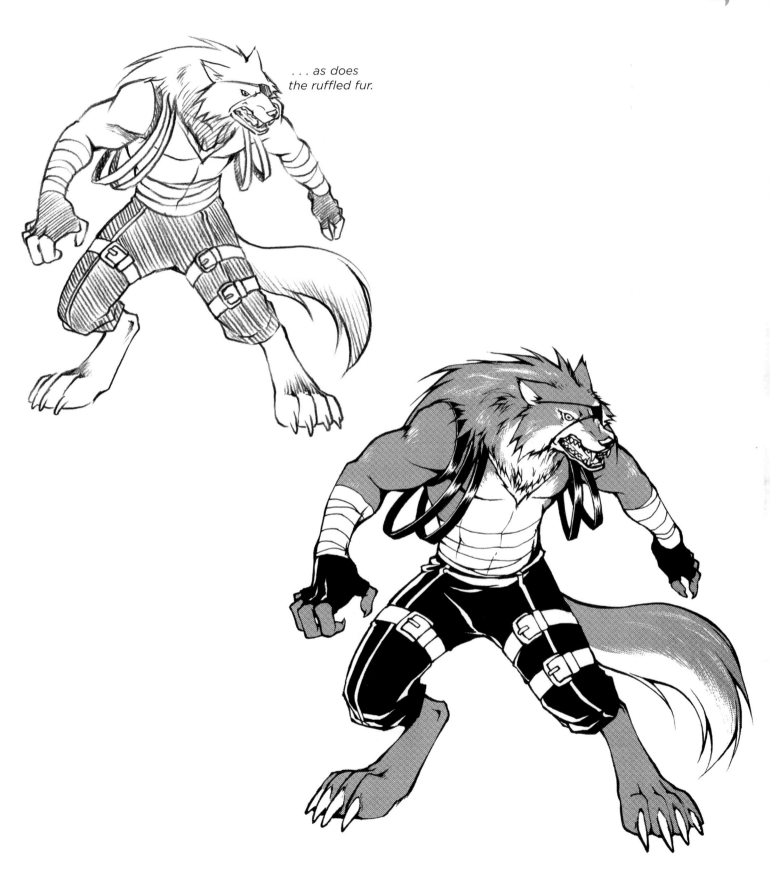

*. . . as does
the ruffled fur.*

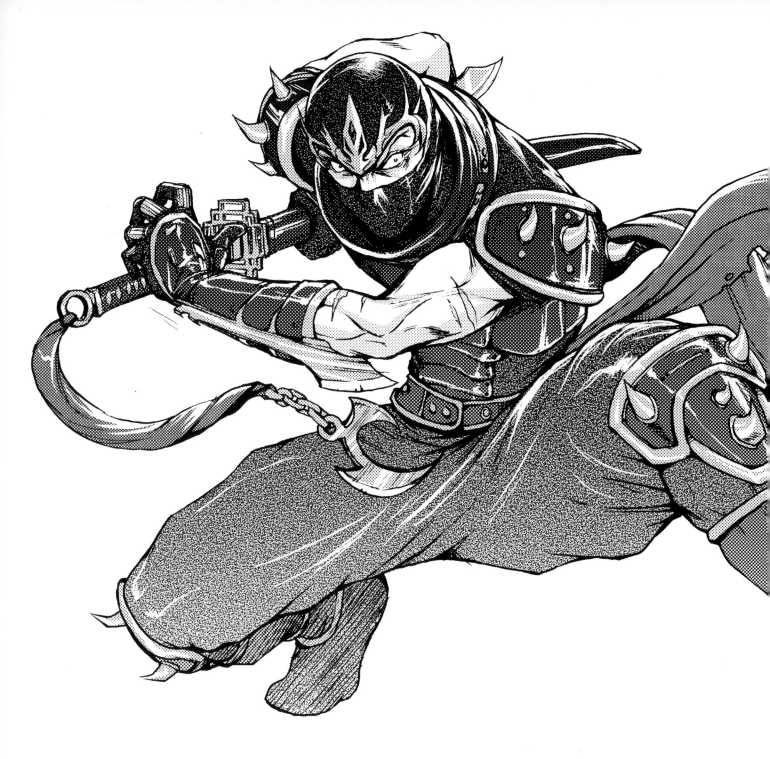

Shounen Characters

THIS EXCITING CHAPTER INTRODUCES YOU to the adventure style of manga, known as *shounen* (pronounced SHOW-nen). Shounen offers some of the most popular, and the widest variety of, characters of any category of manga. There are fighting teens (boys and girls), cool bad boys, characters with special powers, martial arts masters, and amazing monsters. There's everything you need to create power-packed manga adventures. So, strap yourself in. Here we go.

TEEN FIGHTER GIRL

She's a very popular character—pretty, youthful, and earnest, and she can knock the daylights out of the bad guys! Instead of drawing her with the delicate lines that you would see on typical shoujo characters, use loose, energetic lines when first sketching her. Because she's a teen, she should have that classic big-eye manga style. This also gives her a look of integrity. Note that her hair has lots of movement, reflecting her nonstop-action pose.

SIMPLIFIED SKELETON

If you have a problem constructing the basic body, focusing on the ultrabasic first step might help you the most. The majority of artists actually begin their sketches with something that looks like the second drawing. However, the first drawing is a great reference step, especially for beginners. It's the simplified skeleton, and it allows you to clearly see the position of the pelvis (hips) and how they are attached to the great trochanter (that big knobby joint on the upper thigh bone) and the femur (the thigh bone). It also clearly shows the position of the rib cage and of other bones. If you're confused about how to create a troublesome pose, that's the time to go back to the beginning and start with the simplified skeleton.

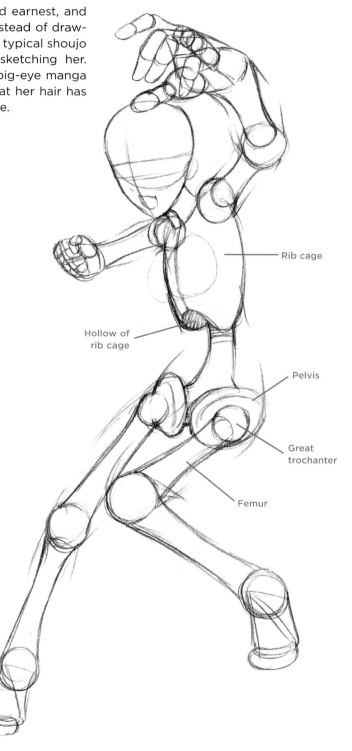

Rib cage

Hollow of
rib cage

Pelvis

Great
trochanter

Femur

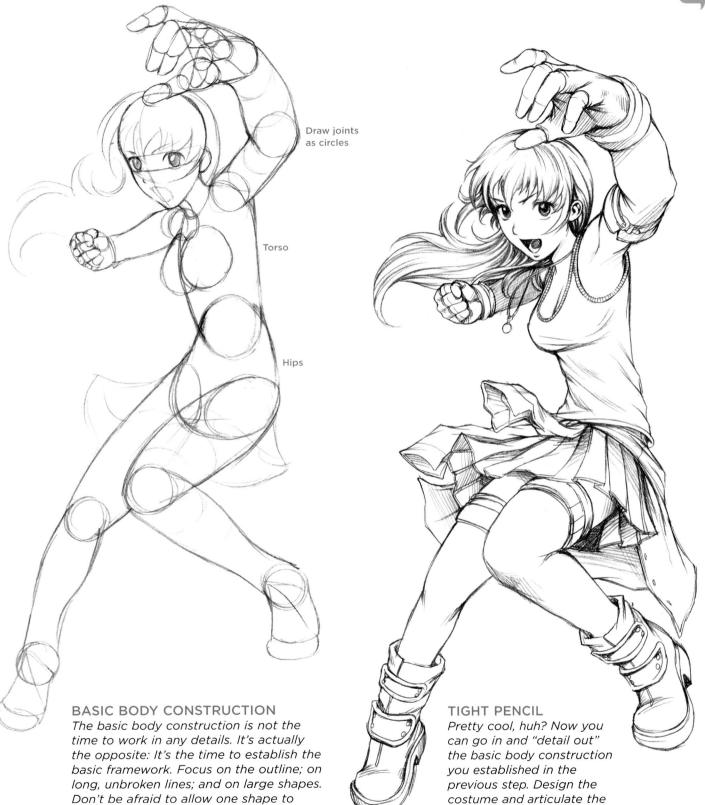

Draw joints as circles

Torso

Hips

BASIC BODY CONSTRUCTION

The basic body construction is not the time to work in any details. It's actually the opposite: It's the time to establish the basic framework. Focus on the outline; on long, unbroken lines; and on large shapes. Don't be afraid to allow one shape to overlap another like, for example, the torso and the hips here. This is the time to work out any foreshortening.

TIGHT PENCIL

Pretty cool, huh? Now you can go in and "detail out" the basic body construction you established in the previous step. Design the costume and articulate the hairstyle at this stage.

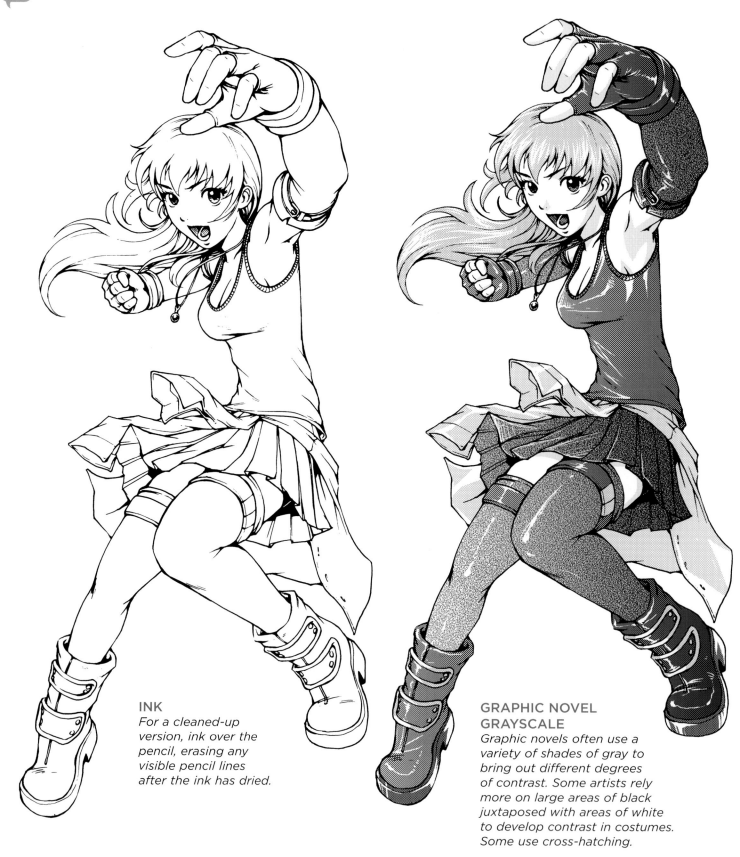

INK
For a cleaned-up version, ink over the pencil, erasing any visible pencil lines after the ink has dried.

GRAPHIC NOVEL GRAYSCALE
Graphic novels often use a variety of shades of gray to bring out different degrees of contrast. Some artists rely more on large areas of black juxtaposed with areas of white to develop contrast in costumes. Some use cross-hatching.

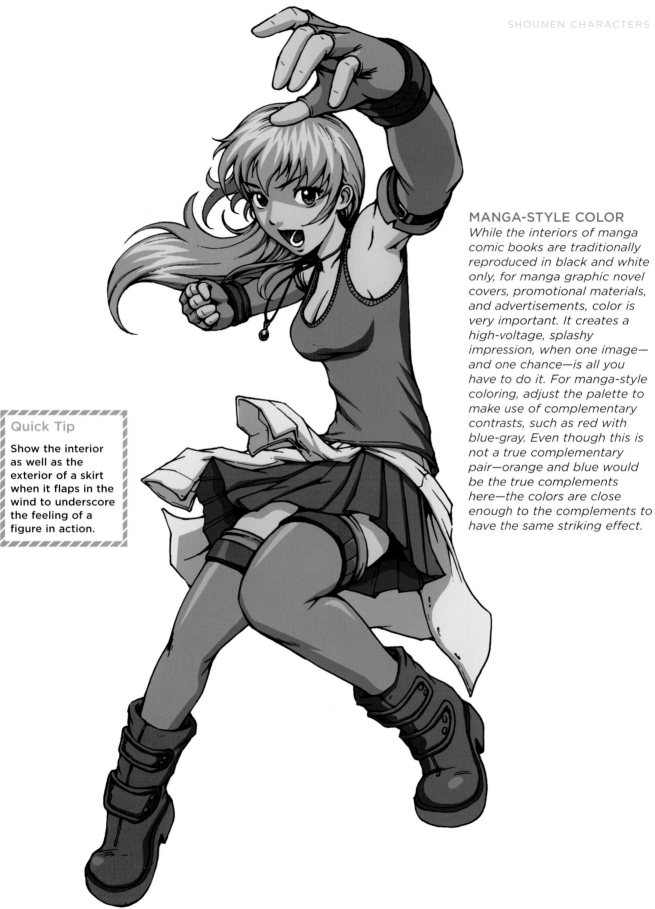

MANGA-STYLE COLOR

While the interiors of manga comic books are traditionally reproduced in black and white only, for manga graphic novel covers, promotional materials, and advertisements, color is very important. It creates a high-voltage, splashy impression, when one image—and one chance—is all you have to do it. For manga-style coloring, adjust the palette to make use of complementary contrasts, such as red with blue-gray. Even though this is not a true complementary pair—orange and blue would be the true complements here—the colors are close enough to the complements to have the same striking effect.

Quick Tip

Show the interior as well as the exterior of a skirt when it flaps in the wind to underscore the feeling of a figure in action.

CLASSIC TEEN HERO

You see this superpopular character everywhere. Readers love him. He's intense and never gives up, no matter how much danger stands in his way. Oh sure, he takes his share of hits, but he's resilient and keeps coming back. Clean-cut, nice looking, and trustworthy, you wouldn't mind if he dated your sister. Well, almost. He is, after all, still a boy.

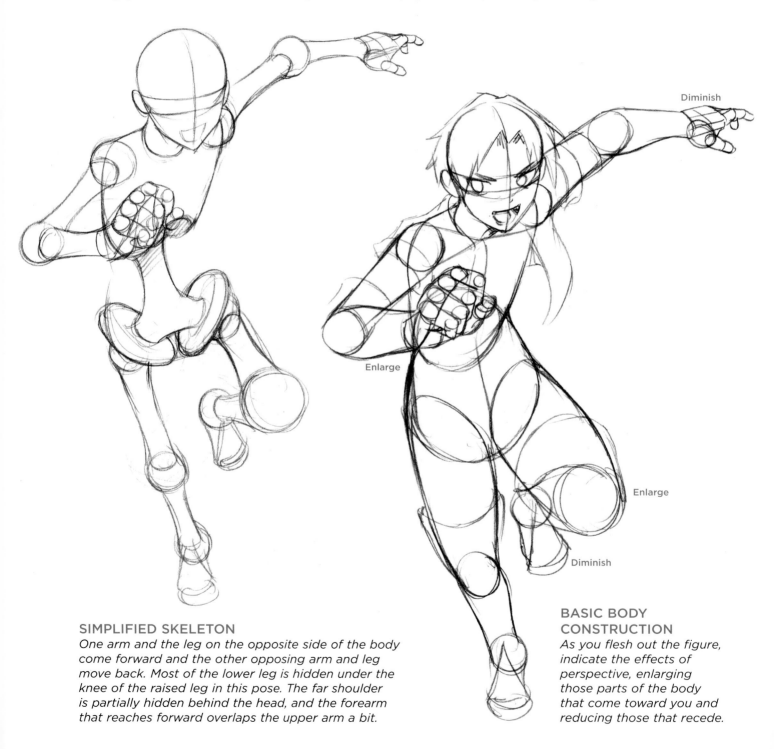

Diminish

Enlarge

Enlarge

Diminish

SIMPLIFIED SKELETON

One arm and the leg on the opposite side of the body come forward and the other opposing arm and leg move back. Most of the lower leg is hidden under the knee of the raised leg in this pose. The far shoulder is partially hidden behind the head, and the forearm that reaches forward overlaps the upper arm a bit.

BASIC BODY CONSTRUCTION

As you flesh out the figure, indicate the effects of perspective, enlarging those parts of the body that come toward you and reducing those that recede.

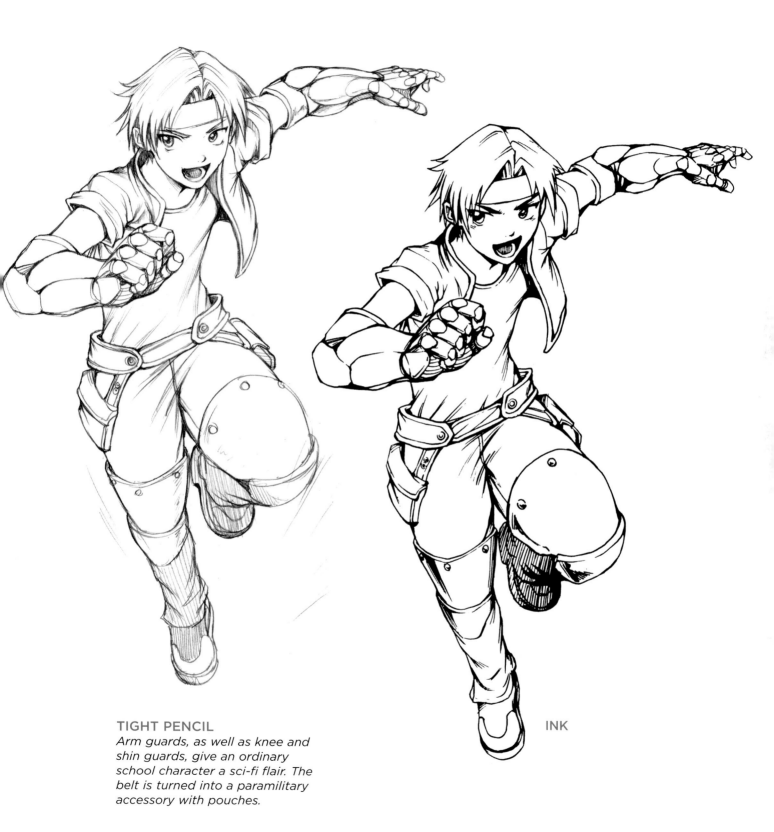

TIGHT PENCIL

Arm guards, as well as knee and shin guards, give an ordinary school character a sci-fi flair. The belt is turned into a paramilitary accessory with pouches.

INK

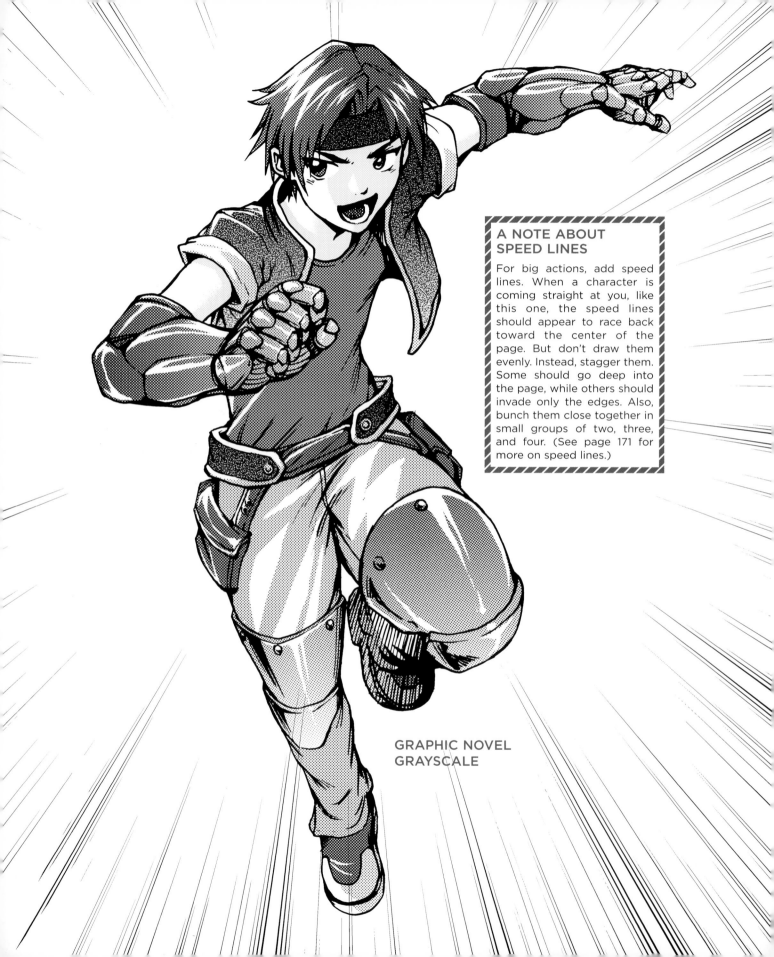

A NOTE ABOUT SPEED LINES

For big actions, add speed lines. When a character is coming straight at you, like this one, the speed lines should appear to race back toward the center of the page. But don't draw them evenly. Instead, stagger them. Some should go deep into the page, while others should invade only the edges. Also, bunch them close together in small groups of two, three, and four. (See page 171 for more on speed lines.)

GRAPHIC NOVEL
GRAYSCALE

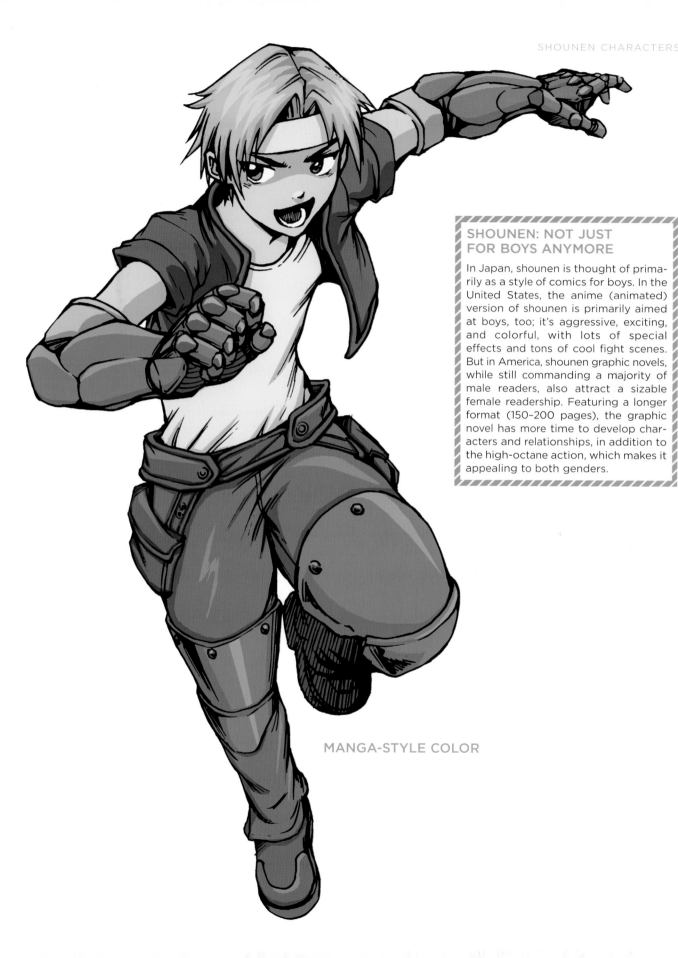

MANGA-STYLE COLOR

SHOUNEN: NOT JUST FOR BOYS ANYMORE

In Japan, shounen is thought of primarily as a style of comics for boys. In the United States, the anime (animated) version of shounen is primarily aimed at boys, too; it's aggressive, exciting, and colorful, with lots of special effects and tons of cool fight scenes. But in America, shounen graphic novels, while still commanding a majority of male readers, also attract a sizable female readership. Featuring a longer format (150–200 pages), the graphic novel has more time to develop characters and relationships, in addition to the high-octane action, which makes it appealing to both genders.

CYBERPUNK

Some girls fall for all the wrong guys. And no one is more wrong than Mr. Bad Boy. A futuristic character capable of violence, he's called a cyberpunk. Cool, charming, dangerous. Maybe he's part of a gang. Maybe he's an enemy of a gang. Either way, he loves danger. And if you're part of his life, you'd better like it, too.

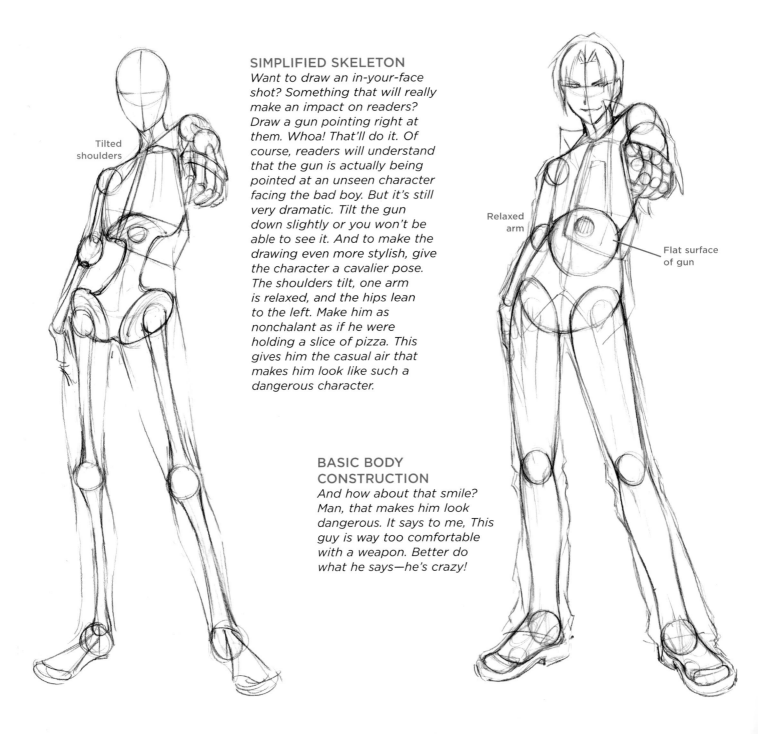

Tilted shoulders

SIMPLIFIED SKELETON

Want to draw an in-your-face shot? Something that will really make an impact on readers? Draw a gun pointing right at them. Whoa! That'll do it. Of course, readers will understand that the gun is actually being pointed at an unseen character facing the bad boy. But it's still very dramatic. Tilt the gun down slightly or you won't be able to see it. And to make the drawing even more stylish, give the character a cavalier pose. The shoulders tilt, one arm is relaxed, and the hips lean to the left. Make him as nonchalant as if he were holding a slice of pizza. This gives him the casual air that makes him look like such a dangerous character.

BASIC BODY CONSTRUCTION

And how about that smile? Man, that makes him look dangerous. It says to me, This guy is way too comfortable with a weapon. Better do what he says—he's crazy!

Relaxed arm

Flat surface of gun

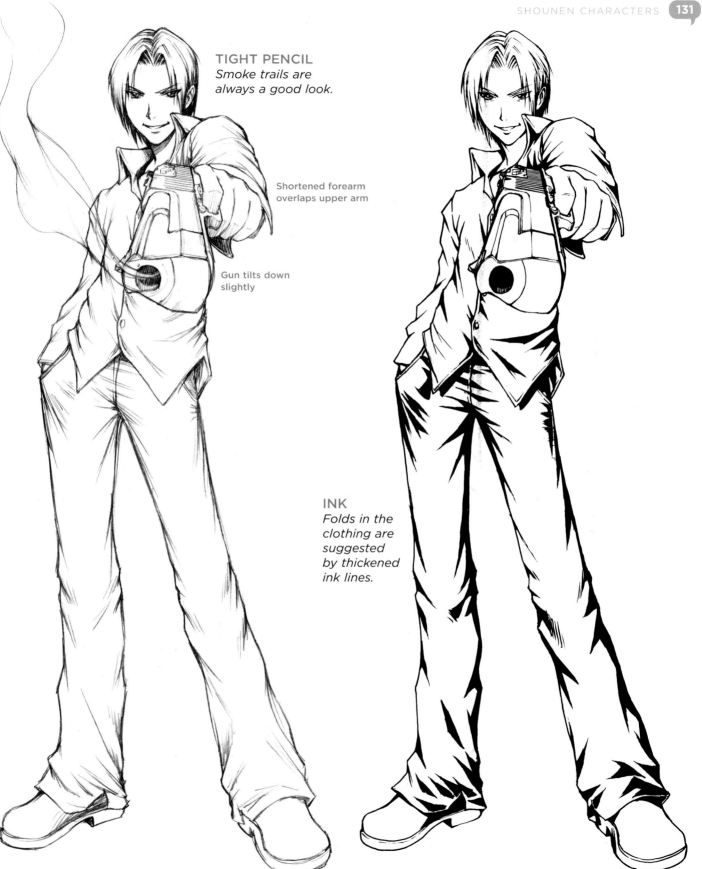

TIGHT PENCIL
Smoke trails are always a good look.

Shortened forearm overlaps upper arm

Gun tilts down slightly

INK
Folds in the clothing are suggested by thickened ink lines.

BAD-BOY EYES

This type of character always has long, thin eyebrows and long, straight hair that falls in his eyes. The eyes are never the big-eye style but are, instead, of the sleek, horizontal variety. They're elegant, with dark upper eyelids and an almost feminine touch. But don't let that deceive you; he's a red-blooded ladies' man.

Once you establish the basic eye shape . . .

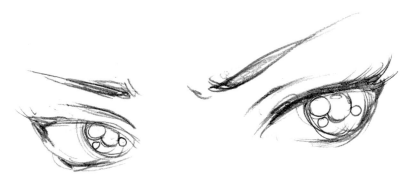

. . . determine the eye shine placement . . .

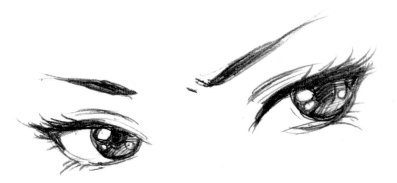

. . . and shade in the eyes more definitively.

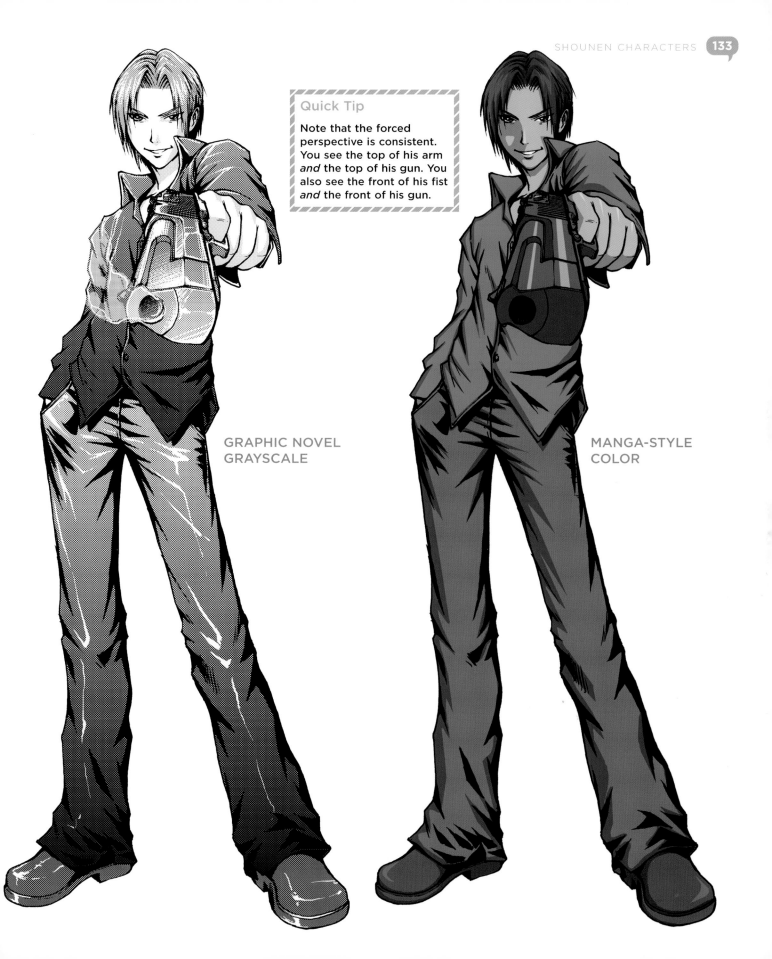

Quick Tip

Note that the forced perspective is consistent. You see the top of his arm *and* the top of his gun. You also see the front of his fist *and* the front of his gun.

GRAPHIC NOVEL
GRAYSCALE

MANGA-STYLE
COLOR

MAGICAL FIGHTER

This powerful character has the ability to unleash his magical forces to combat evil. A tall, slender figure with long hair and a billowing garment, this is a mysterious character who can command forces beyond our understanding. He often battles nefarious creatures, beings with their own dark magic. These exciting, action-packed stories are filled with fantasy and mayhem and are some of the most dynamic in the entire shounen genre.

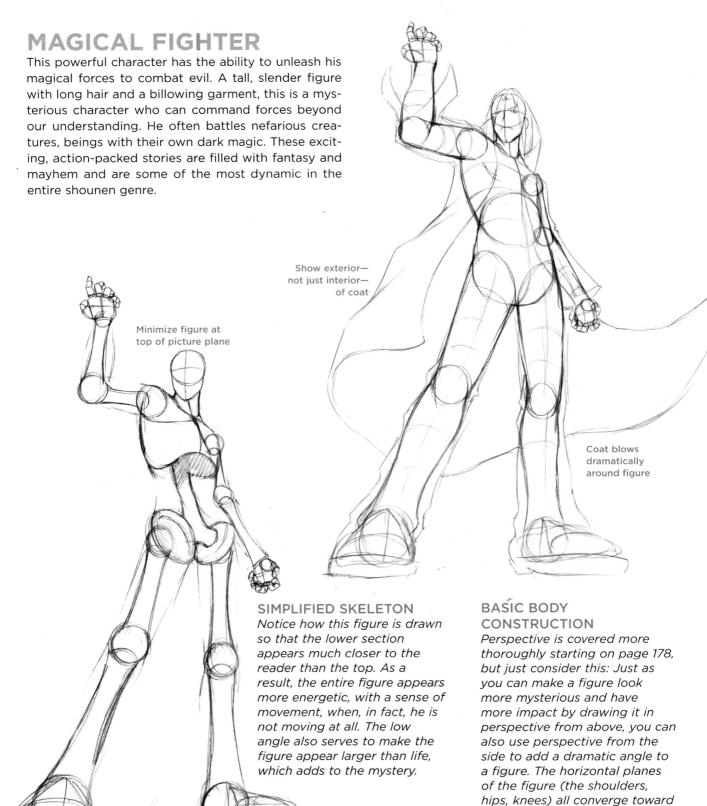

Minimize figure at top of picture plane

Show exterior— not just interior— of coat

Coat blows dramatically around figure

Enlarge figure at bottom of picture plane

SIMPLIFIED SKELETON

Notice how this figure is drawn so that the lower section appears much closer to the reader than the top. As a result, the entire figure appears more energetic, with a sense of movement, when, in fact, he is not moving at all. The low angle also serves to make the figure appear larger than life, which adds to the mystery.

BASIC BODY CONSTRUCTION

Perspective is covered more thoroughly starting on page 178, but just consider this: Just as you can make a figure look more mysterious and have more impact by drawing it in perspective from above, you can also use perspective from the side to add a dramatic angle to a figure. The horizontal planes of the figure (the shoulders, hips, knees) all converge toward a vanishing point on the right.

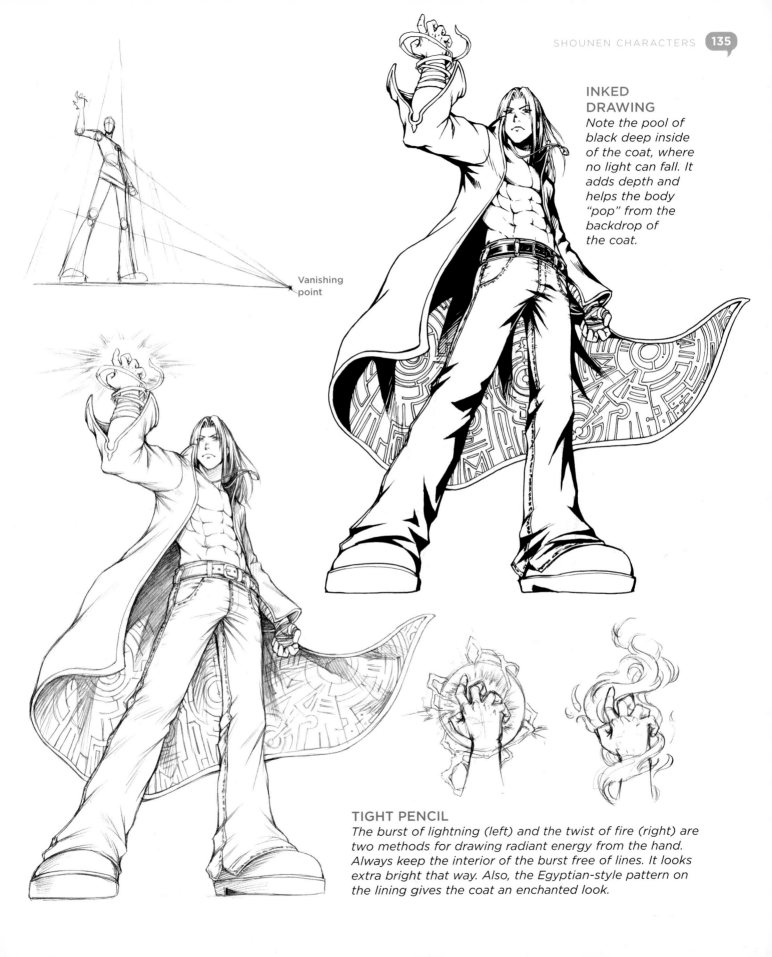

Vanishing point

INKED DRAWING

Note the pool of black deep inside of the coat, where no light can fall. It adds depth and helps the body "pop" from the backdrop of the coat.

TIGHT PENCIL

The burst of lightning (left) and the twist of fire (right) are two methods for drawing radiant energy from the hand. Always keep the interior of the burst free of lines. It looks extra bright that way. Also, the Egyptian-style pattern on the lining gives the coat an enchanted look.

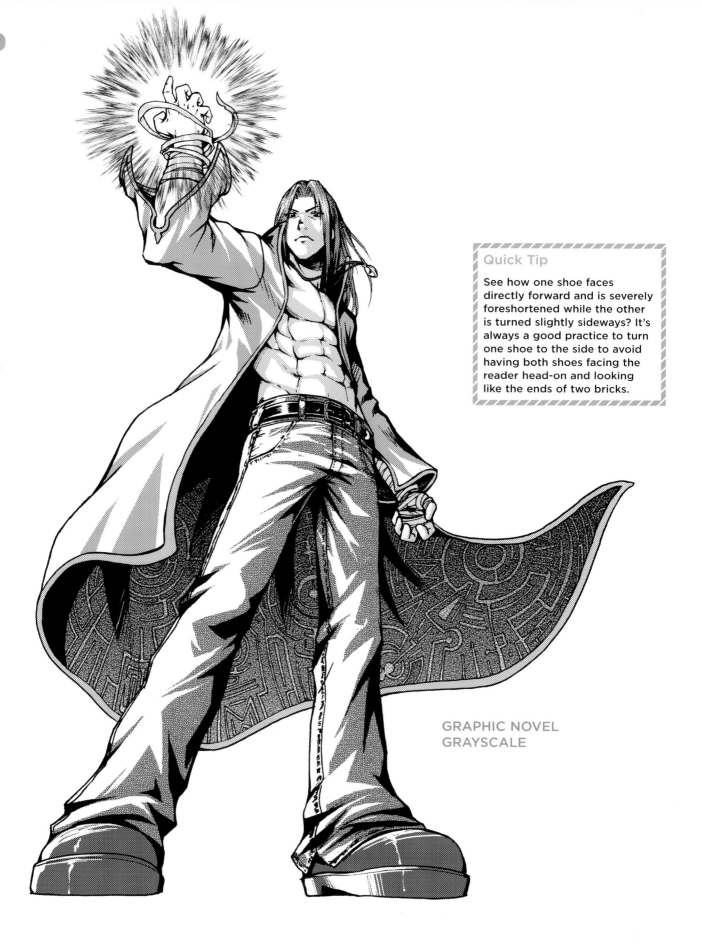

Quick Tip

See how one shoe faces directly forward and is severely foreshortened while the other is turned slightly sideways? It's always a good practice to turn one shoe to the side to avoid having both shoes facing the reader head-on and looking like the ends of two bricks.

GRAPHIC NOVEL
GRAYSCALE

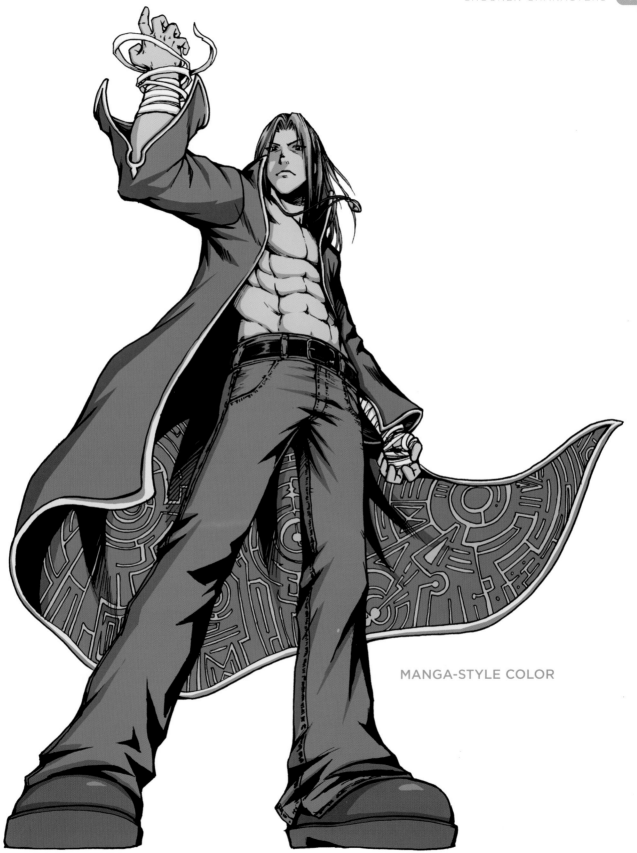

MANGA-STYLE COLOR

FANTASY FIGHTER

Not a magical girl type, this fantasy fighter is more mature; she's in her upper teens or early twenties. She's not a pretty little girl with the big eyes, but a *bishoujo*—a beautiful girl, and one who is also strong.

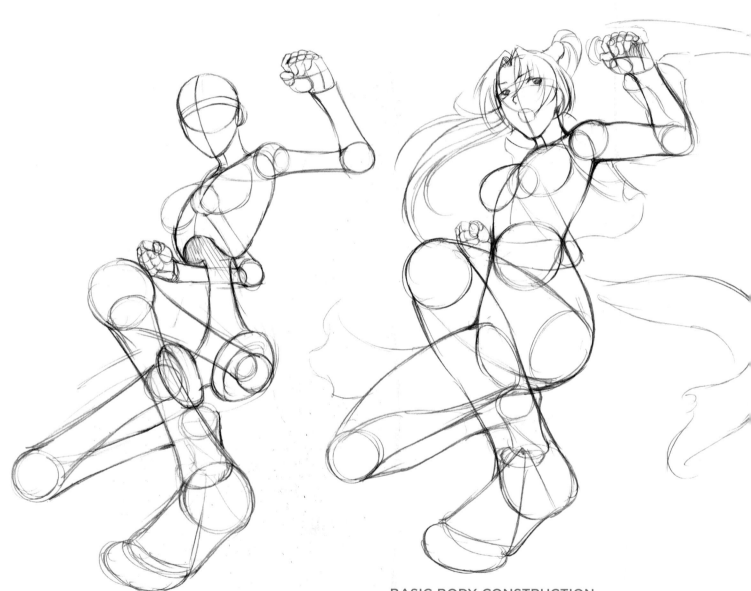

SIMPLIFIED SKELETON
In a pose like this, where so much of the legs and hips are hidden from view and being overlapped by other parts of the body, it helps to look at the simplified skeleton to clearly see how everything is connected.

BASIC BODY CONSTRUCTION
Lightly sketch in the back arm to help you get the correct placement for the far fist.

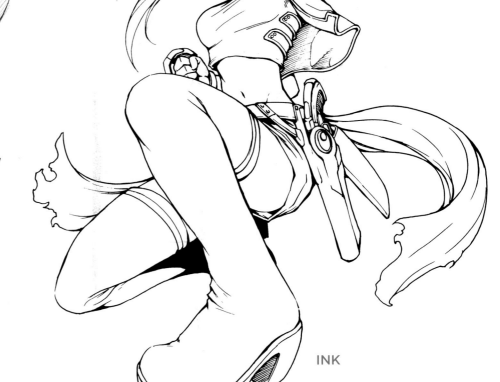

Quick Tip

Anything loose—hair, jacket, sash—should be aloft in the breeze. What breeze, you ask? Hey, if it's an action scene, there's always a breeze!

TIGHT PENCIL

If she's a fantasy character, her blade is going to require a bit of special treatment and finesse. It can't look like a kitchen knife used for carving the Thanksgiving turkey. Add a cool handle and a few extra planes on the blade.

INK

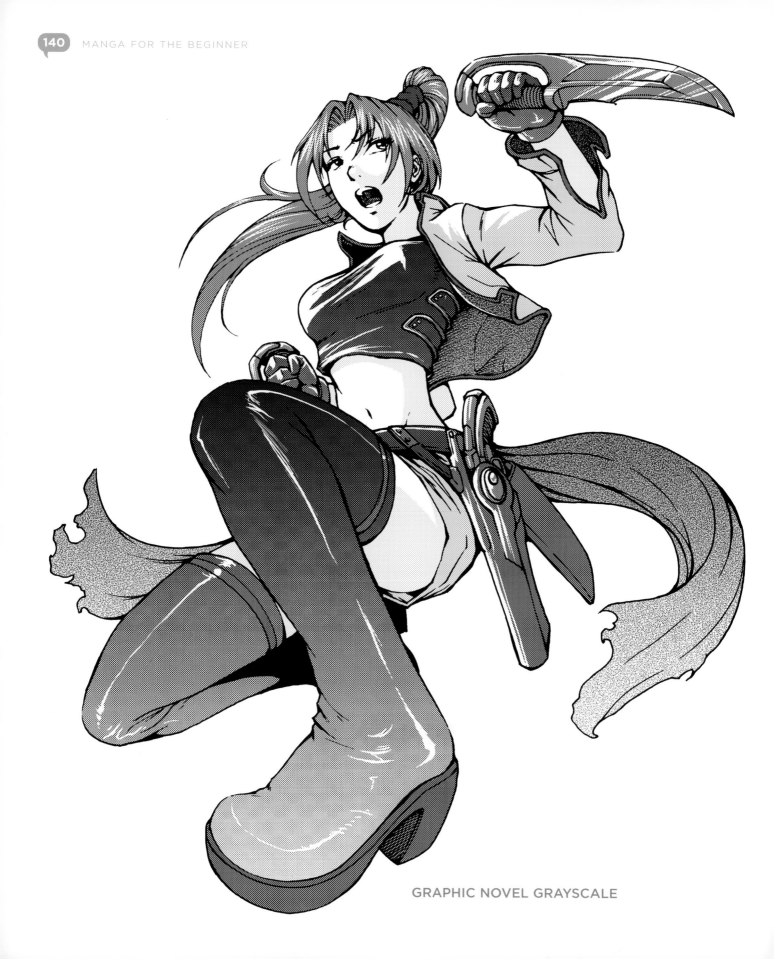

GRAPHIC NOVEL GRAYSCALE

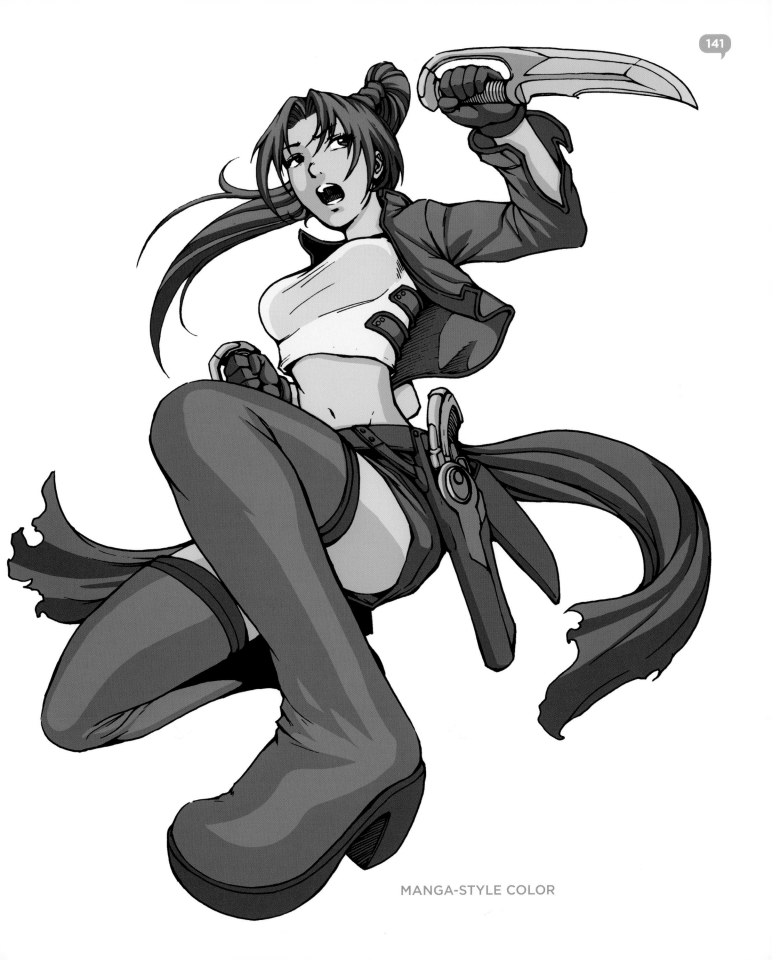

MANGA-STYLE COLOR

MARTIAL ARTS MASTER

The martial arts cover a wide range of fighting types. Let's kick off this section with a group of freestyle fighters. There's something extra cool about these warriors who trained in the ancient arts of combat. Their moves, poses, outfits, and weapons really outdo everyone else's. It's like pulling up beside a four-door hybrid in your Dodge Viper. The race is over before the light even turns green. Not that there's anything wrong with driving a hybrid. Getting 42 mpg is just as impressive as going zero to sixty in under five seconds. It sure is.

Anyway, let's start with the traditional martial arts master. The old saying is that a smaller man who's a black belt can beat a bigger man who doesn't know karate. But when the bigger man also knows karate... um ... you're in trouble. And the martial arts experts in manga are no slouches. They all look like they've been genetically engineered for maximum power.

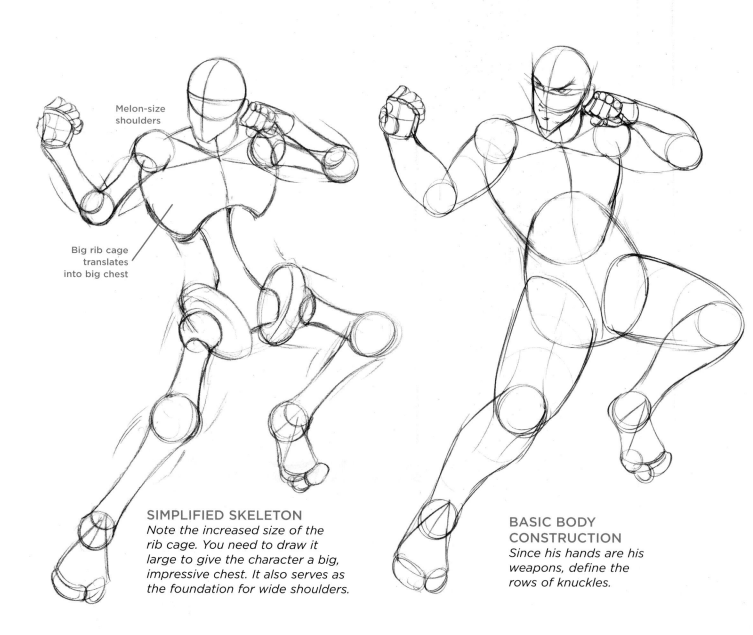

Melon-size shoulders

Big rib cage translates into big chest

SIMPLIFIED SKELETON
Note the increased size of the rib cage. You need to draw it large to give the character a big, impressive chest. It also serves as the foundation for wide shoulders.

BASIC BODY CONSTRUCTION
Since his hands are his weapons, define the rows of knuckles.

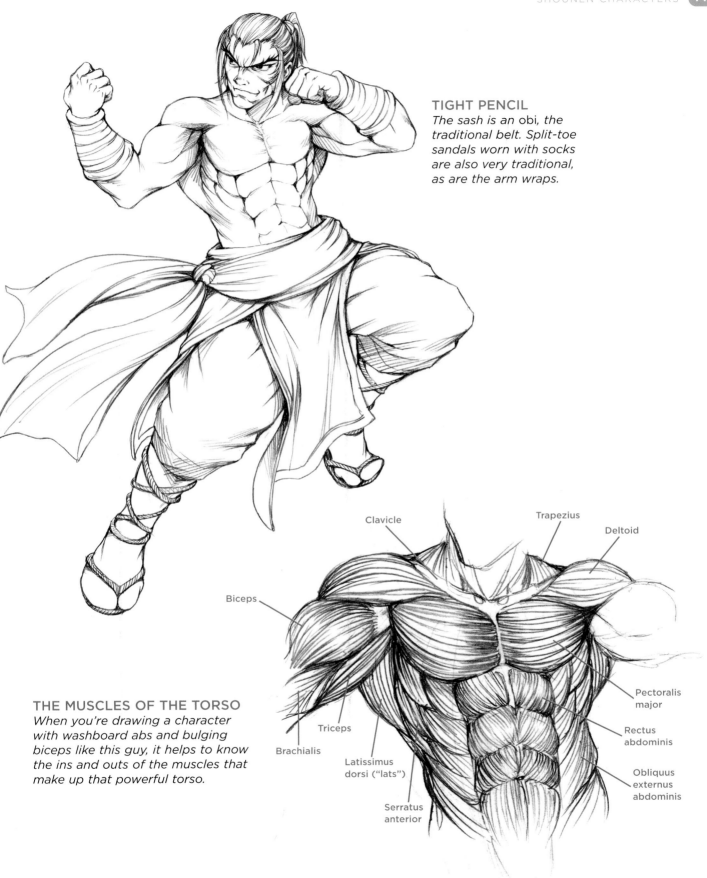

TIGHT PENCIL
The sash is an obi, the traditional belt. Split-toe sandals worn with socks are also very traditional, as are the arm wraps.

Clavicle

Trapezius

Deltoid

Biceps

Pectoralis major

Triceps

Rectus abdominis

Brachialis

Obliquus externus abdominis

Latissimus dorsi ("lats")

Serratus anterior

THE MUSCLES OF THE TORSO
When you're drawing a character with washboard abs and bulging biceps like this guy, it helps to know the ins and outs of the muscles that make up that powerful torso.

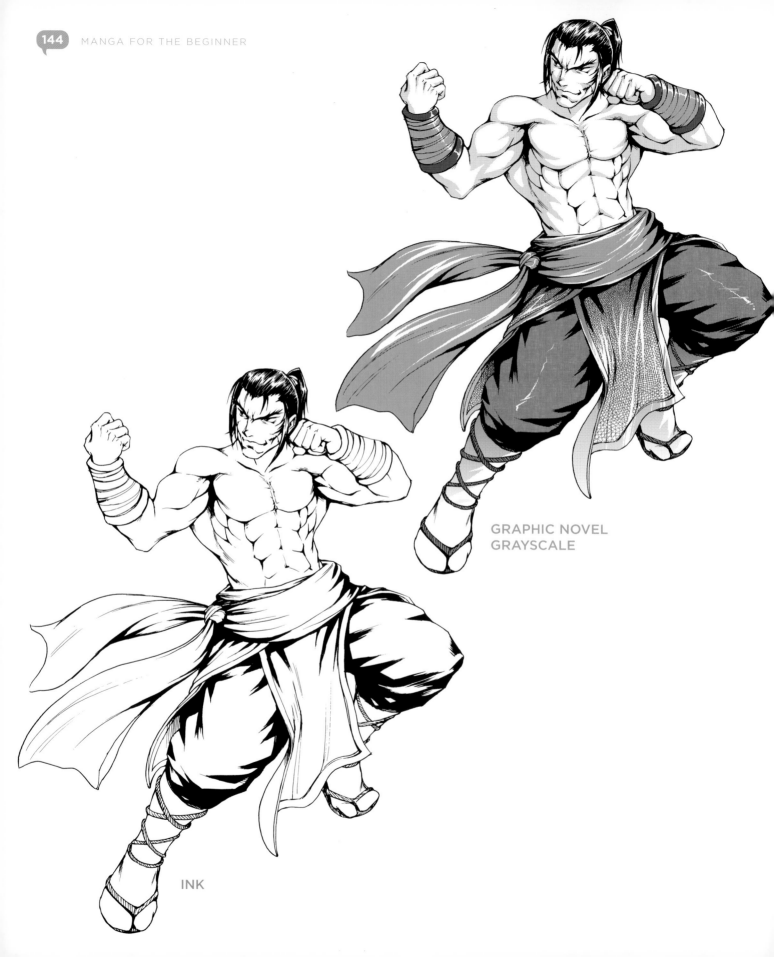

GRAPHIC NOVEL
GRAYSCALE

INK

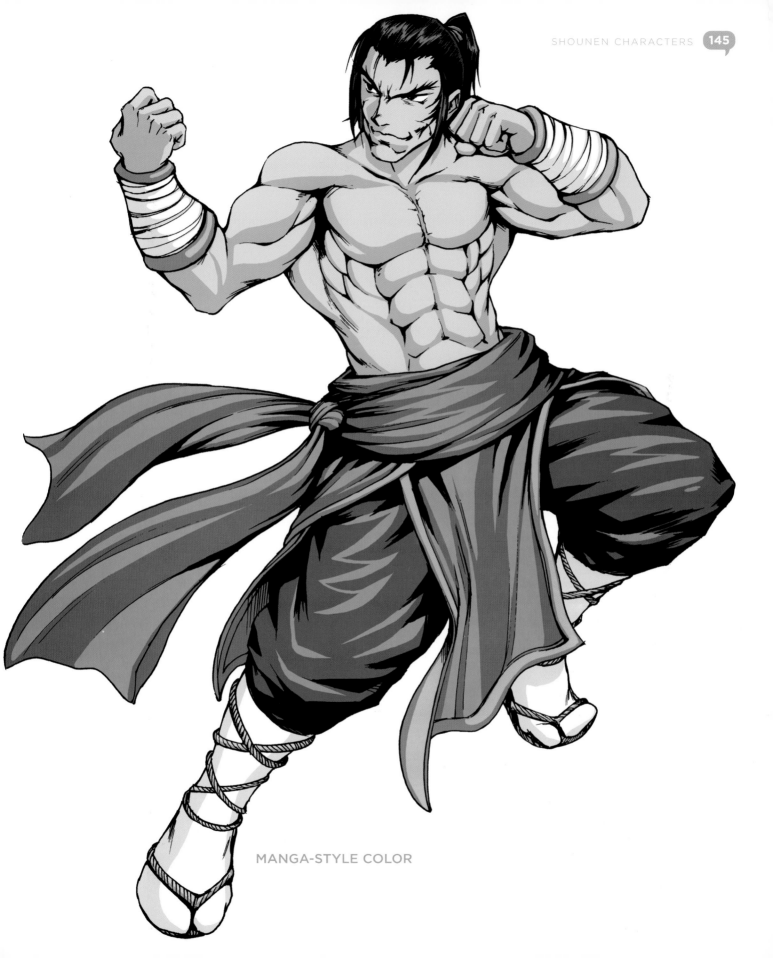

MANGA-STYLE COLOR

THE NINJA: MASTER OF NINJITSU

Ninjitsu is a type of martial arts used by the ninja. The word *ninjitsu* translates to the art of stealth. I sure could have used those skills in high school. With the art of stealth, I could have snuck past the boys' dean, cut class, and made it up to the cafeteria unnoticed. But then, I think of all the algebra classes I would have missed and all the enrichment I would have deprived myself of. . . . Man, I wish I had studied ninjitsu!

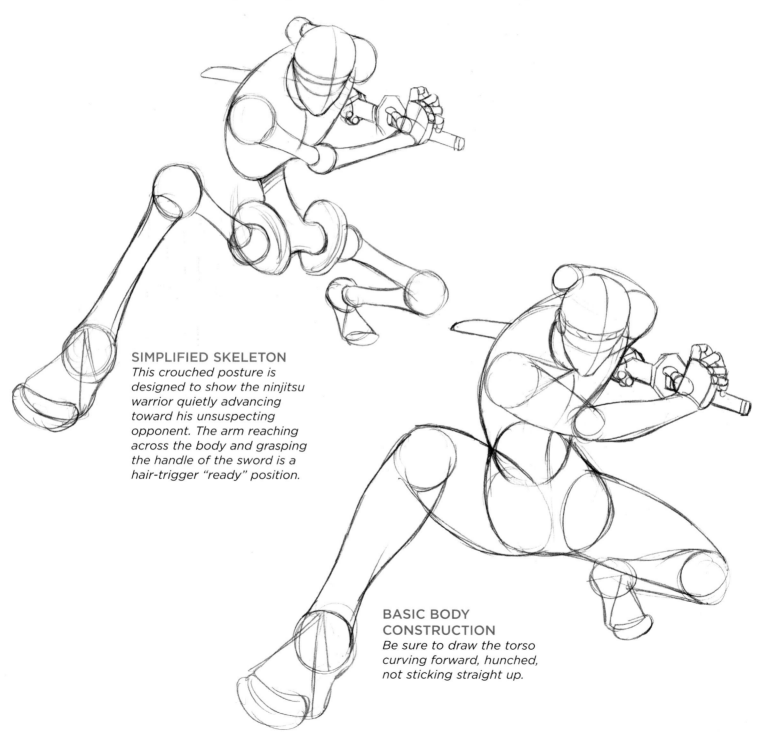

SIMPLIFIED SKELETON
This crouched posture is designed to show the ninjitsu warrior quietly advancing toward his unsuspecting opponent. The arm reaching across the body and grasping the handle of the sword is a hair-trigger "ready" position.

BASIC BODY CONSTRUCTION
Be sure to draw the torso curving forward, hunched, not sticking straight up.

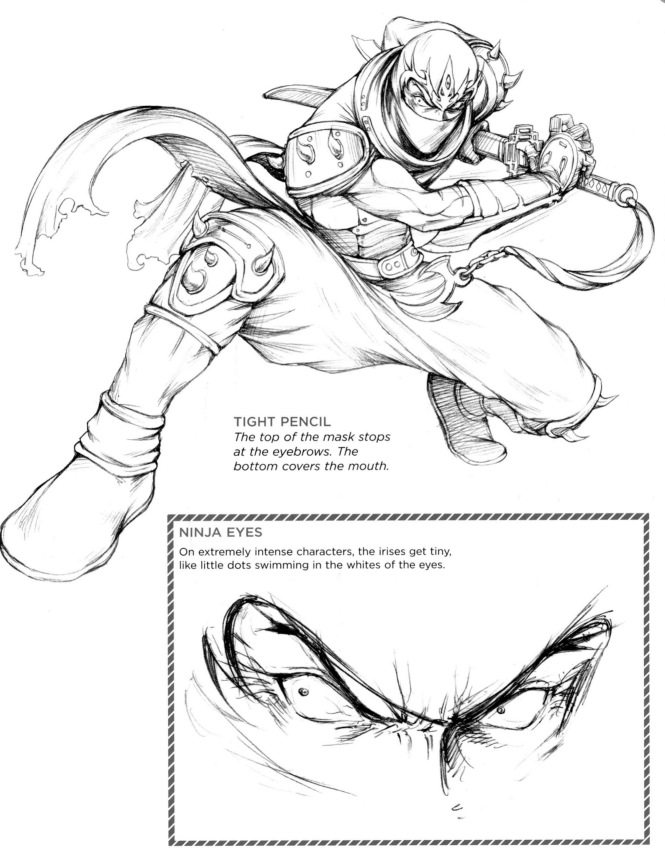

TIGHT PENCIL
The top of the mask stops at the eyebrows. The bottom covers the mouth.

NINJA EYES

On extremely intense characters, the irises get tiny, like little dots swimming in the whites of the eyes.

INK

GRAPHIC NOVEL
GRAYSCALE

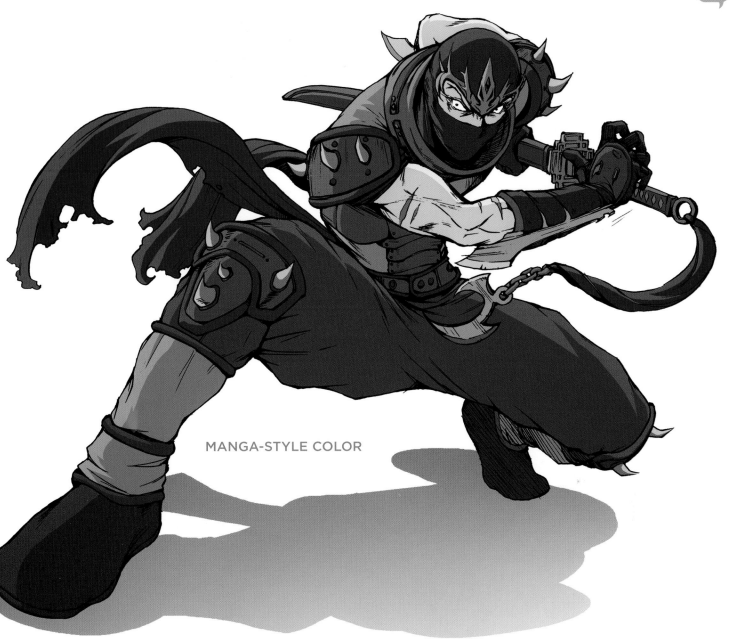

MANGA-STYLE COLOR

CUSTOMIZING TRADITIONAL COSTUMES, MANGA STYLE!

A classic ninja costume is basically all black—and pretty plain, too. But we like our manga characters—especially our bad guys—flashy. Readers like 'em that way, too. It captures the imagination and gives the characters star quality. So, the only thing that's really authentic about this ninja is that he has an open face mask, a long blade, and cloth boots (although even that is a stretch, as real ninja boots have split toes). The rest is customized to add dramatic impact. Feel free to adjust any character's costume to give it that manga look.

KUNG FU GRAND MASTER

This guy isn't spending his nights playing bingo at the local community center. In fact, if you want to learn the most closely guarded secrets of martial arts— including the Dim Mak, the notorious Death Touch—you come to him, but he will impart this knowledge to only his most trusted students.

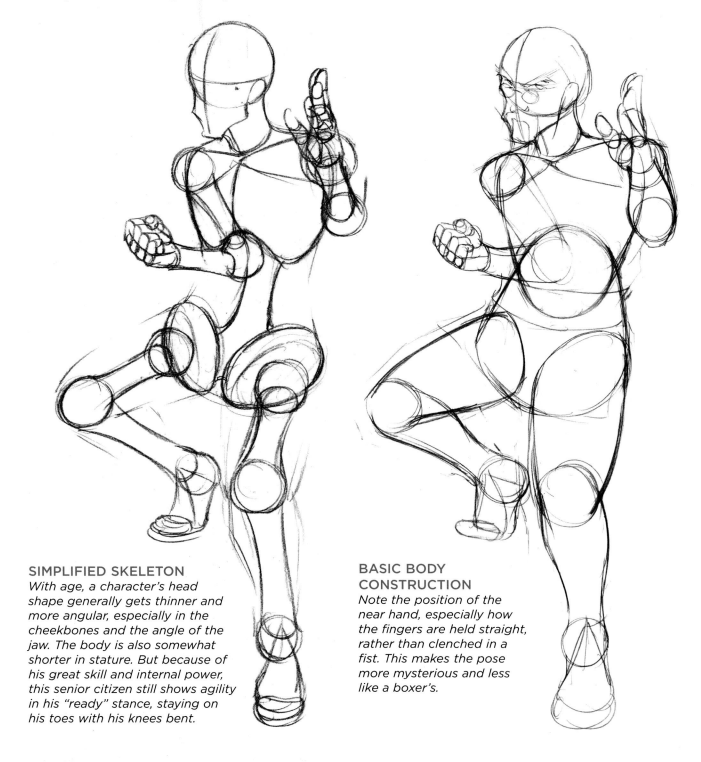

SIMPLIFIED SKELETON
With age, a character's head shape generally gets thinner and more angular, especially in the cheekbones and the angle of the jaw. The body is also somewhat shorter in stature. But because of his great skill and internal power, this senior citizen still shows agility in his "ready" stance, staying on his toes with his knees bent.

BASIC BODY CONSTRUCTION
Note the position of the near hand, especially how the fingers are held straight, rather than clenched in a fist. This makes the pose more mysterious and less like a boxer's.

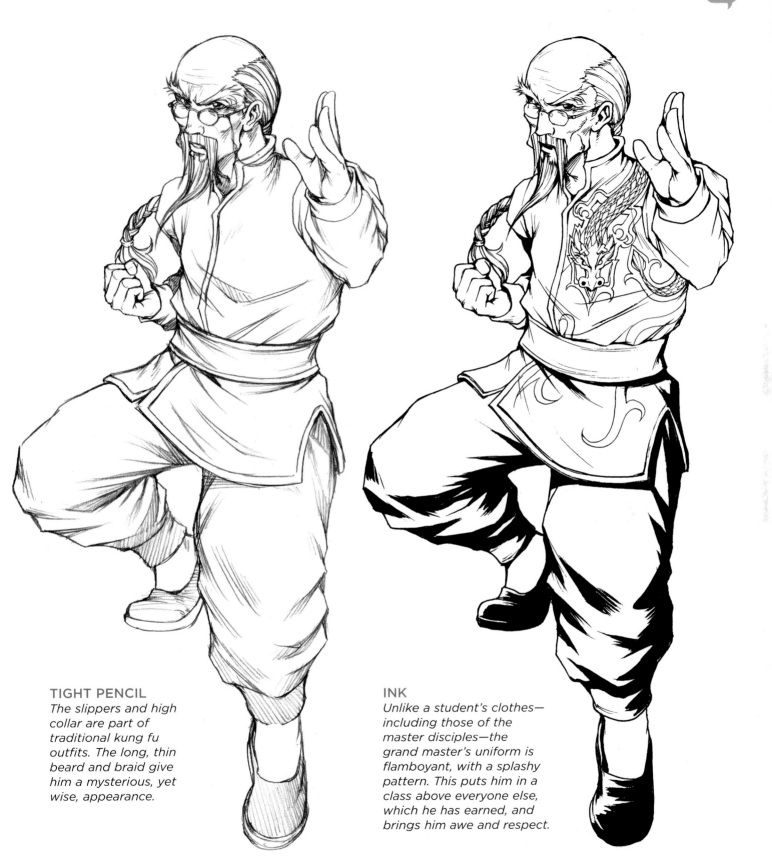

TIGHT PENCIL
The slippers and high collar are part of traditional kung fu outfits. The long, thin beard and braid give him a mysterious, yet wise, appearance.

INK
Unlike a student's clothes—including those of the master disciples—the grand master's uniform is flamboyant, with a splashy pattern. This puts him in a class above everyone else, which he has earned, and brings him awe and respect.

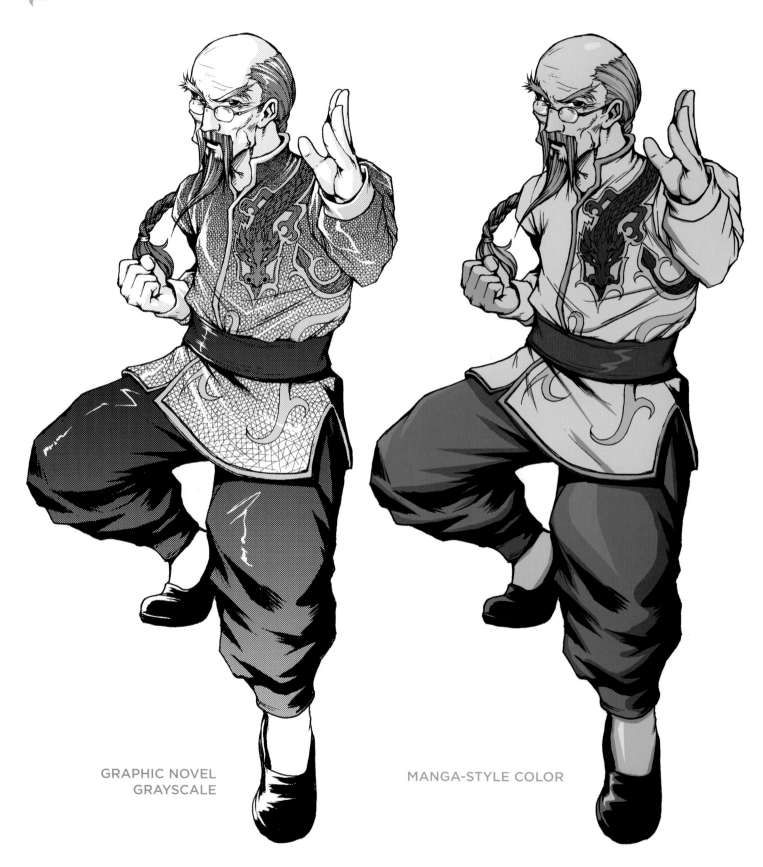

GRAPHIC NOVEL
GRAYSCALE

MANGA-STYLE COLOR

SPIDER MONSTER

When bad guys and criminals just aren't destructive enough, it's time to bring in the big boys: the mutants. These overgrown marauders of manga have but one thing on their agenda: total annihilation. Manga monsters can be based on insects, mythical creatures, animals, beasts, or even robots. But they've got to be large and creepy. There's only one way to deal with this type of enemy: Wipe it out in a hurry.

The spider monster is too big to spray. Maybe a flamethrower would do the trick? What's great about this character is that he's so darn gleeful about being evil! But don't be afraid; he's not laughing at you, he's laughing *with* you.

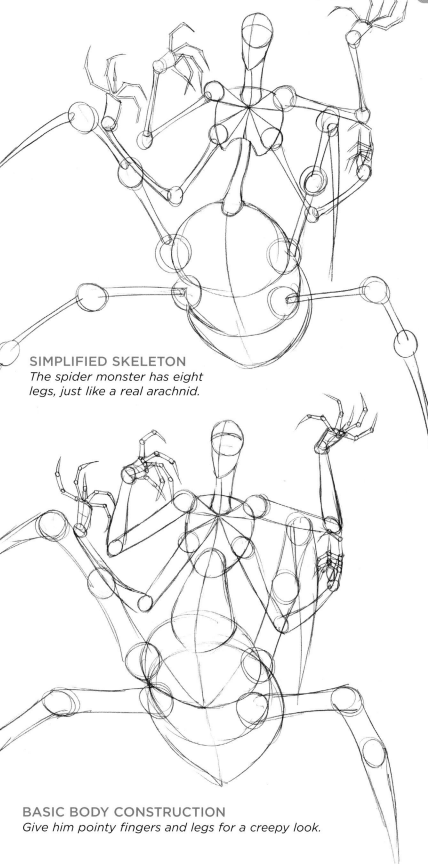

SIMPLIFIED SKELETON
The spider monster has eight legs, just like a real arachnid.

BASIC BODY CONSTRUCTION
Give him pointy fingers and legs for a creepy look.

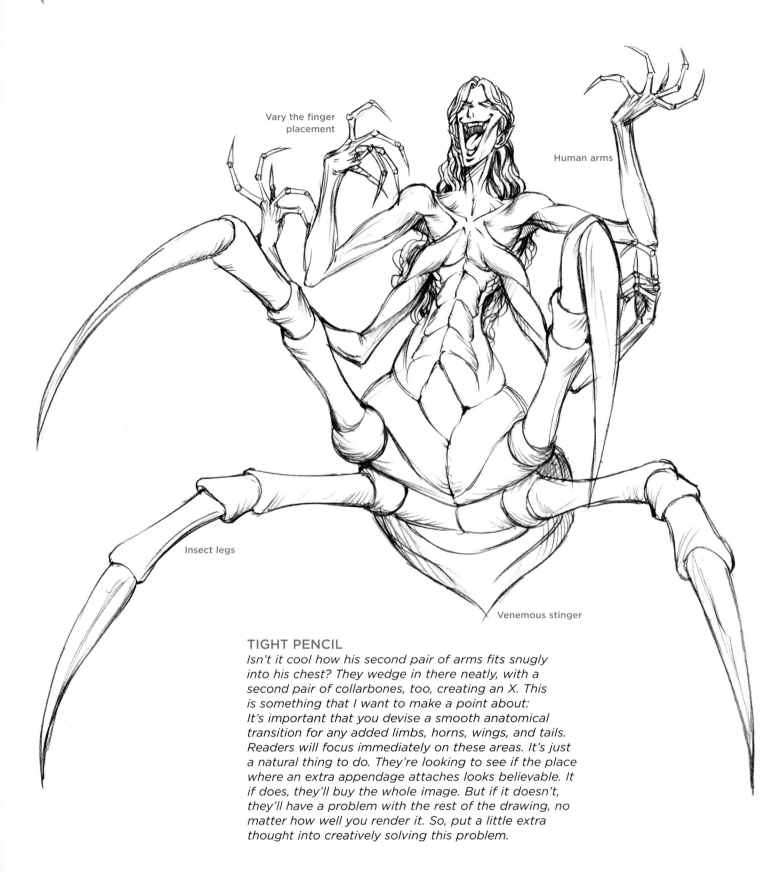

Vary the finger placement

Human arms

Insect legs

Venemous stinger

TIGHT PENCIL

Isn't it cool how his second pair of arms fits snugly into his chest? They wedge in there neatly, with a second pair of collarbones, too, creating an X. This is something that I want to make a point about: It's important that you devise a smooth anatomical transition for any added limbs, horns, wings, and tails. Readers will focus immediately on these areas. It's just a natural thing to do. They're looking to see if the place where an extra appendage attaches looks believable. It if does, they'll buy the whole image. But if it doesn't, they'll have a problem with the rest of the drawing, no matter how well you render it. So, put a little extra thought into creatively solving this problem.

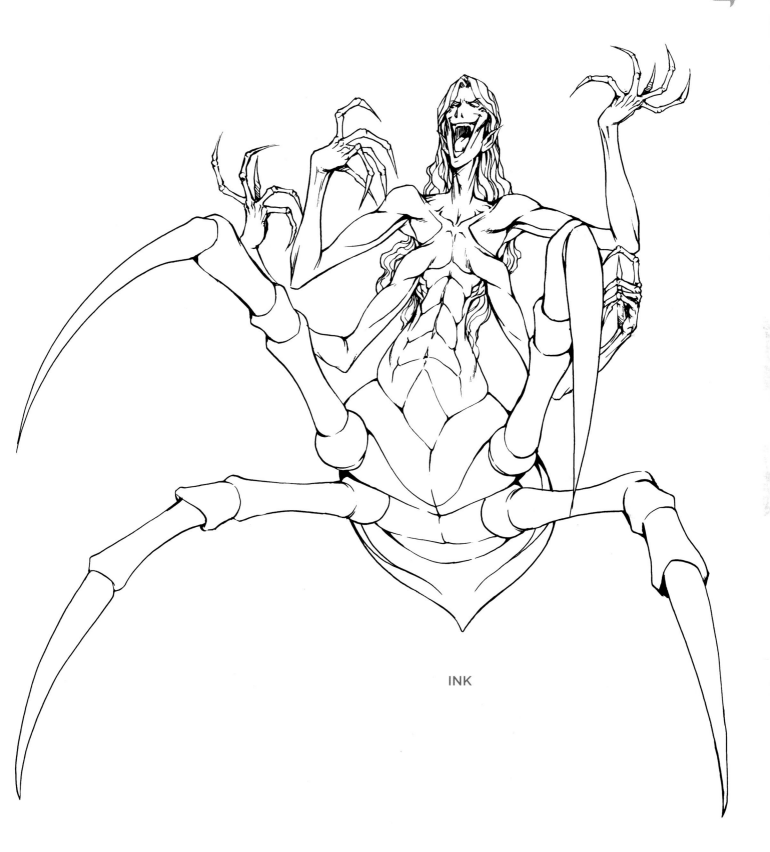

INK

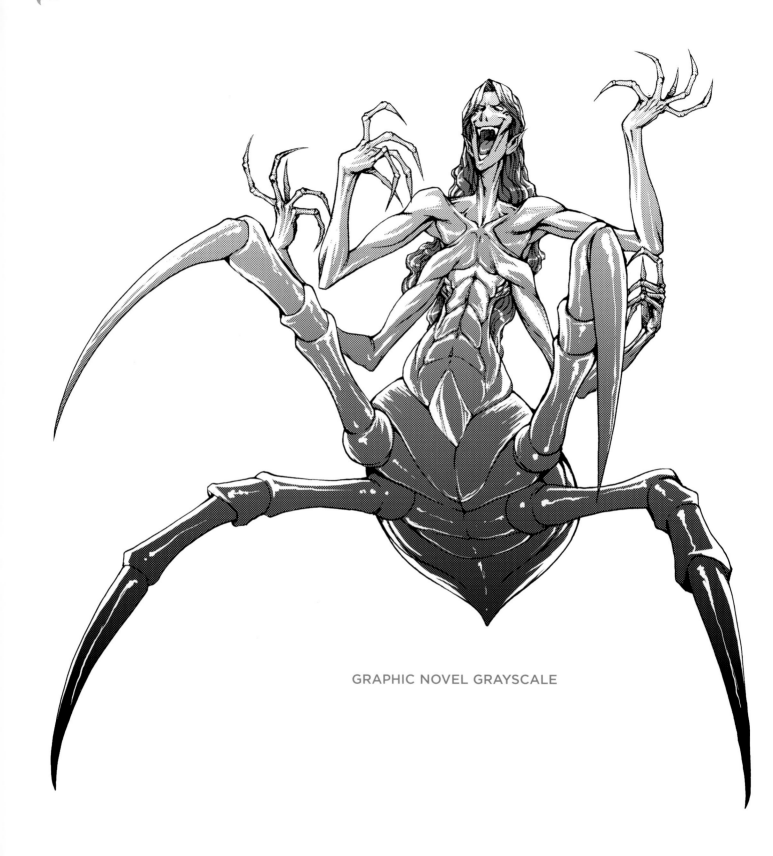

GRAPHIC NOVEL GRAYSCALE

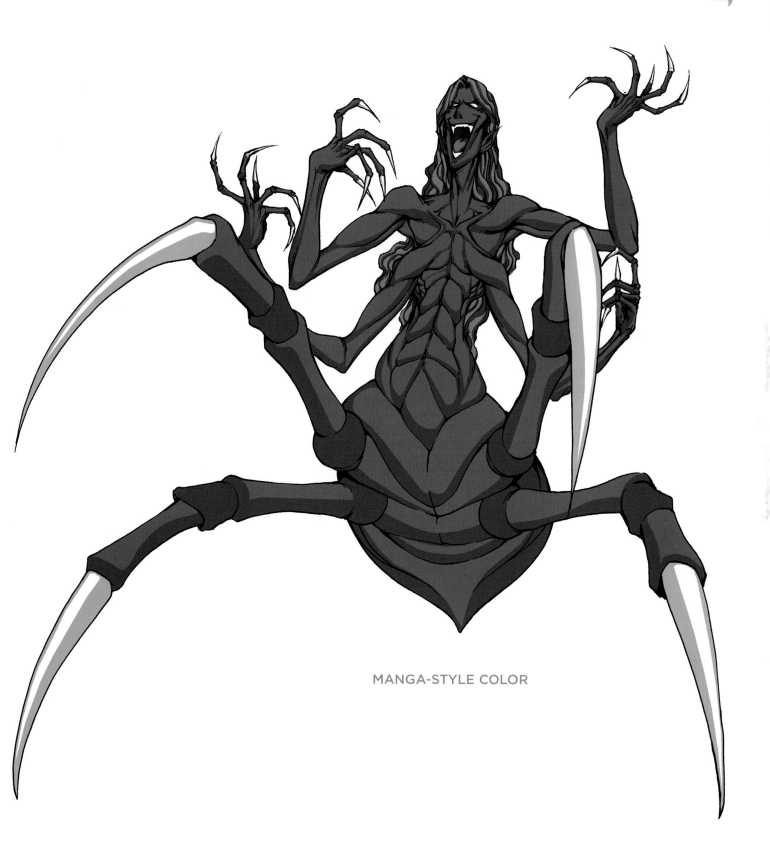

MANGA-STYLE COLOR

MANSECT

What a difference posture makes. Drawn to mimic the configuration of a crab, or perhaps an insect, this guy is as weird as they come. With the face of a demon, elongated arms and legs, and various spikes, this is one scary dude. He could live in the dark crevices of caves. Weary travelers who are lost and looking for shelter might choose such a cave, not realizing the danger that awaits them when they put out the campfire at night.

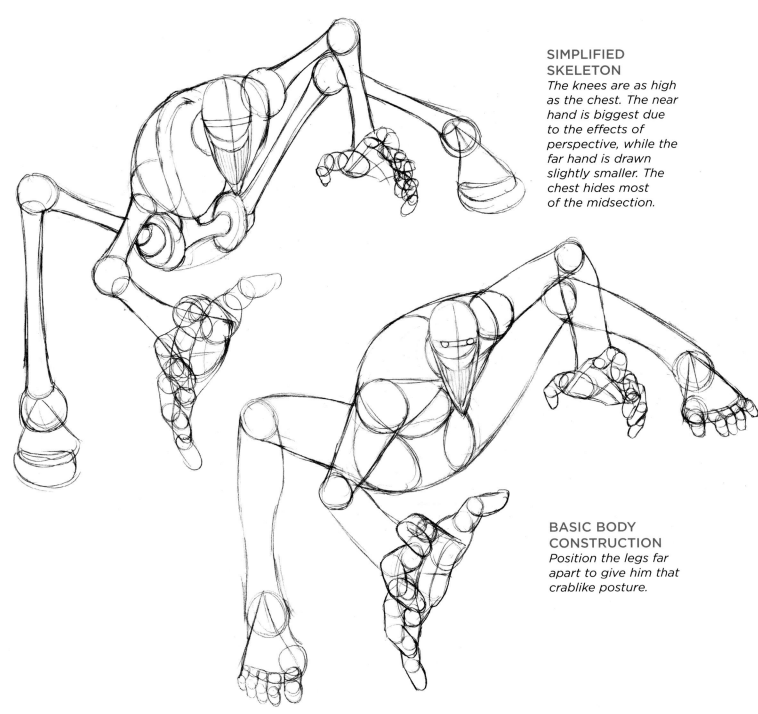

SIMPLIFIED SKELETON
The knees are as high as the chest. The near hand is biggest due to the effects of perspective, while the far hand is drawn slightly smaller. The chest hides most of the midsection.

BASIC BODY CONSTRUCTION
Position the legs far apart to give him that crablike posture.

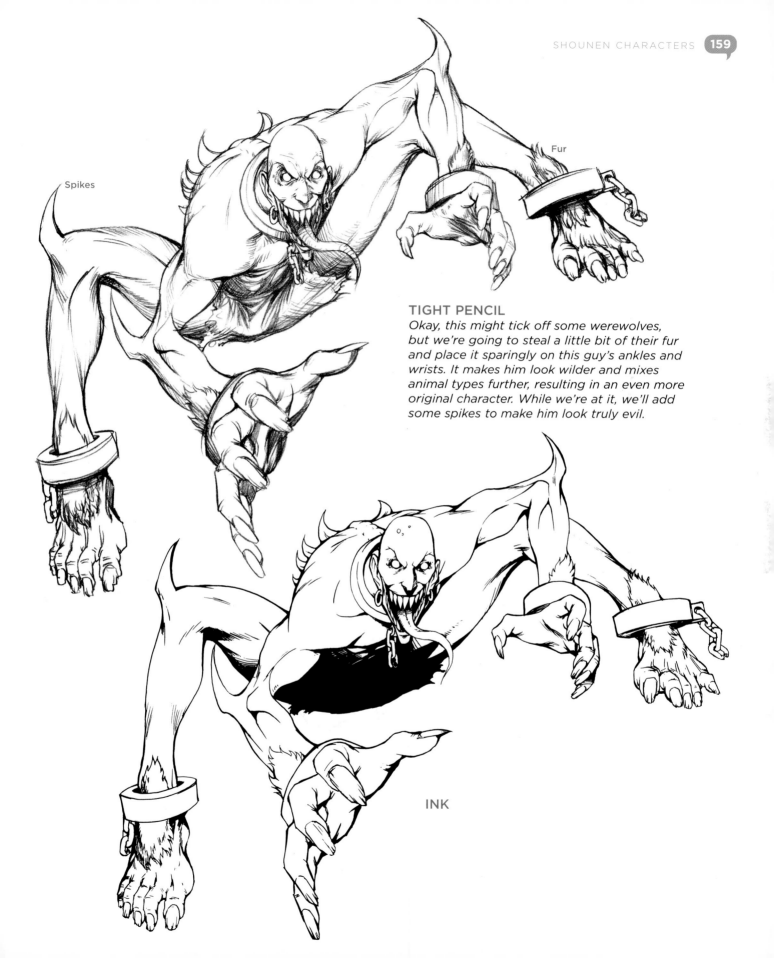

Spikes

Fur

TIGHT PENCIL

Okay, this might tick off some werewolves, but we're going to steal a little bit of their fur and place it sparingly on this guy's ankles and wrists. It makes him look wilder and mixes animal types further, resulting in an even more original character. While we're at it, we'll add some spikes to make him look truly evil.

INK

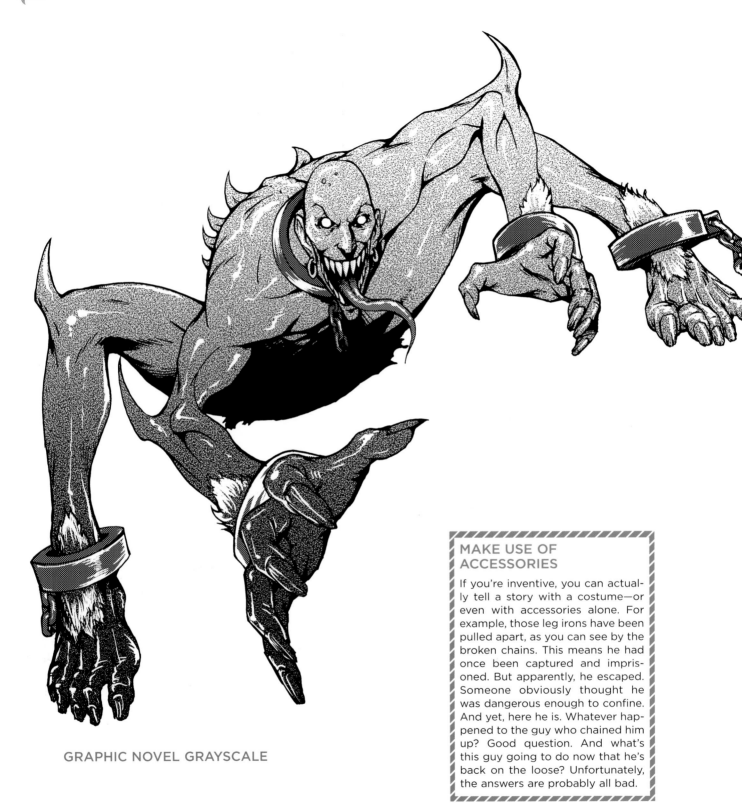

GRAPHIC NOVEL GRAYSCALE

MAKE USE OF ACCESSORIES

If you're inventive, you can actually tell a story with a costume—or even with accessories alone. For example, those leg irons have been pulled apart, as you can see by the broken chains. This means he had once been captured and imprisoned. But apparently, he escaped. Someone obviously thought he was dangerous enough to confine. And yet, here he is. Whatever happened to the guy who chained him up? Good question. And what's this guy going to do now that he's back on the loose? Unfortunately, the answers are probably all bad.

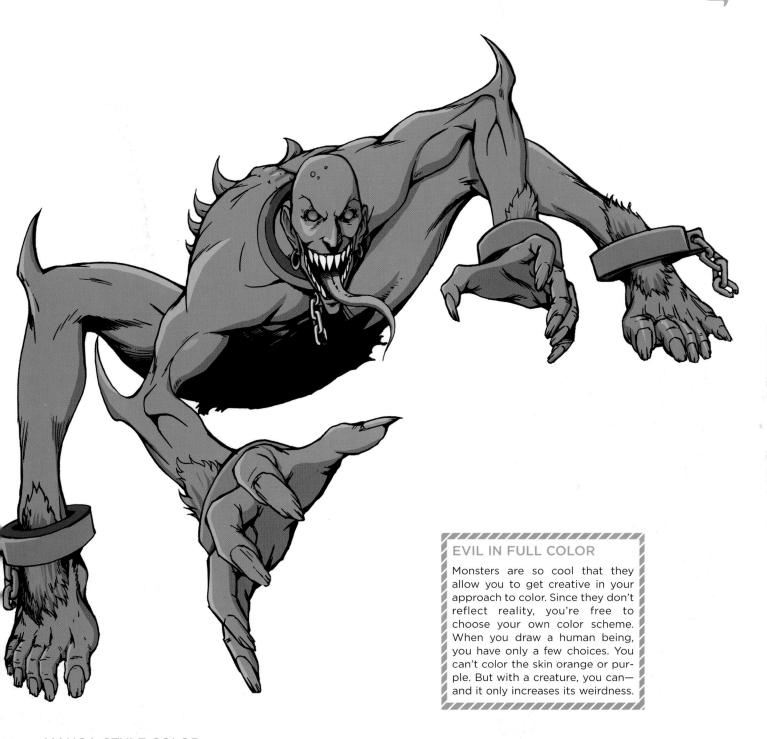

MANGA-STYLE COLOR

EVIL IN FULL COLOR

Monsters are so cool that they allow you to get creative in your approach to color. Since they don't reflect reality, you're free to choose your own color scheme. When you draw a human being, you have only a few choices. You can't color the skin orange or purple. But with a creature, you can—and it only increases its weirdness.

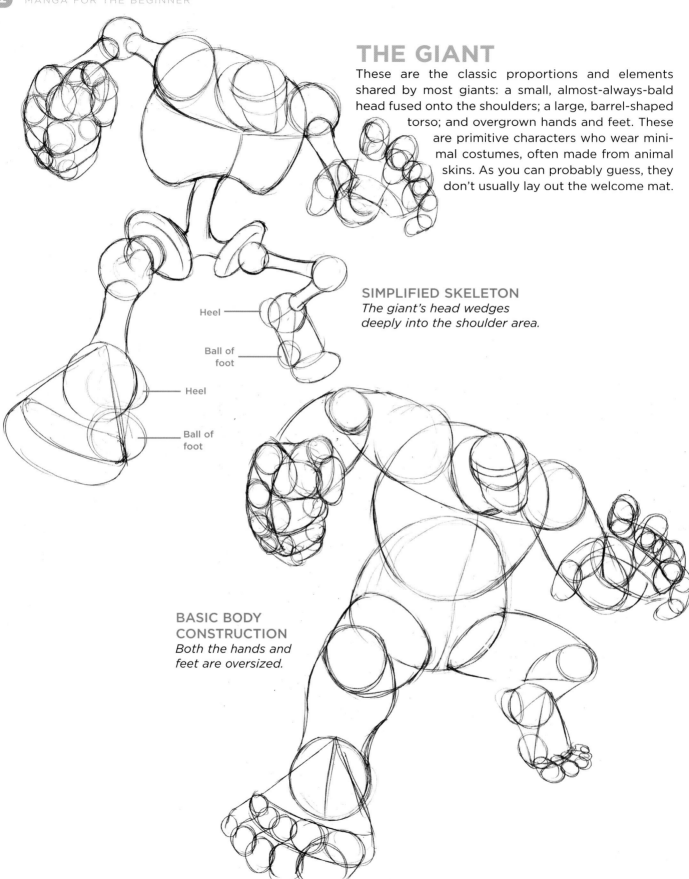

THE GIANT

These are the classic proportions and elements shared by most giants: a small, almost-always-bald head fused onto the shoulders; a large, barrel-shaped torso; and overgrown hands and feet. These are primitive characters who wear minimal costumes, often made from animal skins. As you can probably guess, they don't usually lay out the welcome mat.

SIMPLIFIED SKELETON
The giant's head wedges deeply into the shoulder area.

Heel

Ball of
foot

Heel

Ball of
foot

**BASIC BODY
CONSTRUCTION**
Both the hands and feet are oversized.

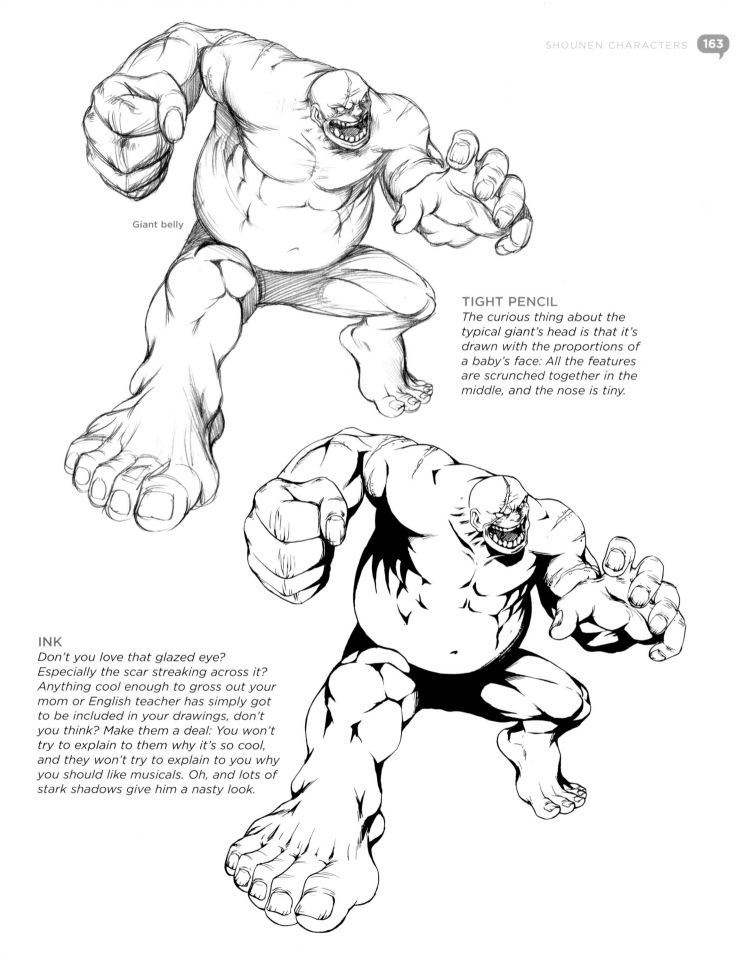

Giant belly

TIGHT PENCIL

The curious thing about the typical giant's head is that it's drawn with the proportions of a baby's face: All the features are scrunched together in the middle, and the nose is tiny.

INK

Don't you love that glazed eye? Especially the scar streaking across it? Anything cool enough to gross out your mom or English teacher has simply got to be included in your drawings, don't you think? Make them a deal: You won't try to explain to them why it's so cool, and they won't try to explain to you why you should like musicals. Oh, and lots of stark shadows give him a nasty look.

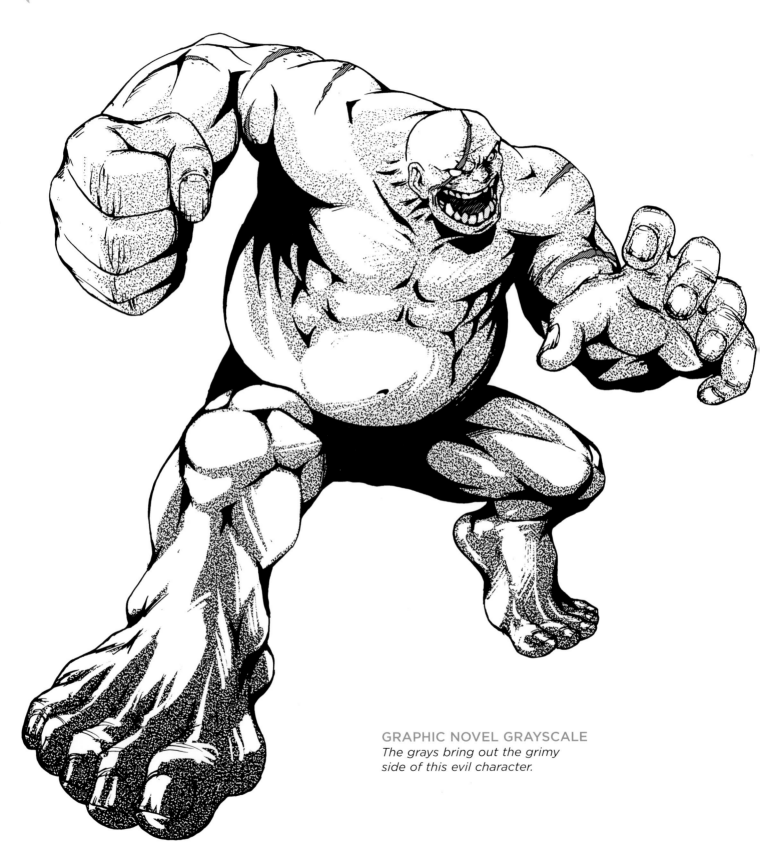

GRAPHIC NOVEL GRAYSCALE
*The grays bring out the grimy
side of this evil character.*

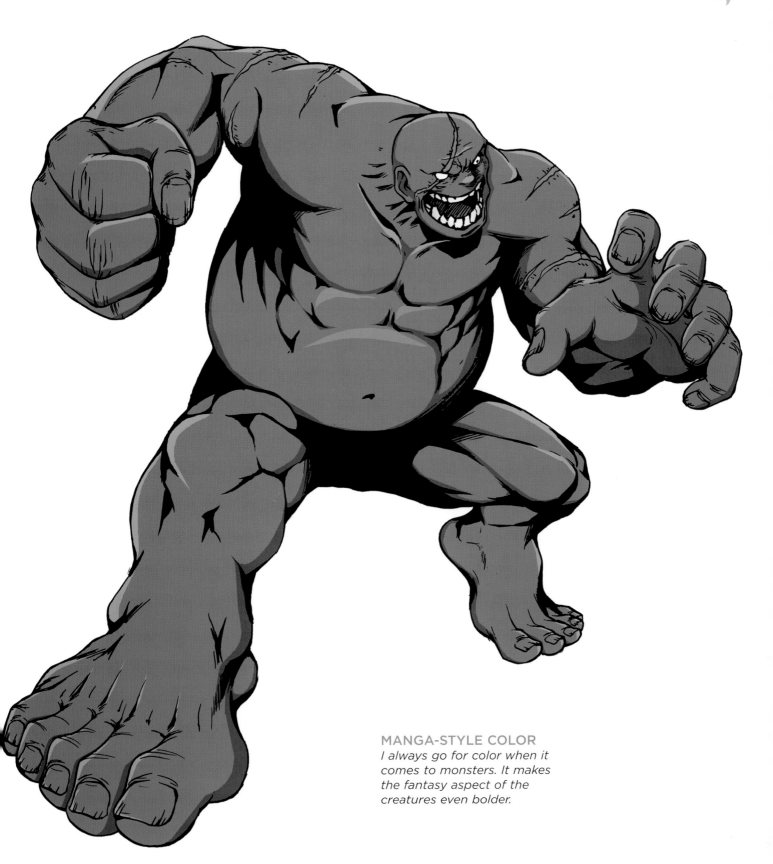

MANGA-STYLE COLOR
I always go for color when it comes to monsters. It makes the fantasy aspect of the creatures even bolder.

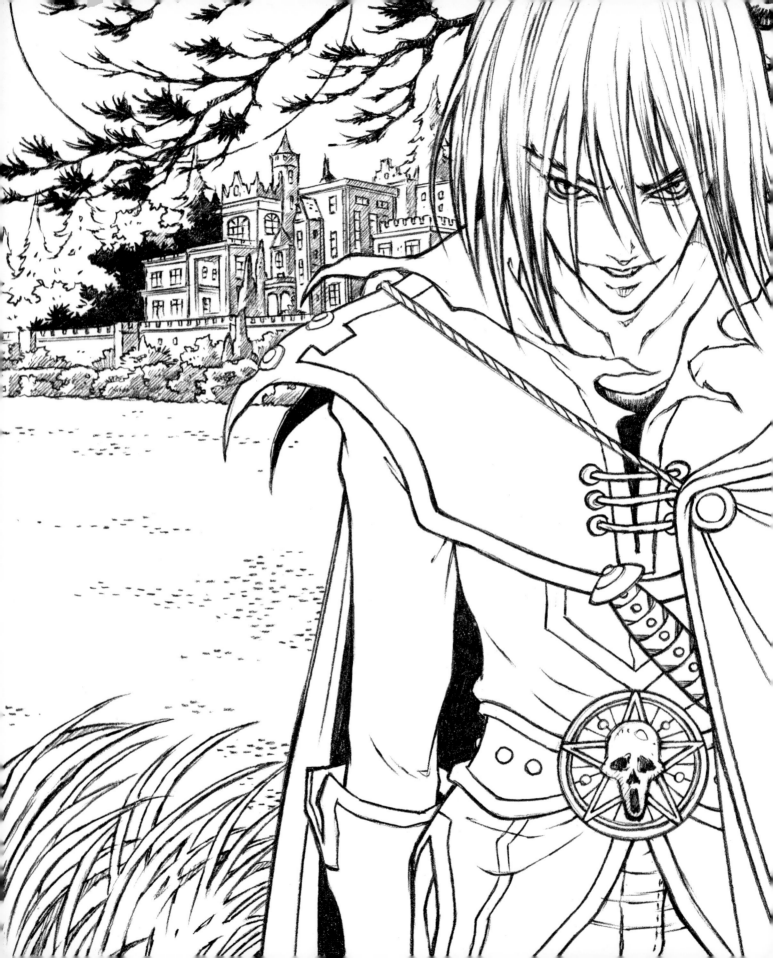

Basic Drawing Techniques

A SUCCESSFUL IMAGE IS MORE than just a nice drawing. It's the result of a combination of a bunch of elements: the right linework for the subject; strategic use of light, shadow, and shading; the addition of special effects; and the implementation of correct perspective. But these things don't have to be intimidating. If you break them down, element by element, you can master them, and pretty soon, including them in your work—while you work—will become second nature to you. You won't even have to think about it.

LINEWORK

There's more than one way to treat the lines in a drawing, and what you decide to do can really affect the final feel of the image. Although these techniques are subtle, their impact is felt by the reader.

Thin, Even Line

Here is a final, clean drawing in its first stage, before any of the finishing touches have been added. This is probably the stage at which many of you stop drawing. There's nothing wrong with stopping here. But as you can see, the drawing somehow lacks impact, and it's not because anything is wrong with the way it has been drawn or conceived. It's because all of the lines are the same thickness, which is pretty thin. As a result, the character looks delicate even though she's a fantasy fighter.

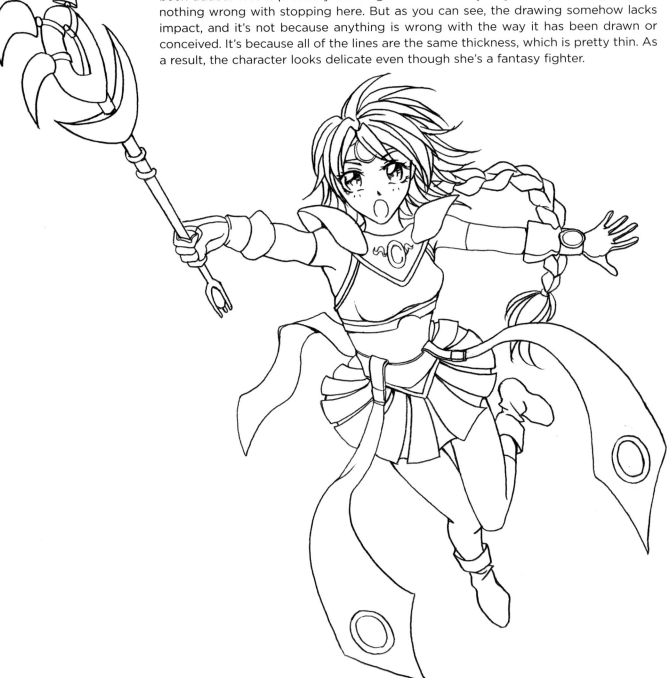

Lines of Varying Thickness

Here, the lines have been thickened at strategic places along the figure, which creates a bold and impressive look.

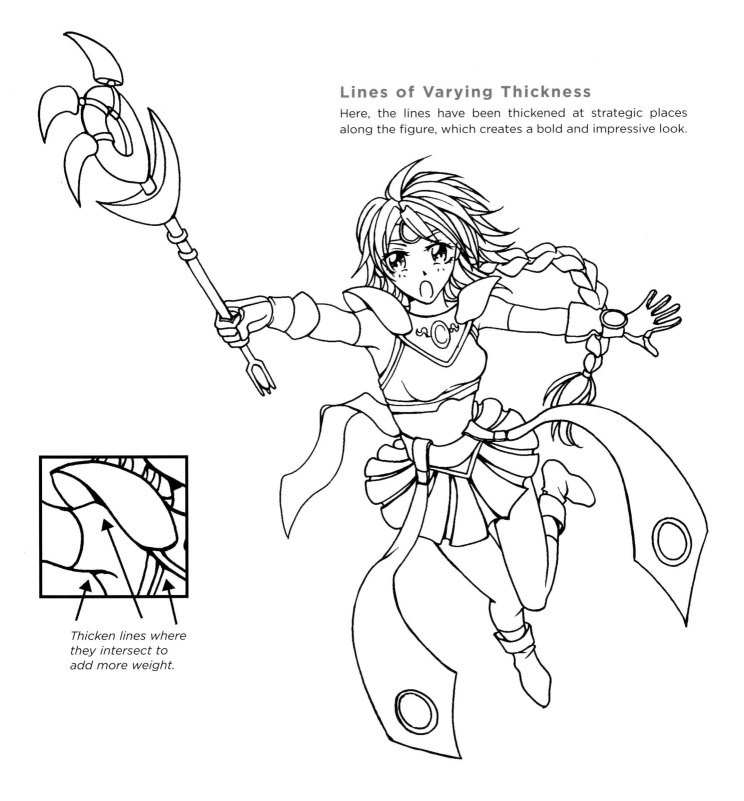

Thicken lines where they intersect to add more weight.

ADDING GRAY TONES AND SPECIAL EFFECTS

Gray Tones

To give your drawings the look of a manga graphic novel, you'll need to add some gray tones. Some people use pencil shading, others use markers, and some scan their drawings into computers to apply gray tones. All of these methods are good. Use whichever you're comfortable with.

 A good thing to remember, and something people tend to forget, is that *gray* is not a single tone. There are many, many variations of gray. Even an ordinary pencil can make four or five different intensities of gray, depending on how hard you press down. Pick up any graphic novel and you'll quickly see that the grays run the spectrum from very dark to extremely light. Make use of the entire palette. You can also use gray on top of gray to add shadows to surfaces that are already colored gray. Some special effects are drawn in gray tones without any black outlines to define them. This makes the special effect look like raw energy.

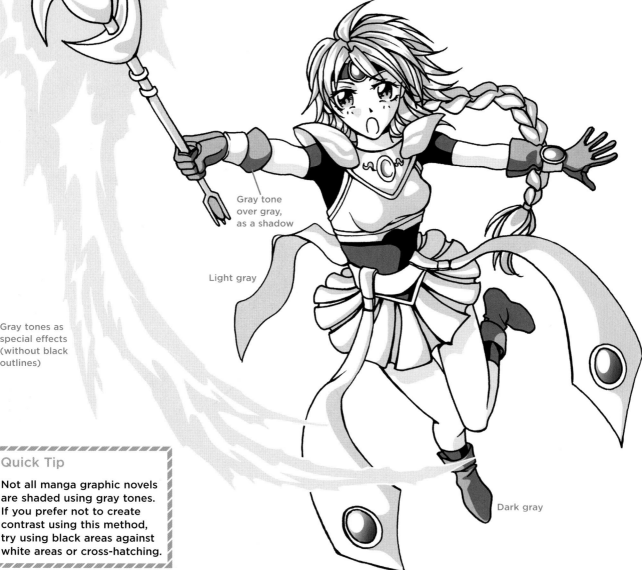

Gray tone over gray, as a shadow

Light gray

Gray tones as special effects (without black outlines)

Dark gray

Quick Tip

Not all manga graphic novels are shaded using gray tones. If you prefer not to create contrast using this method, try using black areas against white areas or cross-hatching.

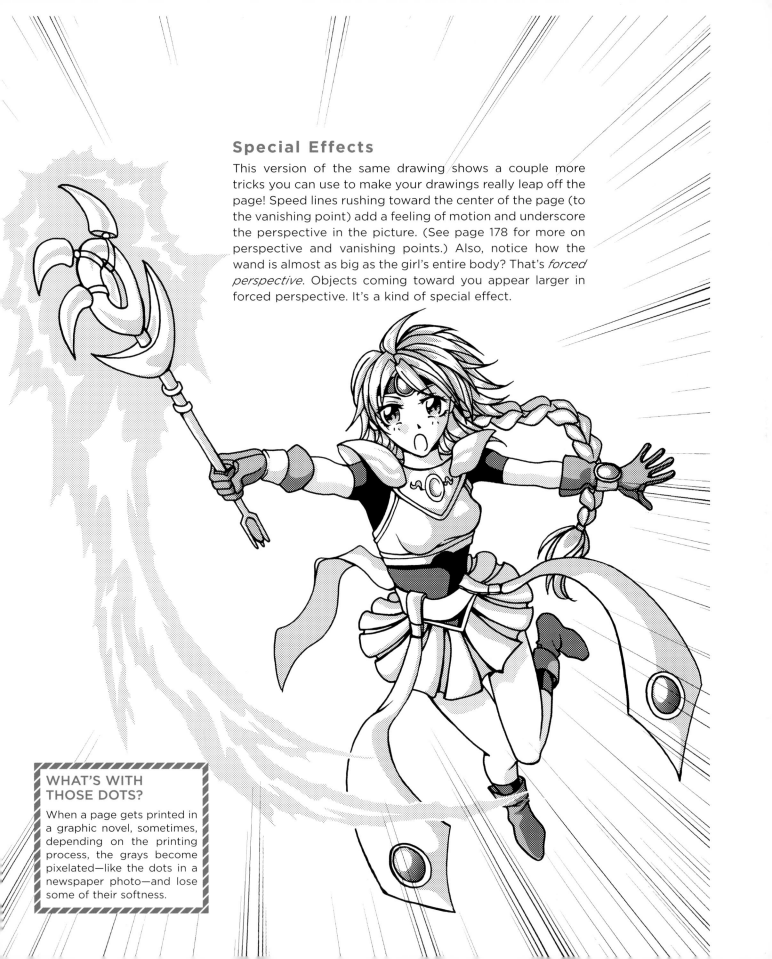

Special Effects

This version of the same drawing shows a couple more tricks you can use to make your drawings really leap off the page! Speed lines rushing toward the center of the page (to the vanishing point) add a feeling of motion and underscore the perspective in the picture. (See page 178 for more on perspective and vanishing points.) Also, notice how the wand is almost as big as the girl's entire body? That's *forced perspective*. Objects coming toward you appear larger in forced perspective. It's a kind of special effect.

See page 178 for more on perspective and vanishing points.

WHAT'S WITH THOSE DOTS?

When a page gets printed in a graphic novel, sometimes, depending on the printing process, the grays become pixelated—like the dots in a newspaper photo—and lose some of their softness.

USING LIGHT AND SHADOW

One of the great things about drawing comics is that you have so many tools at your disposal for directing the feelings of the reader. Light and shadow can help to create powerful, emotional moments. Beginners often leave these effective tools out of their artistic arsenals. Don't forget to include them.

You probably think of shadows in terms of their physical effect. If someone stands by a strong light, a shadow is formed. But manga artists also think of shadows in terms of mood and of the psychology behind the moment. For example, a shadow can be included to create tension—regardless of where a real shadow would fall in a scene. Just like a composer uses various tricks to underscore or highlight important moments in a musical piece, you can use light and shadow to do the same in your drawings. To see what I mean by this, look at how shadows heighten the effectiveness of particular expressions here, without indicating the location of the scene or giving other clues.

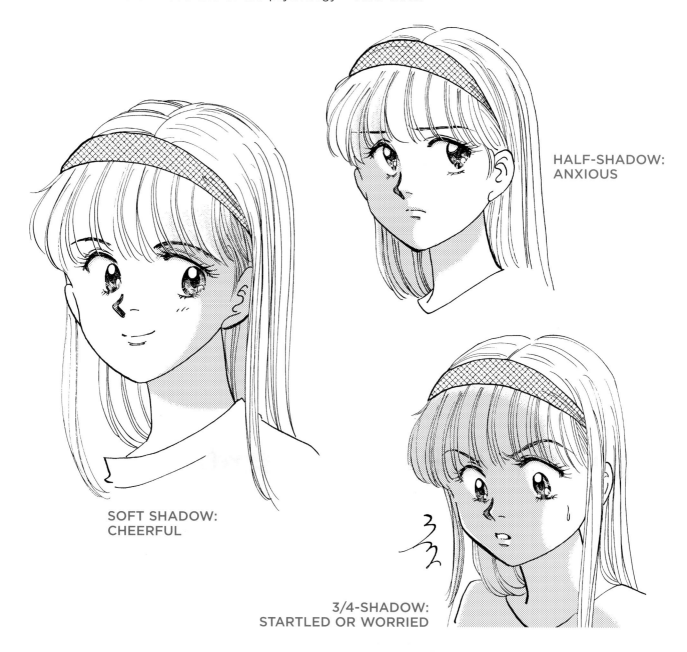

HALF-SHADOW:
ANXIOUS

SOFT SHADOW:
CHEERFUL

3/4-SHADOW:
STARTLED OR WORRIED

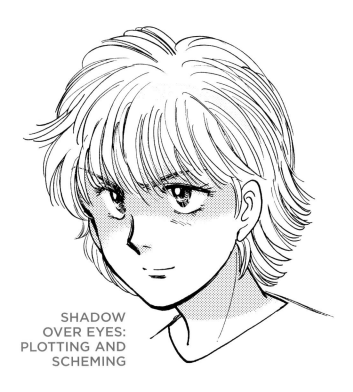

SHADOW
OVER EYES:
PLOTTING AND
SCHEMING

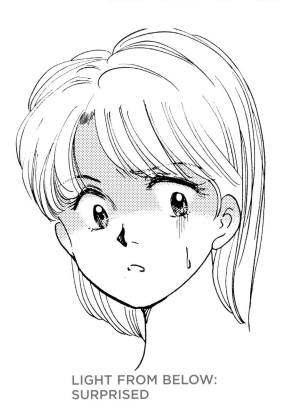

LIGHT FROM BELOW:
SURPRISED

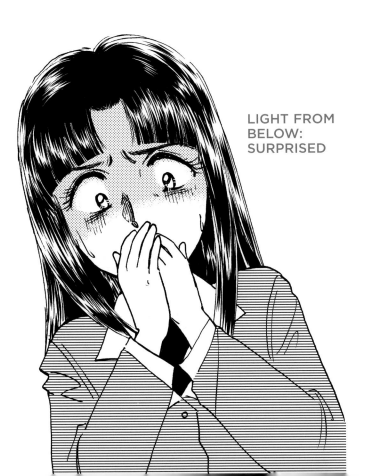

LIGHT FROM
BELOW:
SURPRISED

SEVERE LIGHTING FROM
BELOW: HORRIFIED

TYPES OF LIGHTING

There are many types of lighting, and just as you can use light and shadow to indicate the mood or emotions of a character, you can also use them to cue your reader in to the situation, location, or time of day.

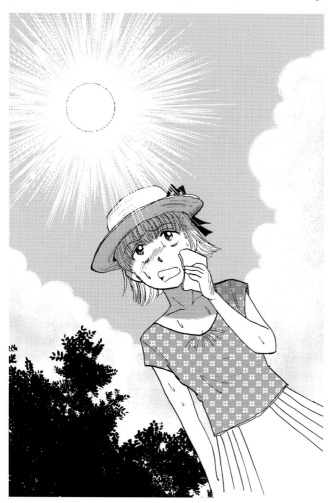

CITY LIGHTS
This effect combines a dark sky with silhouetted skyscrapers, "checkerboarded" with indoor lights.

NOONDAY SUN
Note that the circular outline of the sun is a broken line. The sun's streaks actually begin at a distance from the circle, creating a "glow" effect that reads as intense heat. Also note the harsh shadows created by direct overhead light.

BACKLIGHTING
Backlighting hits subjects from behind, casting them in shadow or silhouette. The darker the figure in the foreground, the brighter the windows (or any other light source) behind the subject will appear to be. The light source that creates the backlighting can be natural, as in this example, or artificial.

THAT SPECIAL GLOW

Artificial light often glows. This glow radiates out from the light source, producing a white aura around it. A diffuse shadow then falls around the scene or on the edges of the characters. This adds warmth to the scene or gives it a spooky feeling, depending on the moment.

LANTERN

CANDLES

FIREWORKS

FLASHLIGHT

SPECIAL EFFECTS LETTERING

Another tool in your manga bag is special effects lettering. It greatly dramatizes actions and adds impact. But it goes beyond that to also bring out emotions—even embarrassing and other humorous moments. Lettering effects are often combined with speed lines or other visual effects. Don't be afraid to let the letters overlap the characters, so long as you can still see the poses and the faces.

Sometimes, sound effects are repeated to become the background. Other times, the lettering is so bold that it fills the foreground. Sometimes, it starts off in the background and winds its way around the character, ending up in the foreground. Mostly, though, lettering is large but placed off to the side.

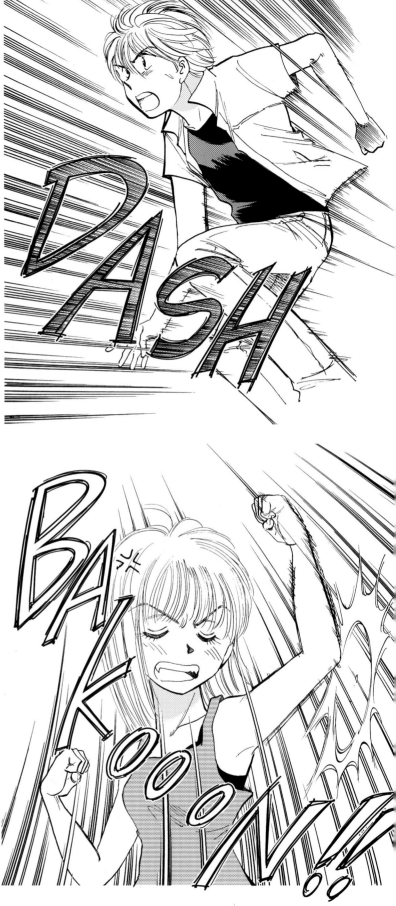

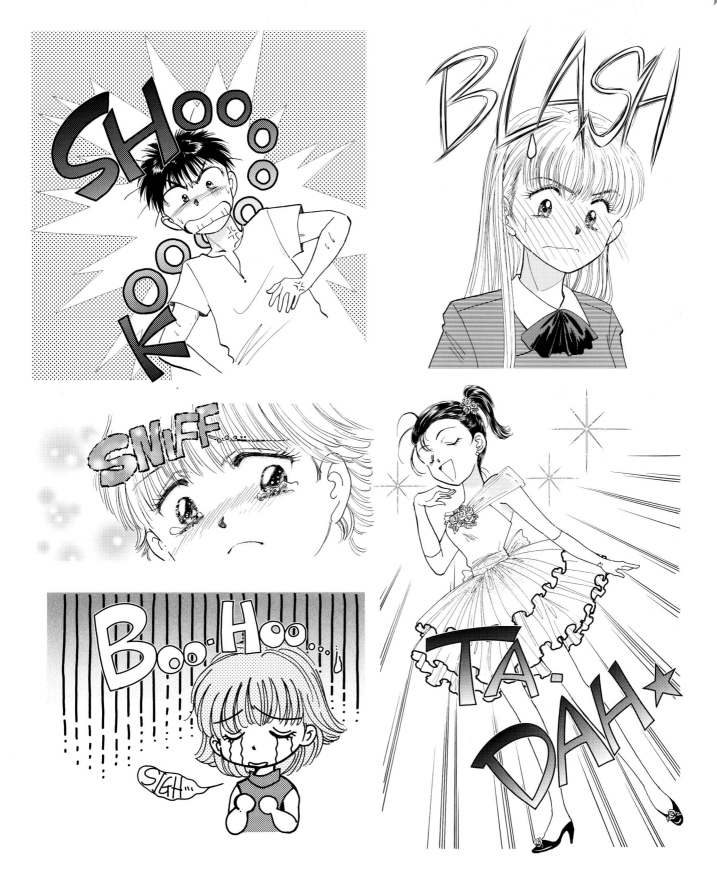

ONE-POINT PERSPECTIVE

When you place your characters in settings, the principles of perspective really come into play. Many books have been written about perspective, and some have made it seem complex, but it needn't be. There are three types of perspective most commonly used: one-point, two-point, and three-point perspective. Don't be afraid of this subject. We'll break it down so that it not only makes sense to you but becomes clear and even interesting.

Let's start off with the most basic form: one-point perspective. This one you'll understand right away at a gut level. The first thing to do when designing a setting is decide where to place the *horizon line*. This is is where the ground meets the sky. However, if you want to create a particular feeling, you can change the placement of the horizon line. We'll see how that works in the next few pages, but in this scene, the horizon line falls pretty much in the middle, at a neutral level, as indicated by the red line.

Now, see the little circle at the center of the page? That's the *vanishing point*. Keep in mind that the vanishing point always falls on the horizon line. In one-point perspective, everything converges at that one point, like parallel railroad tracks that go off into the distance and eventually appear to meet. This happens because you're looking straight on at the picture. The lines that converge at the vanishing point are called *vanishing lines*. Use the vanishing lines as invisible guides to diminish your objects as they recede toward the vanishing point.

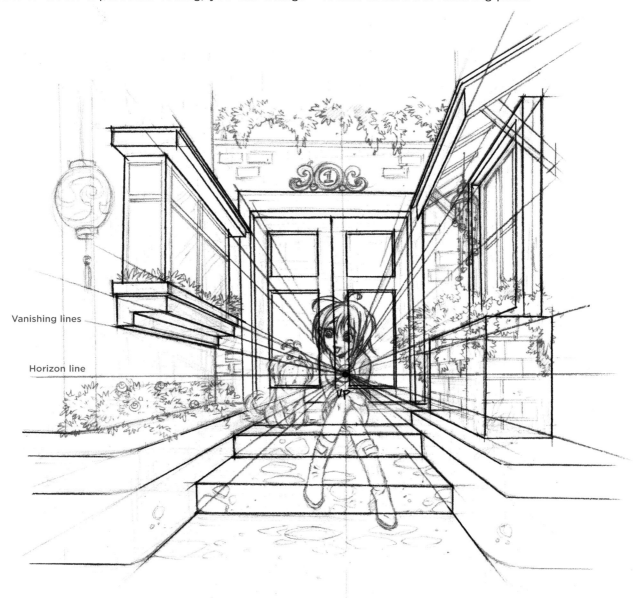

Vanishing lines

Horizon line

VP

Once you remove the vanishing lines, you can see how the scene comes together. All the elements recede toward the middle of the picture as if the entranceway to the house really has depth, which you now know is due to the fact that all the lines that move from front to back in the scene travel along vanishing lines that extend toward the vanishing point.

High Horizon Line and Vanishing Point

In this scene, the height of the horizon line gives the reader a different perspective: looking down at the scene. By placing the horizon line toward the top of the picture, the eye looks down at everything below it. Notice that the vanishing point—the red circle—is still in the center of the horizon line, and all the vanishing lines still converge at it.

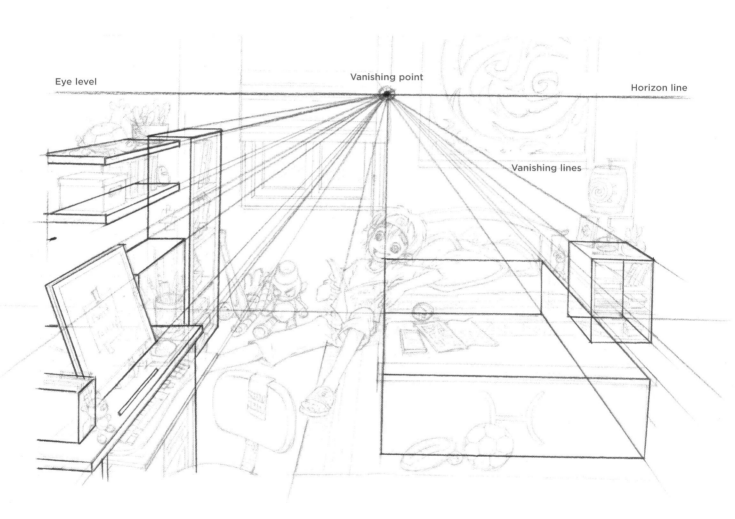

To make the stuff in the room easier to draw in perspective, first simplify it using squares and rectangles that recede along the vanishing lines. Then add the details to make it look like furniture after the basic shapes are already in place and in perspective.

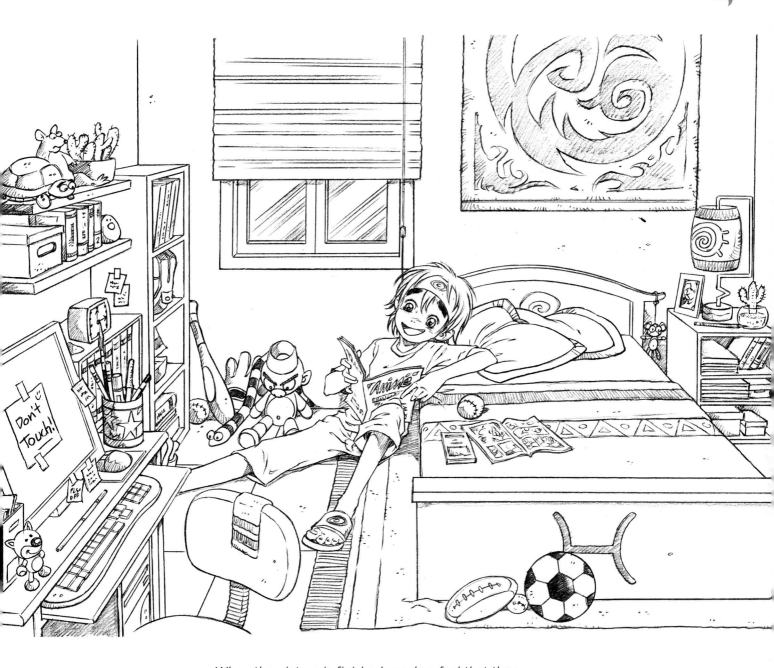

When the picture is finished, readers feel that they are viewing the scene from an elevated position. They are not at the same eye level as the teen in the picture but are above him, at the horizon line, looking down, which provides a good look at the entire room. This makes for a solid establishing shot, which is a standard way to begin a story.

TWO-POINT PERSPECTIVE

In two-point perspective, there are (you guessed it) two vanishing points. They are called *vanishing point left* and *vanishing point right*, due to their placement on the horizon line. Pretty simple so far, right? A bunch of vanishing lines converge at the vanishing point on the left, and the rest converge at the vanishing point on the right. And as in one-point perspective, the vanishing points (both of them) are placed on the horizon line.

Notice that the horizon line hits all the characters at about the same level: midthigh. Is that just a coincidence, or is it planned that way? Hmmm . . . should I tell? Okay, it's part of the plan. This keeps them at the same height. If the horizon line were to hit one character at ankle level, one at neck level, and one at stomach level, the scene would look loony. Some characters would look giant and others teeny. But by intersecting them all at the same point, you maintain order.

Drawing Buildings

What do you notice first about these buildings? What I see is that the corners are facing us. Anytime a corner faces you, the reader, it means that two-point perspective is at work. That's easy to remember, isn't it? And right there, smack in the middle of the picture, is a tower with its corner facing us dead-on. The two sides of the tower that we see travel to vanishing point left and vanishing point right, respectively.

And take a look at this: The bench in the foreground is below the horizon line and also has vanishing lines that travel to vanishing point left and vanishing point right. All objects obey the laws of perspective no matter where they fall on the picture plane, above or below the horizon line.

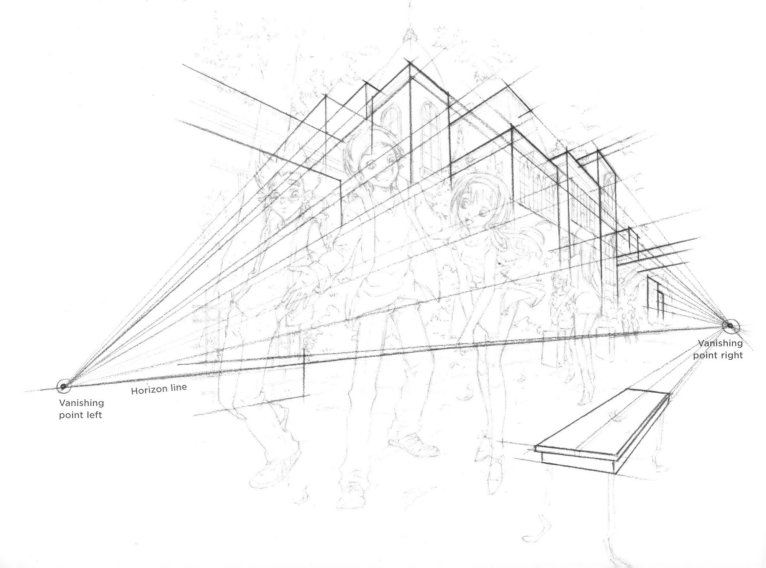

Horizon line

Vanishing point left

Vanishing point right

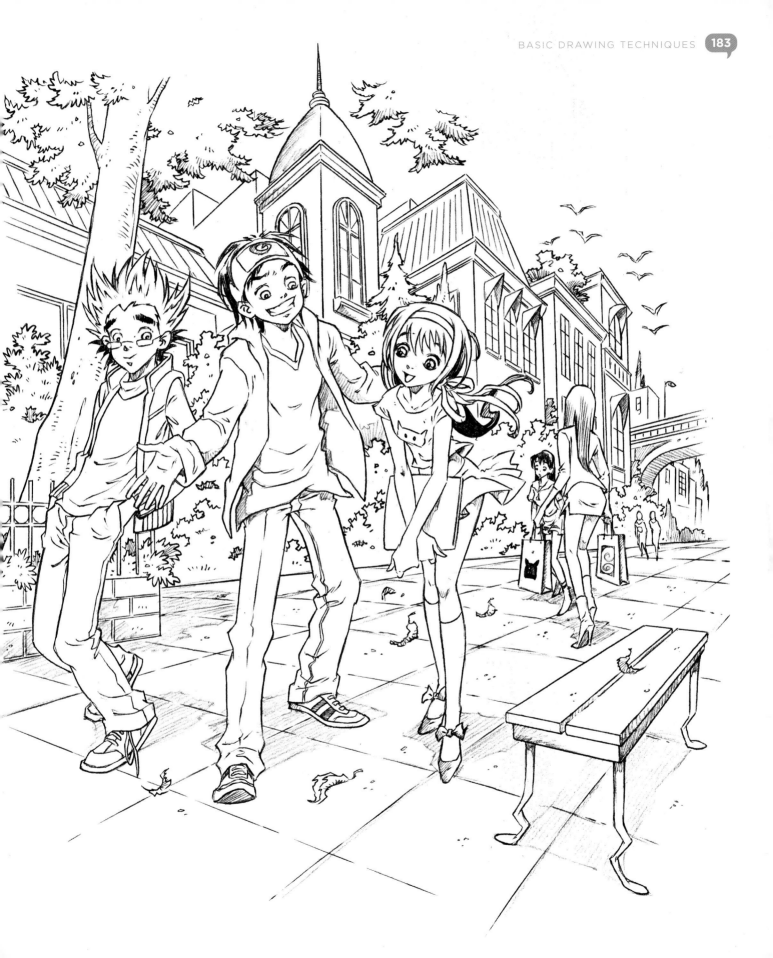

THREE-POINT PERSPECTIVE

You won't use three-point perspective as often as one- and two-point. It's more of a dramatic device employed to convey the grandeur of tall buildings, castles, giant robots, humongous computers, anything big that needs to look awesome or impressive—even towering figures, like heroes and evil guys.

In three-point perspective, the third vanishing point is overhead instead of at left or right. Therefore, it's not placed on the horizon line at all. You simply choose a spot above the horizon line and make that your third vanishing point. If you make it too close to the ground, the building will have to "vanish" very quickly and will look kind of squat and fat. So make sure you leave enough space between the vanishing point and the horizon line.

Don't forget about the other two perspective points, vanishing point left and vanishing point right. All you're doing is adding a third one. And by the way, you can also draw things in one-point perspective with the addition of this "third" perspective point. Just add the additional vanishing point overhead

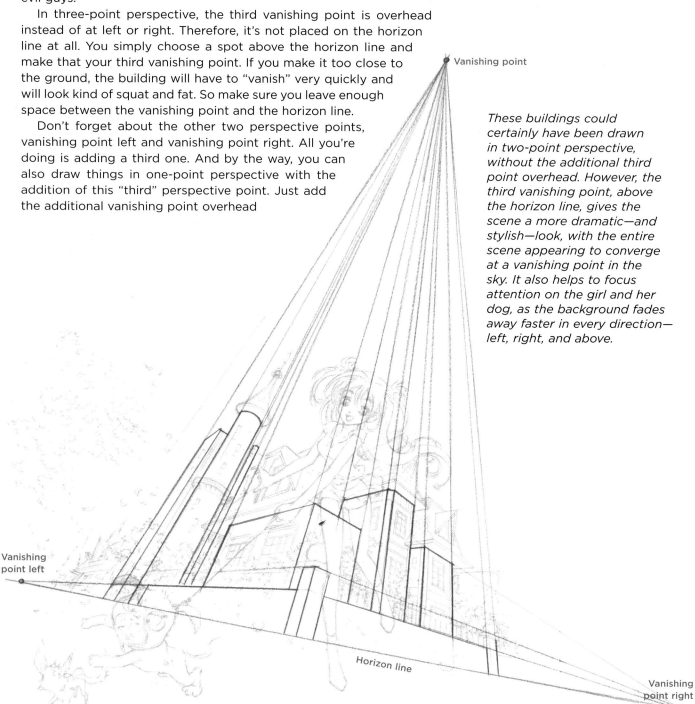

Vanishing point

These buildings could certainly have been drawn in two-point perspective, without the additional third point overhead. However, the third vanishing point, above the horizon line, gives the scene a more dramatic—and stylish—look, with the entire scene appearing to converge at a vanishing point in the sky. It also helps to focus attention on the girl and her dog, as the background fades away faster in every direction— left, right, and above.

Vanishing point left

Horizon line

Vanishing point right

WHEN VANISHING POINTS FALL OUTSIDE THE PICTURE

Try to add vanishing points before you draw the background, otherwise you'll have to erase and adjust everything in order to make things conform.

This scene of an inept apprentice samurai has both the left and right vanishing points falling outside of the picture plane. Notice how all of the slats in the ceiling converge at the same point, vanishing point left. If the vanishing points were scrunched together, onto the picture, it would make the room much, much taller, and the ceiling would slant so dramatically that it would look weird.

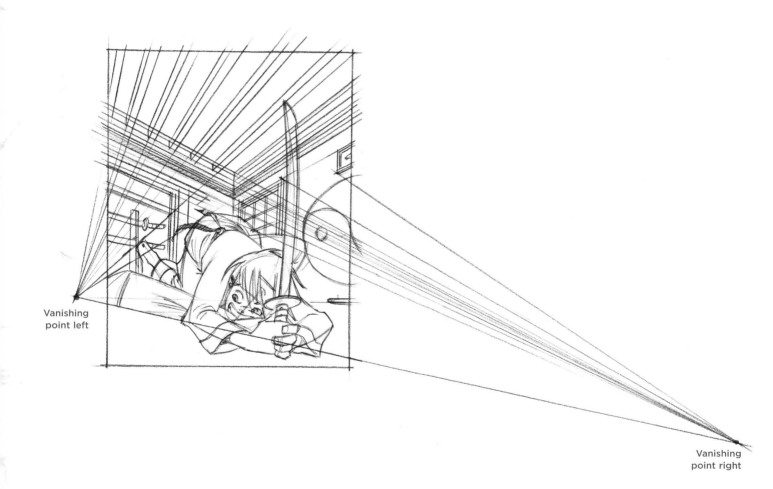

Vanishing
point left

Vanishing
point right

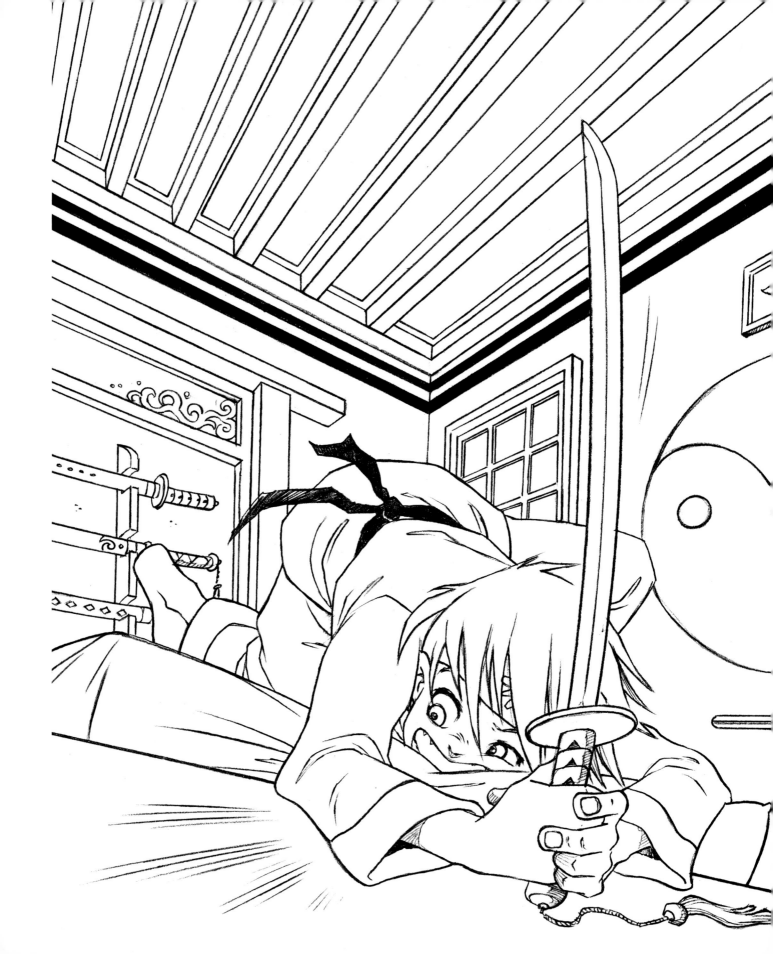

THE LANDSCAPE IN PERSPECTIVE

Okay, so you want to draw in perspective, but you've got a nature scene. What do you do? There aren't any corners anywhere! There's nothing to converge! No vanishing lines to be found. And yet, you still want to give the reader the feeling that the scene takes place in perspective. You want a dense forest. Someplace a person could get lost. Perhaps that's important to the story.

You shouldn't try to invent square or other basic geometric shapes where there are none. But you still have a horizon line to work with. Think of the ground as the board in a board game. Think of the "stuff" that goes on the ground (trees, animals, stones, bushes, and so on) as the playing pieces. To put your playing pieces on the board, you first need to draw a grid, like a checkerboard. One set of lines will trail off to vanishing point left and the other to vanishing point right. Now see what happens? The grid gives you a feeling of a plane that has depth. And as you draw, you'll naturally begin to adjust the size of the objects in the drawing to accommodate the environment you've just created.

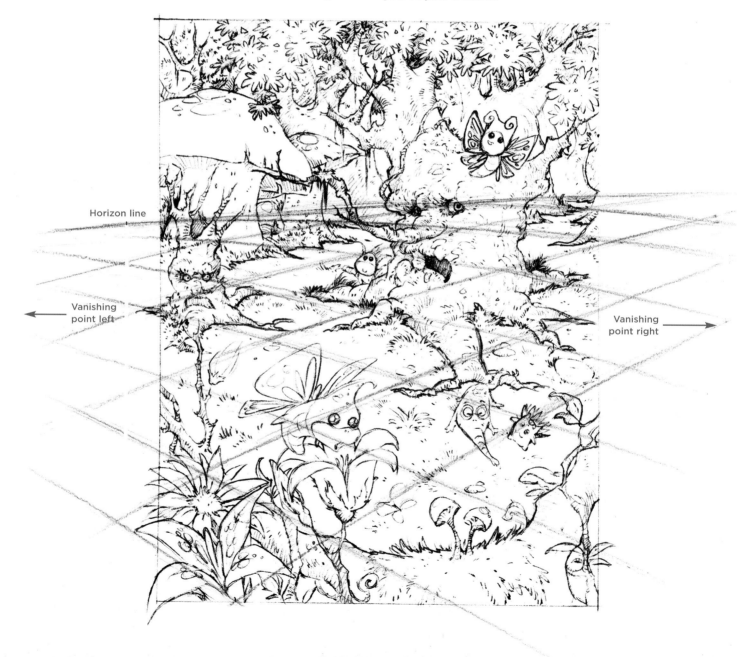

Horizon line

← Vanishing point left

Vanishing point right →

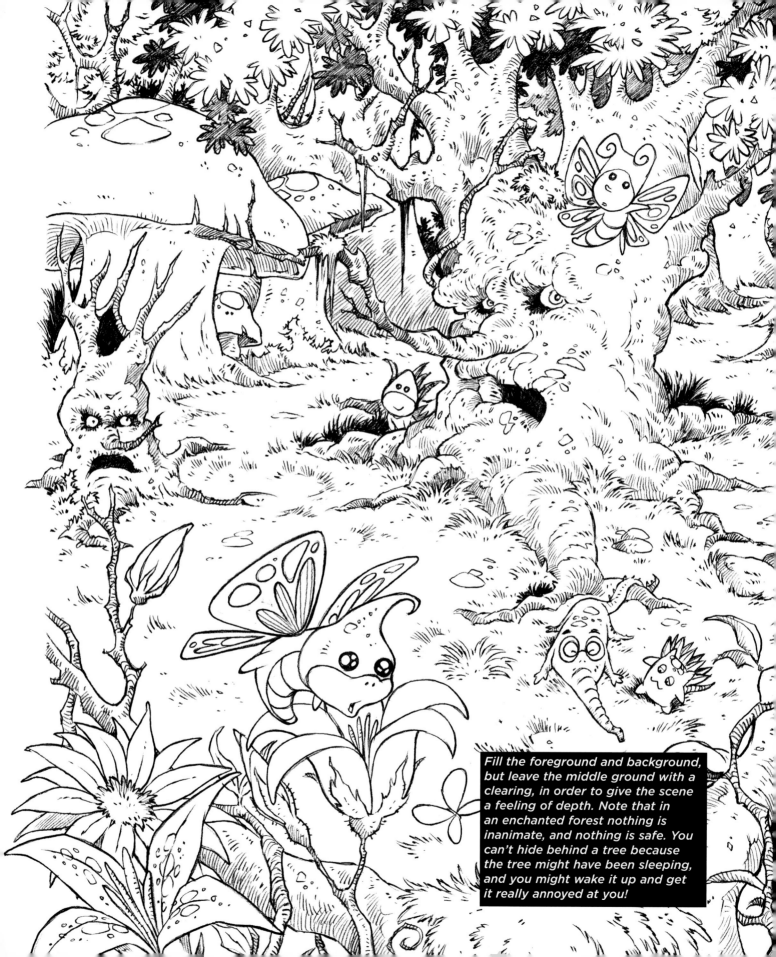

Fill the foreground and background, but leave the middle ground with a clearing, in order to give the scene a feeling of depth. Note that in an enchanted forest nothing is inanimate, and nothing is safe. You can't hide behind a tree because the tree might have been sleeping, and you might wake it up and get it really annoyed at you!

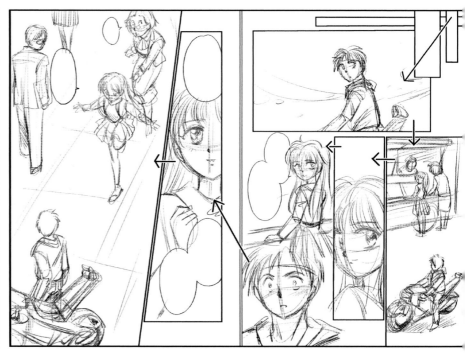

END

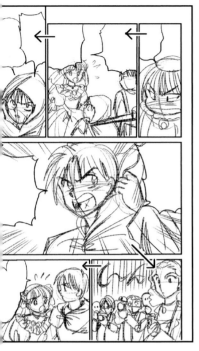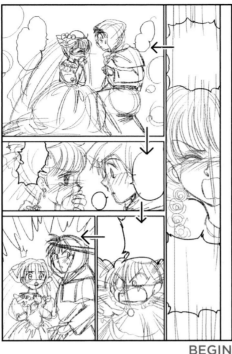

BEGIN

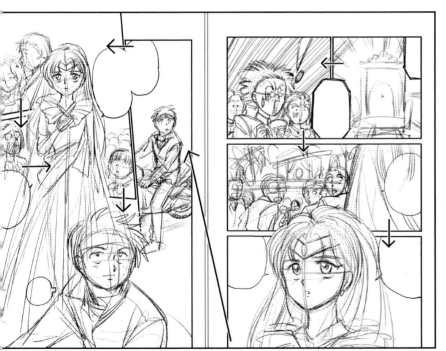

This is a rough pencil layout by Nao Yazawa from the story Dokidoki Half Princess, *which appeared in* Chao DX: Winter *from Syogakukan '92.*

SEQUENTIAL PANELS

In Japan, comics are read from right to left. Some major American publishers publish manga in the left-to-right English format as well as in the traditional right-to-left Japanese format. This is a sign that manga is no longer strictly a Japanese art form but has been co-opted by the global marketplace. Even Tokyo Pop is publishing original manga by American artists. Each country is making its own mark on manga. People who like new trends tend to be open to experimentation; purists tend to disapprove. I think there's ample room for both camps.

The basic concept of stringing together an interesting set of panel configurations is the same whether you're reading from left to right or right to left. Let's take a look at the traditional Japanese right-to-left format, since we're all familiar with left-to-right-format comic books. It's important to notice that this is more than just reading right to left; the panels are also read from top to bottom and at diagonals, as indicated by the arrows marked on the panels (these wouldn't appear in the final pages, of course).

SEQUENCING TIPS

- Move from smaller to bigger panels.
- Insert smaller panels into bigger panels.
- Create odd-shaped panels.
- Alternate vertical and horizontal panels.
- Allow a character's image to overlap a panel.
- Allow speech balloons to overlap panels.
- Vary close-ups, medium shots, and long shots among panels.
- Minimize the number of speech balloons in a single panel.
- Direct the reader's eye to travel from the bottom of one page to the top of the other.

INDEX